2119

POP SHOTS

A 35-YEAR PERSPECTIVE OF MUSIC PERFORMERS THROUGH THE PHOTOGRAPHY OF

D0514883

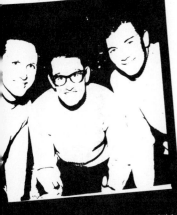
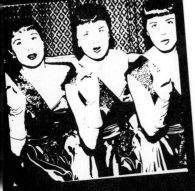
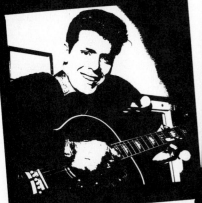
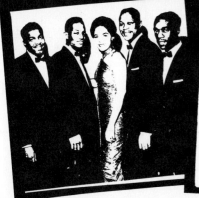

HARRY HAMMOND

AND

GERED MANKOWITZ

Introduction by Peter Hogan

Foreword by Andy Summers of *The Police*

HARPER COLOPHON BOOKS

Harper & Row, Publishers

New York, Cambridge, Philadelphia, San Francisco

London, Mexico City, São Paulo, Singapore, Sydney

This work was first published in England under the title HIT PARADE.

POP SHOTS. Copyright © 1984 by Harry Hammond and Gered Mankowitz. All rights reserved. Printed in the United States of America. No part of this book may be used or reproduced in any manner whatsoever without written permission except in the case of brief quotations embodied in critical articles and reviews. For information address Harper & Row, Publishers, Inc., 10 East 53rd Street, New York, N.Y. 10022.

FIRST U.S. EDITION

ISBN 0-06-091071-2

LIBRARY OF CONGRESS CATALOG CARD NUMBER 83-47562

84 85 86 87 88 RRD 10 9 8 7 6 5 4 3 2 1

We would like to thank Sue Davies and her associates at the Photographers' Gallery in London, without whom the exhibition Pop People, **on which this book is based, would not have been possible.**
Harry Hammond and Gered Mankowitz

For my dear wife Margaret, and our daughter Carole Linda
Harry Hammond

My thanks – past and present – to Maurice Kinn, the BBC, Radio Luxembourg, the London Palladium Management, and Ilford.
Harry Hammond

For Julia, Jessica and Raisin
Gered Mankowitz

I would like to thank the following producers, managers, art directors and record companies, all of whom have helped me over the past twenty years: Andrew Oldham, Chris Blackwell, Simon Napier-Bell, Chas Chandler, Mike Leander, Micky Most, Nicky Chinn, Mike Chapman, Fabio Nicoli, David Costa, Bill Smith, Andrew Christian, Mike Doud, Peter Wagg, Mike Stanford, EMI Records, A&M Records, Polygram Records, CBS Records, Virgin Records, Chrysalis Records, Charisma Records, RCA Records, Island Records, Safari Records, Rocket Records and Ember Records. Special thanks to all at Adrian Ensor for the black and white prints and also to Mike Hales.
Gered Mankowitz

All chart positions referred to in this book are based upon British charts as quoted in The Guinness Book Of British Hit Singles, 4th Edition, *by Rice, Rice, Gambaccini and Read (Guinness, 1983). Special thanks to Patrick Humphries and Fred Dellar.*

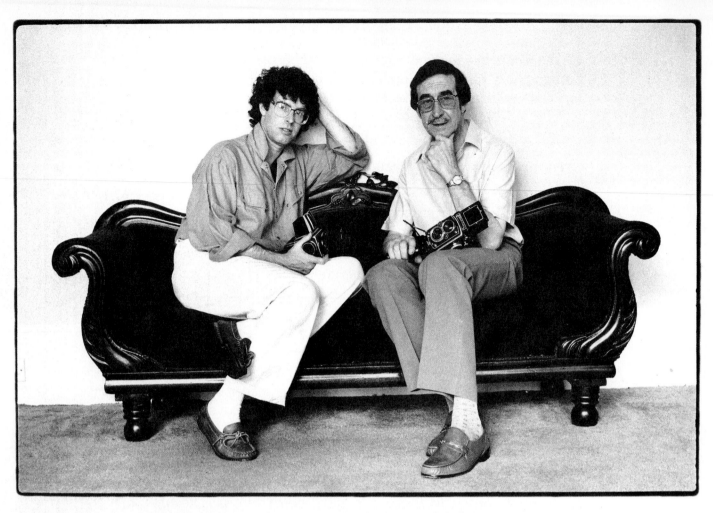

Gered Mankowitz and Harry Hammond. Photograph by Andy Summers.

The marriage between pop music and photography is thirty-five years old. Within that time photographers have become skilled and subtle in dressing their artists' images. In the same way, artists themselves have learnt to project their images with a sophistication which makes me giggle when I look back at my earliest efforts.

When I first stood in front of a camera in the mid-sixties, I was there with my group to get what we then called 'monkey shots', otherwise known as publicity photographs. On being summoned, we would eventually turn up with our guitars, and spend an hour reducing the photographer into a nervous wreck. If he was lucky, we would strike up a few meaningful poses before falling out of the studio and disappearing back into the London suburbs.

This book delightfully reveals the growth of the photographic image into a mysterious and seductive one. The selling is soft and sexy now, and we the public are dazedly beguiled by this latest piece of magic. Now it all seems so different, but if one looks hard enough, it may be that nothing has changed at all.

'Hit parades turn into charts, albums once were LPs. . . .'
– *Johnny G, 'Like Smokey I Smile.'*

In March 1981, the Photographers' Gallery in London staged an exhibition entitled *Pop People* which combined for the first time the work of two photographers – Harry Hammond and Gered Mankowitz – who between them had been photographing popular music performers for over thirty years. In the three weeks the exhibition ran at the Gallery, it set a record attendance figure of over 62,000 visitors. They were of all ages and backgrounds, proving that the subject matter cannot just be conveniently pigeonholed as 'nostalgia' on the one hand, nor as 'youth culture' on the other. The exhibition has since toured Britain extensively, to uniform acclaim. *Hit Parade* is a development of that exhibition.

Today, the power of pop, both commercial and social, is widely recognized. Ever since the Beatles met the Queen and Bob Dylan was asked his opinions about Life, it has formed a large part of Western culture. When London swung, pop stars rubbed shoulders with actors and designers, artists, comedians and countesses; the influence spread inexorably from high society to the high street. To some, pop itself became Art with a capital A; it was certainly less possible for it to be dismissed as (totally) frivolous entertainment. But it was not always that way.

When Harry Hammond first started photographing musicians in the late 1940s, the record industry was in its infancy, and the music business was a long way away from being influential. Harry Hammond was born in London in 1920, and was apprenticed at the age of fourteen to the London Art Service in Fleet Street, where he spent four years learning all aspects of the photographic trade – printing, developing, optics, chemistry, camera mechanics and repairs, as well as the finer points of commercial and advertising photography. From there he moved to the studio of Bassano of Dover Street, one of the court and society photographers of the day. It was here that Harry learnt the art of portrait photography. 'That's where I had my first experience of photographing people, and I discovered that I preferred it to photographing objects and buildings,' Harry has recalled. 'All the people were famous – dukes and duchesses, like the Duchess of Norfolk, famous authors like H. G. Wells, and sometimes members of the Royal Family. Each coming out season, we would photograph all the debutantes, who would visit the studio in the evening after being presented at court, during the summers of 1938–39. Those were the last grand days of the Empire, soon to vanish forever, with war imminent.' Apart from Elliott & Fry, Bassano was the last of the great studio photographers who dominated the last century, and who vanished completely during the 1960s. Distinguished guests were not charged for their photographs, provided the copyright could be retained by the studio in order to obtain reproduction fees from such prestigious society magazines as *The Tatler* and the *Illustrated London News*. 'It was this idea which later prompted me to become freelance,' Harry continued, 'although I never used a studio again – all my work is done on location, as I feel that studio photography can be too contrived.'

When the war came, Harry joined the RAF as a photographer. 'During the early days of the war, we used hand cameras, hanging them out over the side of the airplane for reconnaissance work. Eventually they were mounted in the base of the plane, and by the middle of the war it all became remote control, operated by the pilot.' Harry spent the remainder of the war training pilots in aerial photography, and after a period as photographer at the Royal Aircraft Experimental Establishment he returned to Fleet Street as a freelancer in 1947. 'They were very hard times just after the war, and I started doing general news features, *haute couture* fashion shows, and for a period worked again as a society photographer – this time at smart

point-to-point meetings, Ascot, annual Hunt Balls and cocktail parties at Claridges – but the market for photographs of the idle rich was on the wane.' About this time, Harry remembers, 'I was also taking photographs of famous bandleaders and jazz people at these functions which I sold to *Jazz Journal*, and this led me to Denmark Street, off the Charing Cross Road, known as "Tin Pan Alley".' Around 1950 Harry began selling photographs of musical celebrities to the newly established pop columns of newspapers and magazines, and to the music trade press. For several years he was the *only* photographer recording this pioneering period of British pop.

Harry sold some of his pictures to the *New Musical Express*, at this time little more than a broadsheet with a small circulation. 'It was losing money until impresario Maurice Kinn bought it in 1953. He had a great deal of foresight – he could tell what was going to happen. Nobody else at the time could see that there was going to be a great surge of interest in gramophone records – sheet music was still the big thing. But Maurice seemed to know this, and he started getting advertising from the record companies. That was really the start of it all, when the music publishers realized that records were going to replace sheet music as the source of their income.'

In the early 1950s, pop was the domain of the big band and the ballad singer, and was little more than a wing of showbusiness. 'It was a very clean and tidy age,' said Harry. 'There weren't any fashions for young people, there was no such thing as a rebellious entertainer. If you were an entertainer you were expected to look well groomed.' The nature of the industry at the time dictated the nature of Harry's photographs – they were taken wherever and whenever possible. The idea of a record company or a manager commissioning a photo session was unheard of. 'I was basically a reportage photographer. I never used elaborate lighting, because there just wasn't time to set it up. I worked with a hand flash and a camera, and made the best of what was available – background, available light – whatever there was. I was always rushed for time. I usually liked to photograph an artist when they were dressed ready to go on stage, as editors liked to see the artist nicely presented – we even re-touched pictures to remove blemishes in those days. Unless there was a dress rehearsal, the only opportunity I'd have would be when the artist got ready for the actual show, and they usually got ready at the last minute. I'd hopefully get five minutes before the curtain went up, to take whatever I could. It was either do it like that, or not at all. The artists wanted to be photographed, because they knew the value of the publicity, but it was still a bit of a nuisance as far as they were concerned, to have to stop doing whatever they were doing to be photographed. You had to work in an almost apologetic way to get what you wanted. You couldn't bulldoze in at all.'

'Often in dressing room shots, there'd be other people in the room, and I'd either have to get them out of the room, or get them behind me – even the top stars' dressing rooms were tiny. It was a case of knowing what you wanted, having it set out in your mind, getting the people in position and getting on with it as quickly as you could.' The fact that all Harry's photographs were taken on location – backstage at the venue, in hotel rooms – with little time and under difficult circumstances, is amazing when one considers the quality of the results. Even the live shots were taken without the benefit of telephoto lenses, and again under the pressure of time. 'There were no automatic cameras then, no auto-rewind cameras, so reloading took up precious time. I would normally carry a flash, or flash bulbs, because available light was not always practical, and emulsion speeds were much slower in those days. There was one golden rule – you *had* to go back to your editor with a picture, and he didn't want excuses that the light was bad. Of course, the pictures were always wanted hours before they were even taken, and as a result very often were still damp from my darkroom when they reached the editor's desk. I've always printed my

own photographs, as I think this is essential for a professional photographer.'

In the early fifties, two singers – American Johnnie Ray and Englishman Dickie Valentine – created something previously unheard of in Britain: teenage hysteria, 'bigger than any rock concert that I saw years later,' remembers Harry. Showbusiness was beginning to change, thanks to a brand new invention – the teenager. In 1954 Bill Haley and his Comets released a song called *Shake Rattle And Roll*. Elvis Aaron Presley was about to give up truckdriving, and things would never be the same again. In the mid-fifties a native British phenomenon called skiffle (based largely upon American country blues and jugband music) got under way. Its high priest was Lonnie Donegan, and the simplicity and energy of the music caused thousands of British teenagers – John Lennon and Paul McCartney among them – to dive into garages with guitars in their hands. In 1956 Britain got its first pop music show, *6.5 Special*. Its producer, Jack Good, was lured to commercial television from the BBC two years later, and given virtual *carte blanche* to create his own show: *Oh Boy!*, which was arguably the most important factor in the growth of British rock'n'roll. Good launched a whole plethora of British rockers: Cliff Richard, Marty Wilde, Billy Fury, Joe Brown. At the same time, the American Invasion was well under way, and – with the glaring exception of Elvis – all the major American rock'n'roll stars visited Britain during the fifties: Bill Haley, Jerry Lee Lewis, the Everly Brothers, Buddy Holly, Eddie Cochran, Gene Vincent. Harry Hammond was there throughout, to record it all.

Record companies began to prosper. Once in a while they would even hold press conferences for their artists, and Harry had a little more time to photograph them. Records started to come out in sleeves with pictures on them, and some of those pictures were Harry's. By the early-sixties, things had come full circle. Elvis was in the army, Buddy Holly and Eddie Cochran were dead, Chuck Berry was in jail and Jerry Lee Lewis had been banished to the wilderness for marrying his thirteen year old cousin. The excitement and outrage of the early days of rock were over, and respectability reigned again. Those rockers that survived were instructed to get cleaned up and become entertainers; neat haircuts, mohair suits, sweet faces and sweet songs were the order of business. Pop became pap, by and large, and even Elvis fell for it when he returned from the service of Uncle Sam. The managers were in full control, and the music business was pretty much the same as it had ever been. Then a furniture salesman from Liverpool called Brian Epstein discovered the Beatles. Even if they did wear suits, even if their hair was neat (if somewhat longer than everybody else's), they signalled the end of the old order of music showbiz, and pretty soon everybody knew it.

'For some fifteen years – up to about 1963 – I spent seven days a week recording it all on film' recalls Harry. 'By the time the Beatles appeared, I'd seen it all: jazz, swing, blues, boogie, be-bop, ballads, country, skiffle, pop, R&B, bossa nova, and finally, Britain's reluctant acceptance of rock'n'roll. With the arrival of the Beatles, and finding that there were now 200 photographers at every concert, I decided to slow down and do intimate photographic features on pop and rock stars in their own homes, for the international press – and that is what I do today. But I still think that the fifties was the greatest decade ever for the pop world, and produced more long-lasting talent and significant changes than any other.' It's appropriate that Harry's part of the story ends here. Other photographers were to document what was to follow, but Harry Hammond had justly earned the title of 'the father of pop photography'.

It is quite probably the understatement of the century to say that the Beatles changed *everything* about pop. In their wake came a host of new, young British groups, bearing the banners of Merseybeat and London R&B. Everybody that could – from the Animals to the Zombies

– went to America's greener pastures as part of 'the British Invasion', in their turn influencing a similar host of new young American groups.

After Brian Epstein, a tide of young managers emerged – Andrew Loog Oldham with the Rolling Stones, Simon Napier-Bell with the Yardbirds, Kit Lambert with the Who. The whole industry was slowly becoming younger, more image-conscious. There were now dozens of papers and magazines devoted, wholly or in part, to pop music, and photography was becoming a lot more important in 'selling' an artist. Pictures were needed for record sleeves, for advertising, for publicity, for pin-ups. Inevitably, a new generation of photographers would become involved with pop, and one of the first to do so was Gered Mankowitz.

Gered was born in 1946, and first became interested in photography during a school trip to Delft in Holland, when he was fourteen years old. He was able to sell some of the photographs he had taken there to the Camera Press photographic agency, and they offered him a job when he left school. Gered began an apprenticeship at Camera Press when he was fifteen, and learnt all the aspects of photography much as Harry had done; his first job was to learn how to mix chemicals in a zinc bath in the gents lavatory. Camera Press were the agents for a number of prestigious photographers, such as Anthony Armstrong-Jones (later to become Lord Snowdon) and Karsh of Ottowa, and as with Harry, Gered saw at an early age the possibilities of a freelance career. After he had been at the agency for about six months, Gered moved with his family to the West Indies for a short while, and while there began freelancing – taking portraits, architectural studies and whatever advertising and commercial work that was available. When his family returned to Britain, he worked briefly as an assistant to a fashion photographer named Alec Murray, before going to work for a successful commercial photographer, Jeff Vickers. By this time Gered had established his own approach to photography, and he already knew what he did not want to do, which included fashion photography, reportage and working in a darkroom. 'I'd learnt how crucial that whole side was, how printing could change a photograph totally, and it was very magical to see pictures appear – it still is – but I didn't want to spend my life there.' With Jeff Vickers, Gered began to gather his own clients, and started taking theatrical portraits. He became the youngest photographer ever to have his own front-of-house pictures in a West End Theatre. Through theatrical circles he met an actor called Jeremy Clyde who, with his partner Chad Stuart, was half of a pop duo called Chad and Jeremy. This contact led to him photographing them for their LP cover, which in turn led to more work in the music world – a logical development from the theatrical portraiture he had been doing. 'It just moved on from there, quite rapidly,' recalls Gered. 'Jeff Vickers and I – with some help from the bank – got a studio in Masons Yard, Piccadilly. Through Jeremy Clyde I met Marianne Faithfull, and through her met her managers, Tony Calder and Andrew Loog Oldham, who asked me to photograph the Rolling Stones. I then started a relationship with the Stones, and more importantly with Andrew Oldham – I became the Stones' official photographer from that point until the end of '67. Masons Yard began to flourish as a studio, Jeff Vickers left, and a photographer called Red Saunders moved in. He was to become a very close working colleague and friend, and we still share a studio today. I became totally freelance at the end of '64. Doing a lot of stuff for the Stones was very exciting, because they *were* the second most important band in the world. I always thought they shared top honours with the Beatles, because they were so different.'

Perhaps the most important difference between the careers of Harry Hammond and Gered Mankowitz lies in the fact that whereas Harry sold pictures wherever he could as a freelance photojournalist, Gered always worked on a commission basis, and nearly always for bands

and their management. 'All my work was done for managers – Don Arden, Chas Chandler, Simon Napier-Bell, Ken Pitt, Andrew Loog Oldham – and therefore directly for the bands. Record companies didn't seem to have art departments in those days – I don't remember any of the corporate record companies as being anything other than great corporate monoliths that had nothing to do with creative artists. Even though photograpers like Bailey and Beaton had started to take pictures of pop personalities for the glamorous magazines of the sixties, things didn't really change until record companies began to hire really good art directors and designers. Up until the late sixties very few LPs were conceptualized – people did not commission you to take a record cover. They'd commission you to take a picture which might be *used* for a cover.'

The music industry was still fairly staid, and experiments with technique and style were limited, out of the sheer necessity of having to sell photographs in order to live. Few record companies really understood the audience they were dealing with – notable exceptions being Chris Blackwell's Island label, and the new label started by Andrew Loog Oldham, Immediate, for which Gered became a regular photographer and designer. He was fortunate, in that through Immediate, he was actually encouraged to experiment, which was exceptional at that time. As Gered recalls: 'I liked doing experimental photography, but it frustrated me if it never appeared. I learnt very quickly that I could try certain things for myself – or for the band – but the bulk of the session had to be commercially usable. Even the magazines of the era didn't care about the material they were given, artistically. There was no respect for anything, they didn't care about the music and the art direction was appalling. What mattered was that the photograph would reproduce well, because if it didn't look good in print, the record didn't sell. Anything out of the ordinary was often dismissed as ''arty'', which was why it was such a joy for me to work for Immediate.'

There was still a kind of innocence about it all. Despite the growing awareness all round that this was a *business*, business could still be fun if you were young in the sixties. 'Somehow the reasons for taking pictures of bands then were not the same as now. Then . . . there was a certain amount of marketing; if you put a record out, you tried to sell it, but nobody talked about ''marketplace'' or ''product''. We'd do a session, but it was never really planned – there wouldn't be any reason for doing it other than there was a break in touring or recording, and somebody thought we *ought* to do one. It wasn't a formula, the way it is now. If you didn't get a picture, it didn't really matter, and if it was a great picture, then that was great. Obviously, as the business became more professional, I had to become more professional.' In the late sixties, pop musicians – and youth in general – were beginning to be taken more seriously. An entire generation believed that it was possible to change the world, and to an extent they did, though most of the ideals of flower power died en route. In 1969, when respectable businessmen were growing their hair over their ears and the record cover was well established as a contemporary art form, Immediate Records folded, and a somewhat disillusioned Gered Mankowitz decided to give up pop photography. He spent the next year working in different areas – as stills photographer on several films, and as a designer/photographer of book jackets – before Chas Chandler persuaded him to return to pop and photograph a group he was managing: Slade. As a result, Gered was present at the birth of a new commercial boom in pop – the glitter/glam era, and throughout the seventies he was much in demand by the biggest stars of the time – Wings, 10 CC, Elton John. Again, it was the managers who were the main impetus – Mickie Most, Mike Leander, Chinn and Chapman – but now record companies themselves were far more aware of the need for a specially created image, and Gered became well known on the basis of his record covers alone. He tended to work almost entirely

in the studio, often creating elaborate sets in which to frame the artist – a craft he had learnt through producing book covers. 'Record companies today are more prepared to spend money in advance for a definite concept. They've recognized the power and value of a visual campaign, and are prepared to give it support – whether it be building a special set, or going away to an exotic location to shoot a video.'

With the advent of punk in the late seventies, Gered became temporarily unfashionable. 'Punk was wonderful – I think it did everything a lot of good. It was sad for me personally, because I wasn't involved. It was very exciting, and it genuinely made me wish that I was younger. But I wasn't a photographer that punk bands could relate to – the only punk bands I worked with were more "poseur-punk" than real punk.' But to every attraction comes a reaction, and Gered's skills were at a premium again once the harshness of punk became sublimated by more consciously stylish phenomena – the somewhat ill-defined New Wave, the Mod revival, the New Romantics . . . now the names are almost meaningless. There are so many audio/visual styles around that labels do not really matter any more. In Britain today, with little chance of employment for many people under twenty, pop groups abound – there's nothing else to do. But even so, the chances of a groundswell movement to rival Merseybeat or Punk are slim, and pop's next turning will probably confound every prediction. Gered Mankowitz is still working, capturing each new style as it emerges, and seldom gets bemused by it all: 'Usually there's something about the music, about the band, that I can relate to. It's almost impossible to work with someone with whom you have no rapport, but that's very rare. I understand about performance. Today, you run across some bands that are poseurs, but not performers. But if they're great poseurs, that's OK.'

Hit Parade is not a complete visual history of pop music; it is a collection which juxtaposes the work of two very different photographers to tell, in fragmentary glimpses, something of what they witnessed of pop's development in Britain. There are many famous names present here, but many others are missing, simply because Harry and Gered never had the opportunity to photograph them. You'll also find quite a few one-hit wonders, and some complete no-hopers – they too are part of the story. But there is more than one story being told here. The work of Harry Hammond and Gered Mankowitz reveals how pop photography developed in the light of the music's commercial growth. In their pictures the parade of changing fashion passes, from tuxedos to kaftans, from brothel creepers to Mod haircuts, from leather trousers to silk suits. By 1983, a merman you could be . . . or at the very least, a fifties rocker, a sixties Mod, or a forties jiver, or even a White Rasta street urchin, if you so desired.

Harry Hammond and Gered Mankowitz have captured – perhaps even fostered – some of the seminal pop images of the last thirty years. Some of their photographs – Harry's picture of Billy Fury, or Gered's portrait of Jimi Hendrix for instance – are classics of cool, style, or whatever it is that makes pop magic, that changes people's lives when they hear that first, special, slab of black vinyl. This is where the cliché comes true: a thousand words cannot tell that story, but these photographs can. Find your own example – there are plenty here to choose from.

Peter Hogan, 1984

HARRY HAMMOND

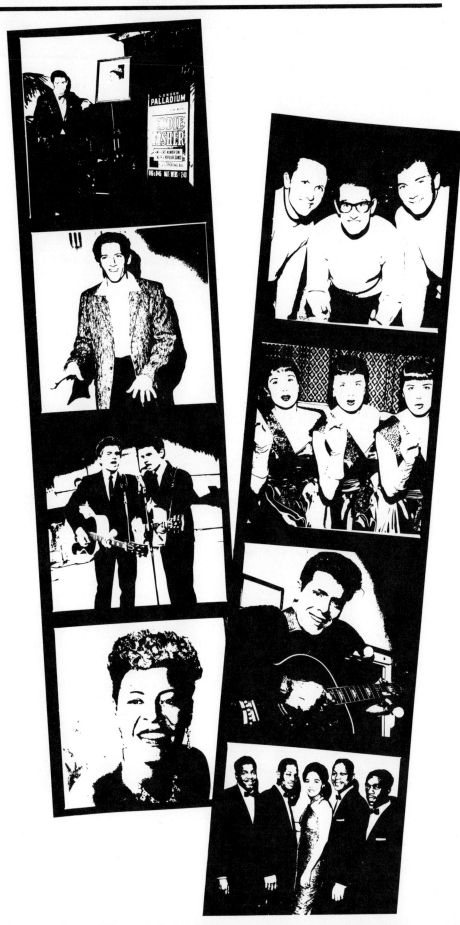

TONY BRENT: Discovered in a talent contest at the Kingston Regal, he became a band singer for Ambrose, and later for the BBC showband. *1951*

AL MARTINO: A protégé of Mario Lanza, this American singer reached No. 1 with *Here In My Heart* in 1952. Originally a bricklayer, legend has it that en route to a concert at the Palladium he insisted on helping some British labourers finish building a wall. His *Spanish Eyes* was a Top 10 hit in Britain in 1973, eighteen years after it was recorded. *1952*

13

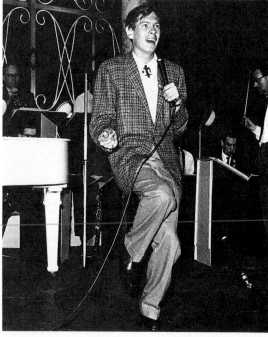

JOHNNIE RAY: Part Blackfoot Indian, Johnnie Ray earned his first million seller in 1952 with *Cry*, and topped the British charts three times during the fifties. His unrestrained and highly emotional stage act earned him a variety of imaginative press labels – 'the Cry Guy', 'the Nabob of Sob', 'the Ultra Violent Ray' – and caused teenage hysteria on a scale undreamt of by Sinatra's bobbysoxers. *1952*

GUY MITCHELL: Real name Al Cernik, and winner of an Arthur Godfrey talent show. He reached No. 1 four times, with *She Wears Red Feathers* and *Look At That Girl* in 1953, and *Singing The Blues* and *Rockabilly* in 1956. *1953*

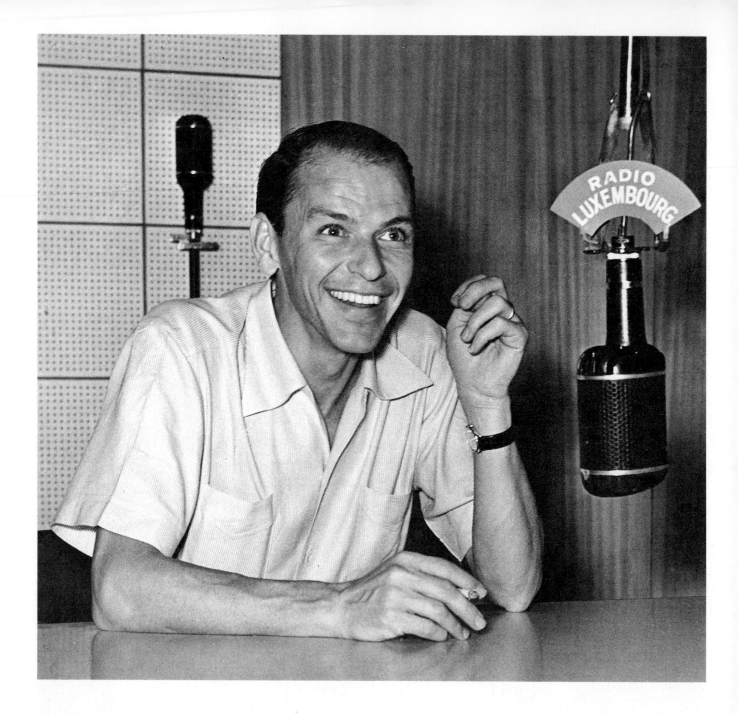

FRANK SINATRA: Taken while promoting his British tour. His career was faring badly, but his performance in *From Here To Eternity* helped put him back on top, and in 1954 he had a No. 1 hit with *Three Coins In The Fountain*. *1953*

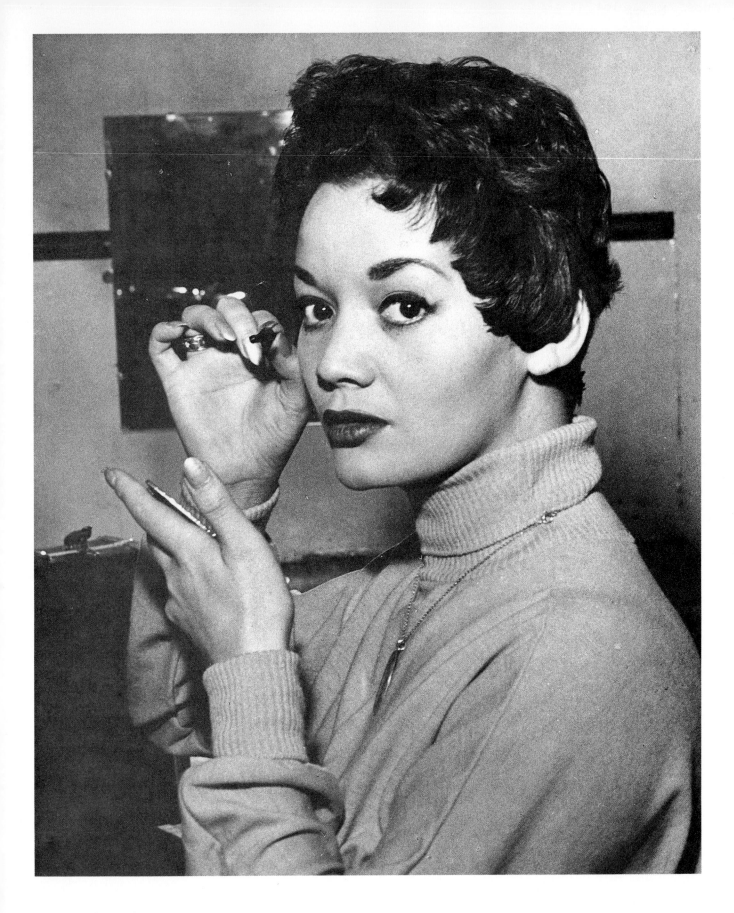

LITA ROZA: Originally a vocalist with the Ted Heath Orchestra, she scored a No. 1 hit in 1953 with *How Much Is That Doggie In The Window*. *1953*

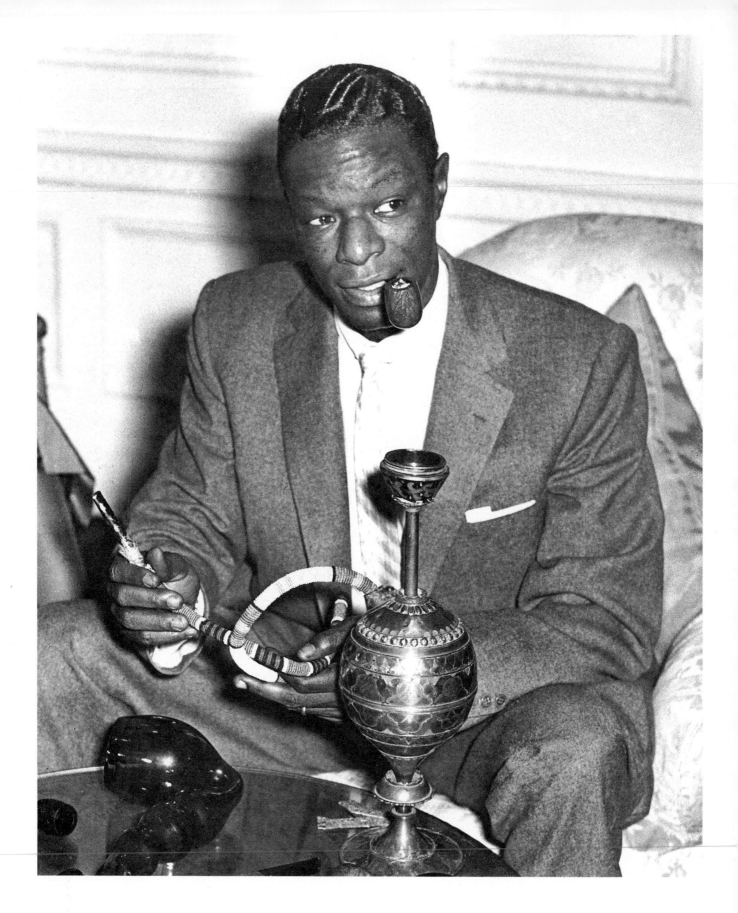

NAT KING COLE: Photographed in his room at the Savoy Hotel, before an appearance at the London Palladium on his second UK tour. Originally a jazz singer, his effortless ballad style took him into the Top 10 fifteen times between 1952 and 1957. He died in 1966, aged 48. *1954*

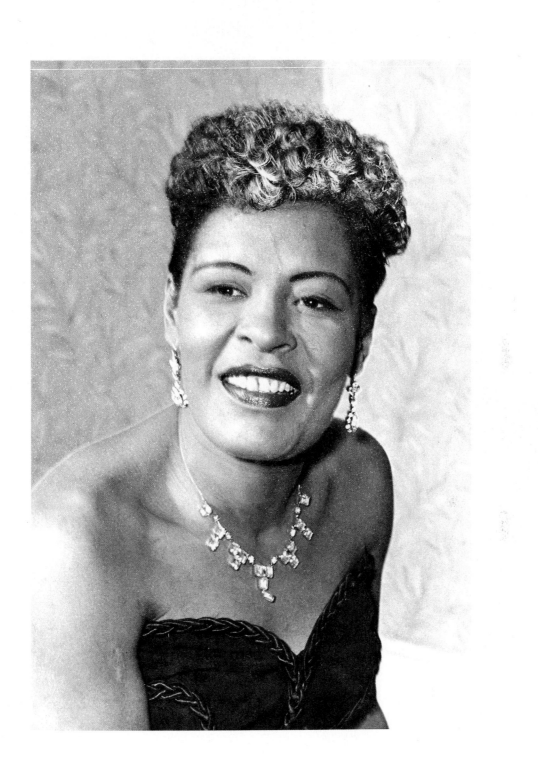

BILLIE HOLIDAY: A rare portrait of 'Lady Day' on her only visit to London, where she played at the Albert Hall. Producer John Hammond called her 'the greatest jazz singer I ever heard'. She died in 1959, aged 44. ***1954***

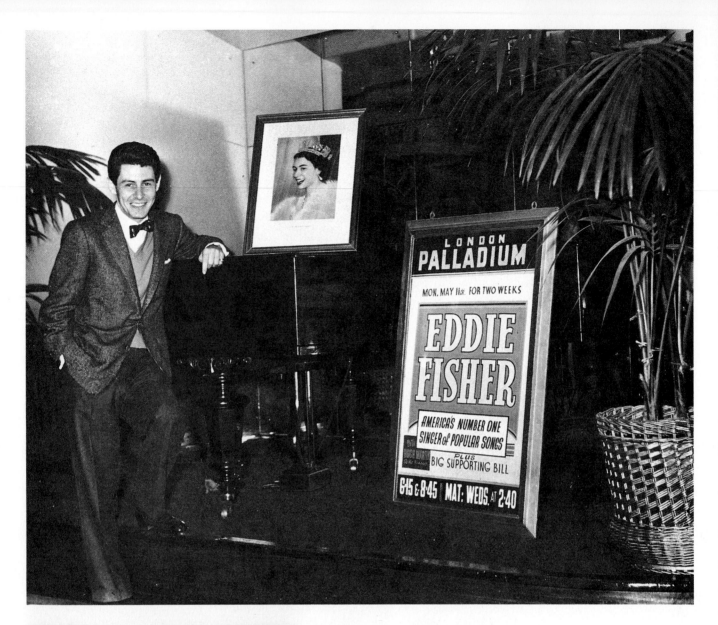

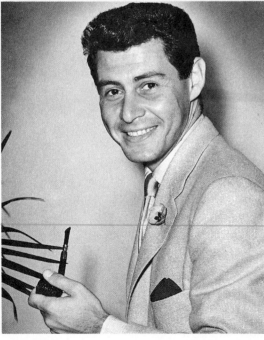

EDDIE FISHER: Husband to both Debbie Reynolds and Elizabeth Taylor, Fisher topped the British charts twice in 1953, with *Outside Of Heaven* and *I'm Walking Behind You*. **1954**

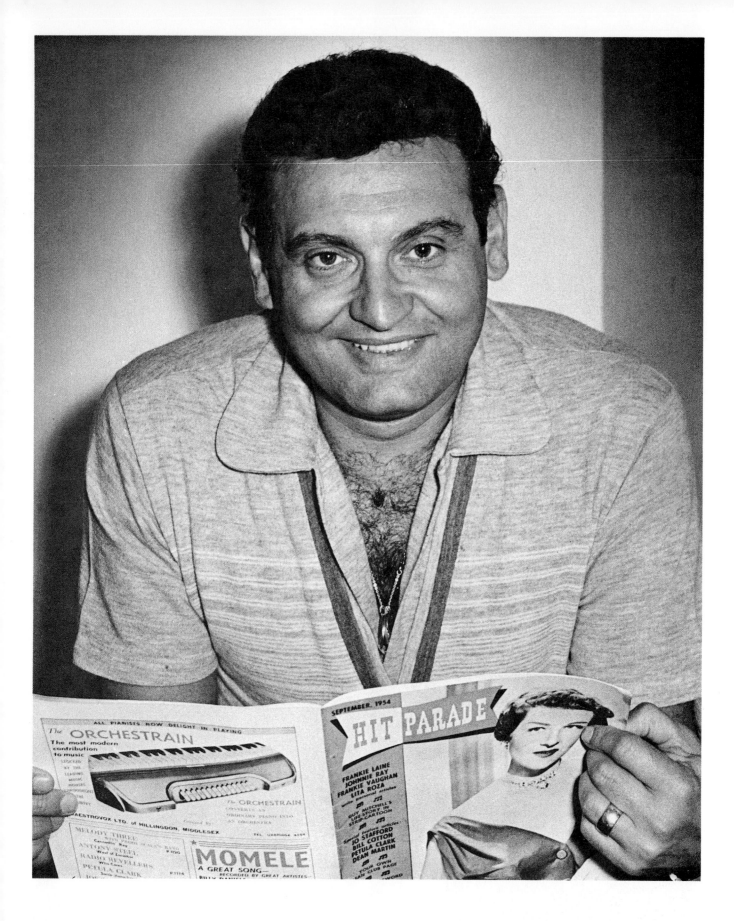

FRANKIE LAINE: Winner of a marathon dance contest in the 1930s, Laine was supposedly discovered singing in a club by the songwriter Hoagy Carmichael. His big ballad style earned him four No. 1 hits, but today he is probably best remembered for having sung the theme songs to the film *High Noon* and the TV series *Rawhide*. **1954**

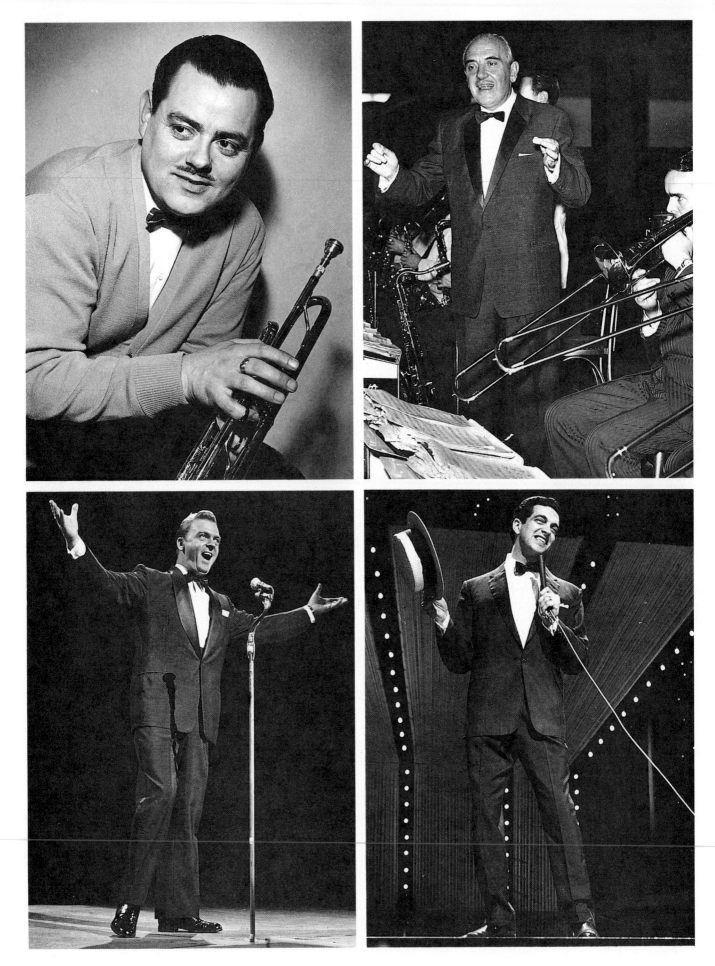

RONNIE CARROLL (*Above*): His Eurovision entry *Ring A Ding Girl* failed to win, and got no higher than No. 46. He reached the Top 10 in 1962 with *Roses Are Red*, and again the next year with *Say Wonderful Things*. He was married to Millicent Martin, chanteuse on TV's *That Was The Week That Was*. **1956**

Opposite page, clockwise from top left:
EDDIE CALVERT: 'The Man With The Golden Trumpet', who had a No. 1 hit in 1953 for *Oh Mein Papa*, and another in 1955 for the oft-covered *Cherry Pink And Apple Blossom White*. **1954** **TED HEATH:** Ted Heath, kept big band music alive through the fifties, entering the Top 10 four times between 1953 and 1958. **1955** **FRANKIE VAUGHAN:** Today he's remembered for the straw hat, the cane, the high kick and *Give Me The Moonlight*, but he took *Green Door* into the Top 10 twenty-five years before Shakin' Stevens. **1955** **DAVID WHITFIELD:** An ex-sailor from Hull, who was discovered through Hughie Green's *Opportunity Knocks* programme on Radio Luxembourg. He reached the No. 1 slot twice with *Answer Me* and *Cara Mia*. **1955**

BERT WEEDON: Session guitarist supreme. His cover of the Virtues' *Guitar Boogie Shuffle* reached the Top 10, and his guitar tuition manual was an almost essential purchase for budding rockers. *1955*

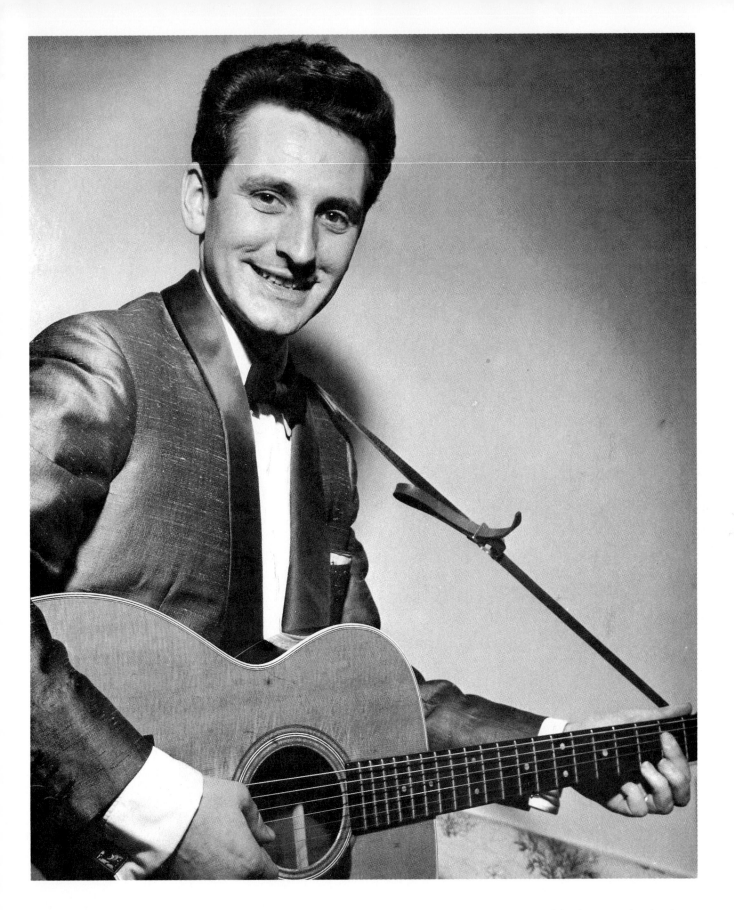

LONNIE DONEGAN: If Lonnie Donegan did not invent skiffle, he was certainly its most public face. *Rock Island Line* changed the face of pop, and skiffle became true folk music: it was accessible and easy to imitate (guitar shops throughout Britain should be grateful to Donegan). During the late fifties and early sixties, his records were seldom out of the charts; he achieved thirty chart entries, the same number as the Rolling Stones. *1956*

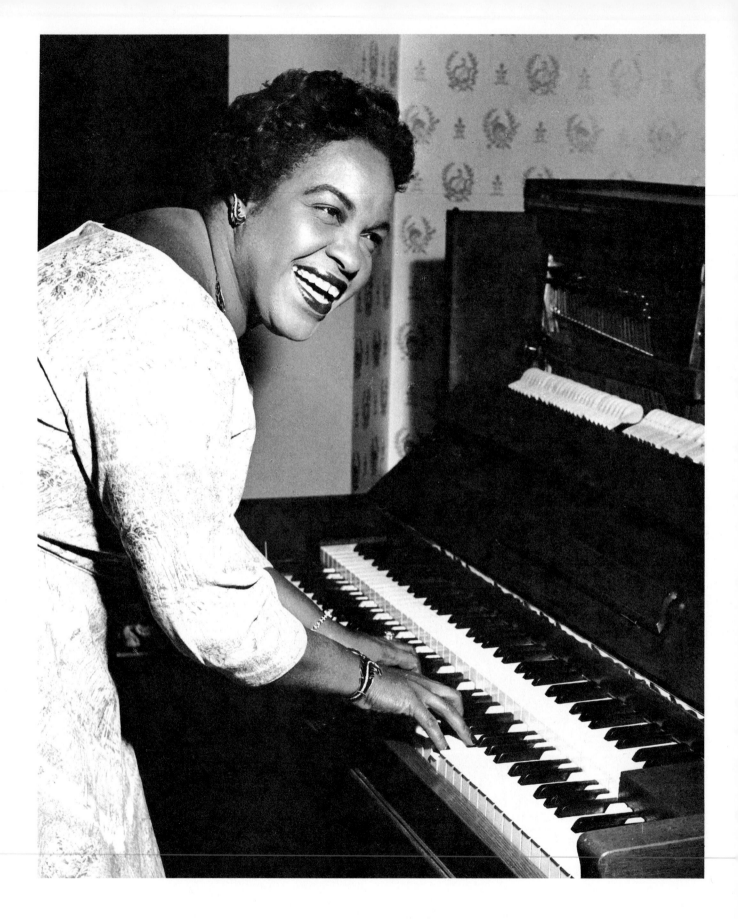

WINIFRED ATWELL: A classically trained pianist, Winifred Atwell's records dominated Christmas parties during the fifties. She reached No. 1 twice, with *Let's Have Another Party* and *Poor People Of Paris*. *1956*

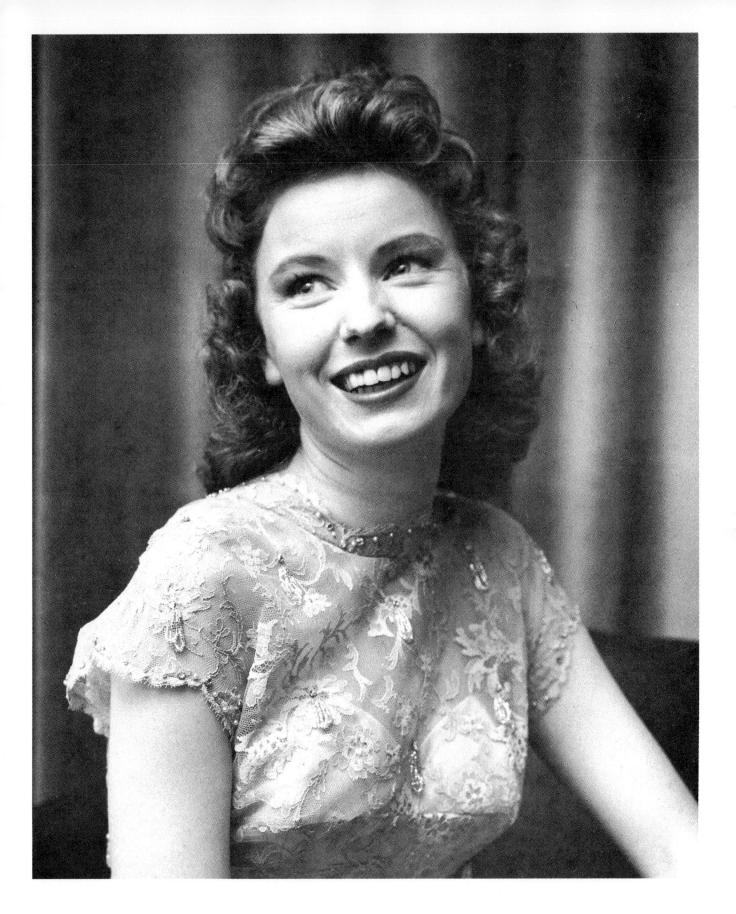

RUBY MURRAY: This Irish singer has the unique distinction of having had five records in the Top 20 at the same time during one week in 1955. *1955*

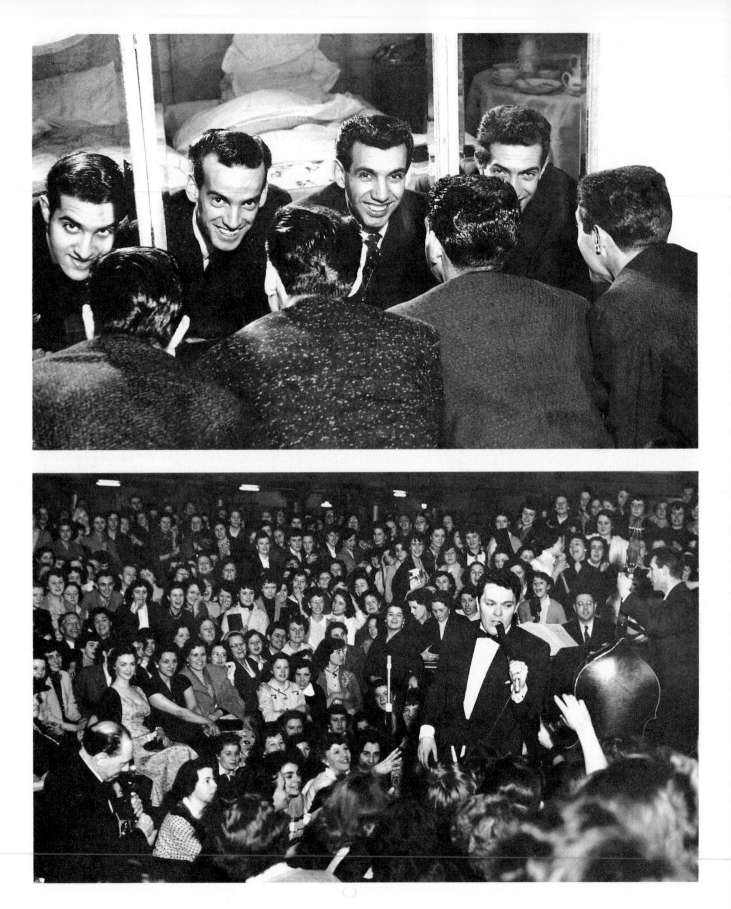

THE CREWCUTS (*Above*)**:** A Canadian quartet who specialized in diluted R&B. *Earth Angel* reached No. 4 in 1955. ***1955***
DICKIE VALENTINE (*Below*)**:** Probably the most popular British male singer of the early fifties, with an enormous teenage following. He began as a singer with the Ted Heath Orchestra, and notched up eight Top 10 singles between 1953 and 1956, including two No. 1's: *Finger Of Suspicion* and *Christmas Alphabet*. ***1956***

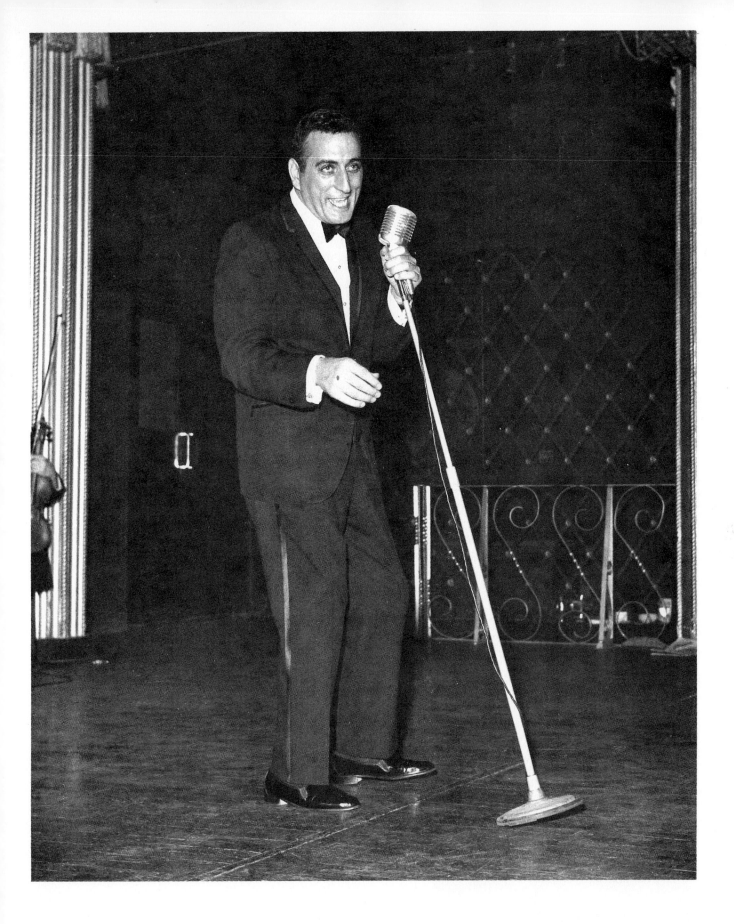

TONY BENNETT: Pictured in cabaret at London's Pigalle Club. His first hit was a number one, *Stranger In Paradise,* from the musical *Kismet.* ***1957***

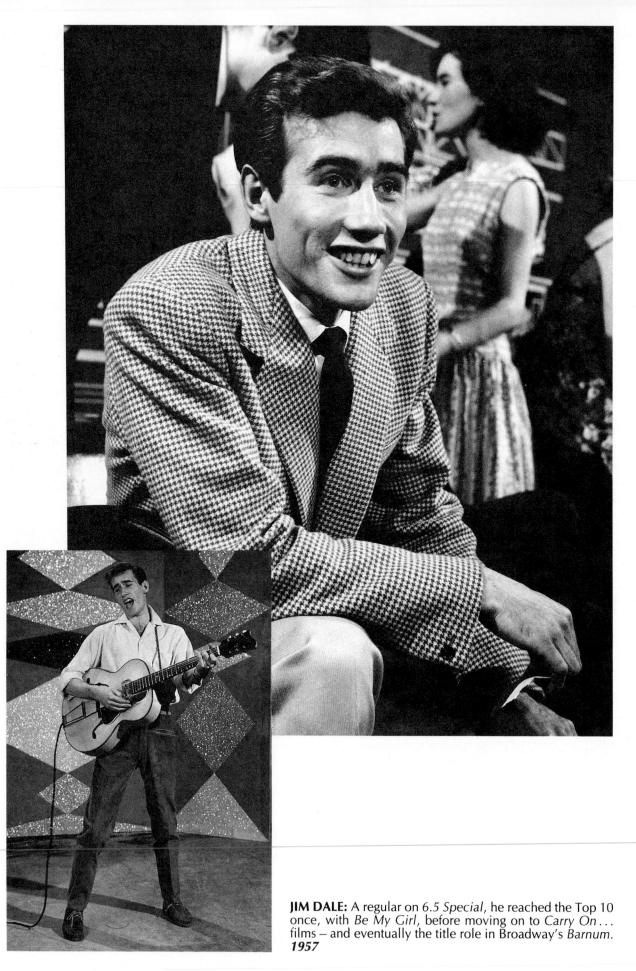

JIM DALE: A regular on *6.5 Special*, he reached the Top 10 once, with *Be My Girl*, before moving on to *Carry On ...* films – and eventually the title role in Broadway's *Barnum*. *1957*

JOHNNY DUNCAN: An American GI who settled in Britain. After a brief flirtation with skiffle, he formed his own group, the Blue Grass Boys, and scored a No. 2 hit with *Last Train To San Fernando*. Today he enjoys some success as a country singer. *1957*

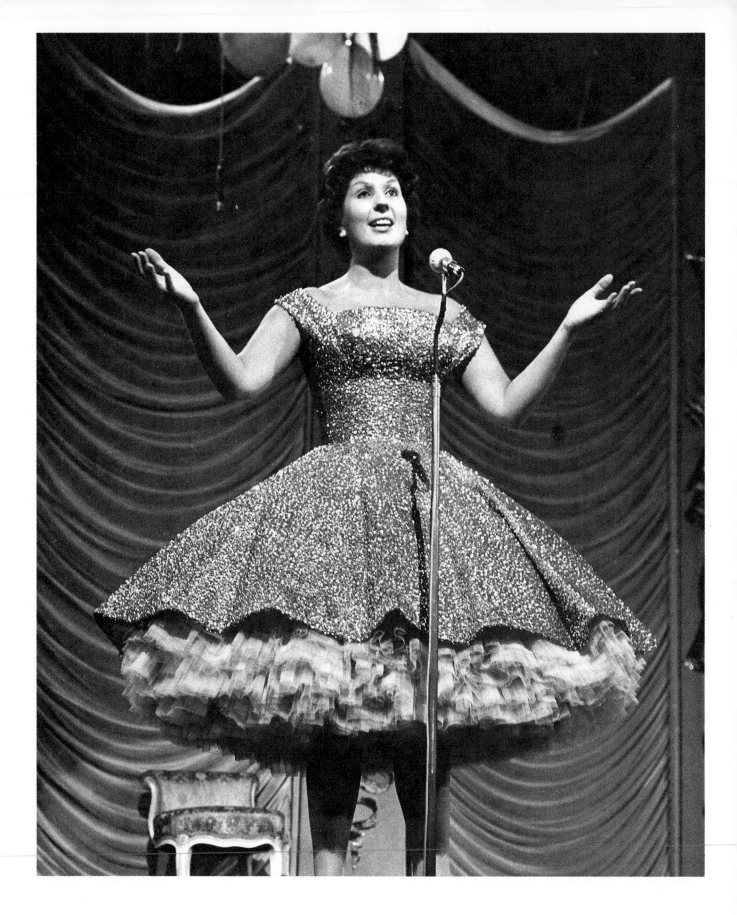

ALMA COGAN: Known as 'the girl with the smile in her voice', who never seemed to wear the same dress twice. She was discovered in a stage show called *High Button Shoe* (in which she shared a dressing room with Audrey Hepburn), and reached the Top 10 on four occasions in 1954–5, including one No. 1, *Dreamboat*. She died in 1966, aged 33. *1957*

PAUL ANKA: Photographed backstage at the Elephant and Castle Empire, at the start of his first British tour. *Diana* reached No. 1 and sold nine million copies worldwide – Anka was sixteen at the time. He has not done badly since then, either – he wrote the English lyrics to *My Way*. *1957*

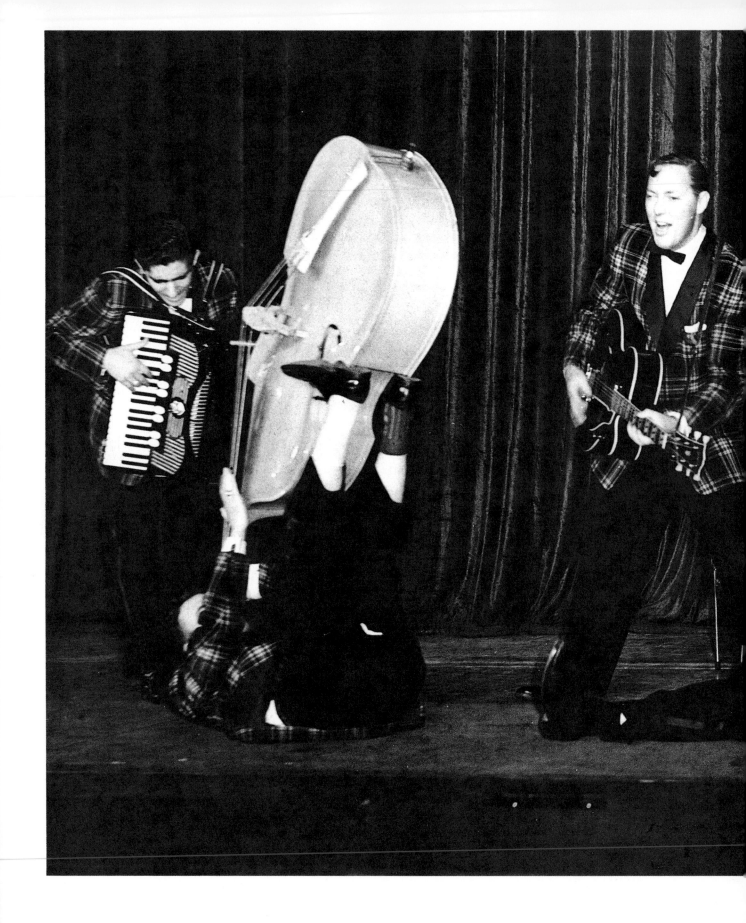

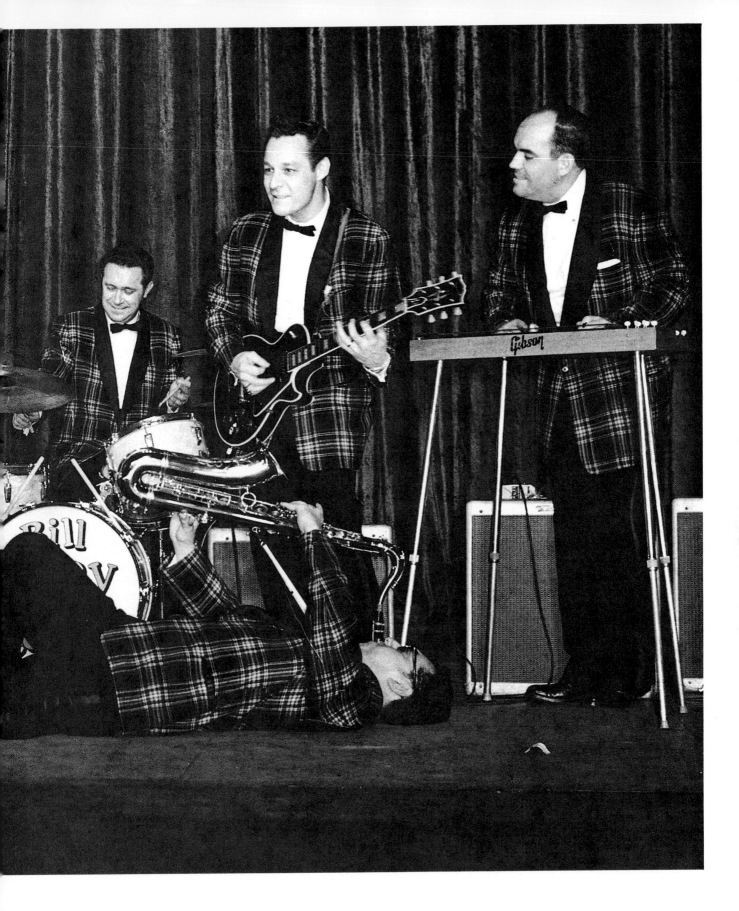

BILL HALEY AND HIS COMETS: When *Rock Around The Clock* appeared on the soundtrack of the *Blackboard Jungle* film, teenagers throughout Britain proceeded to rip the seats up. The song went to No. 1 in 1955, and the Teddy Boy was born. Haley died in 1981. (Bill Haley *was* his real name.) *1957*

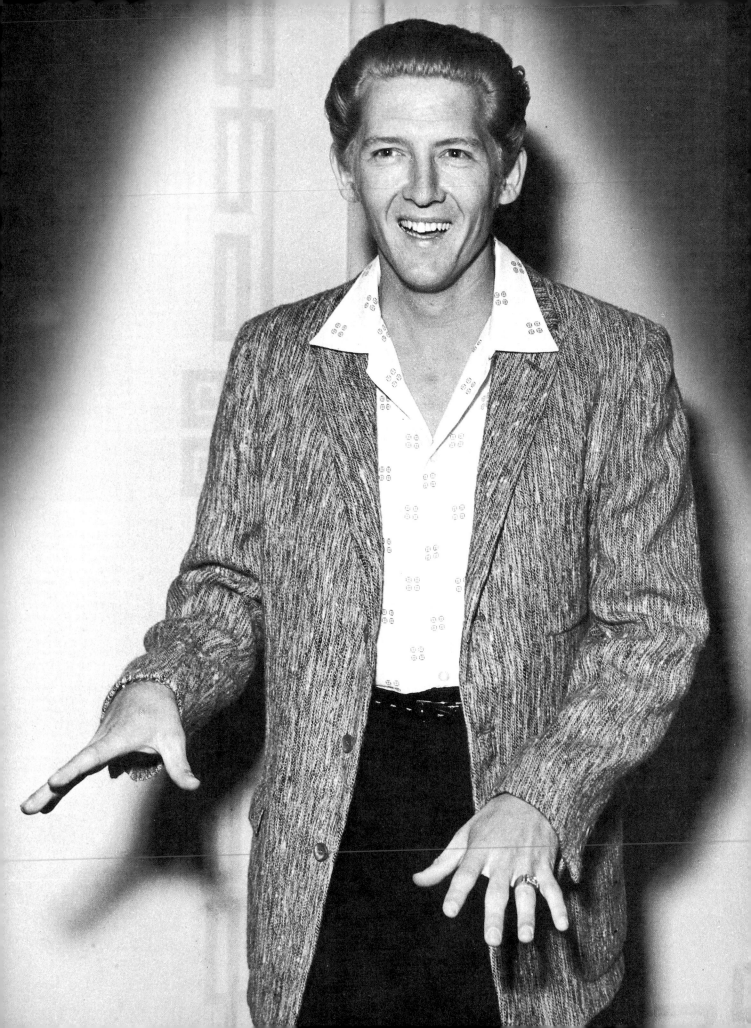

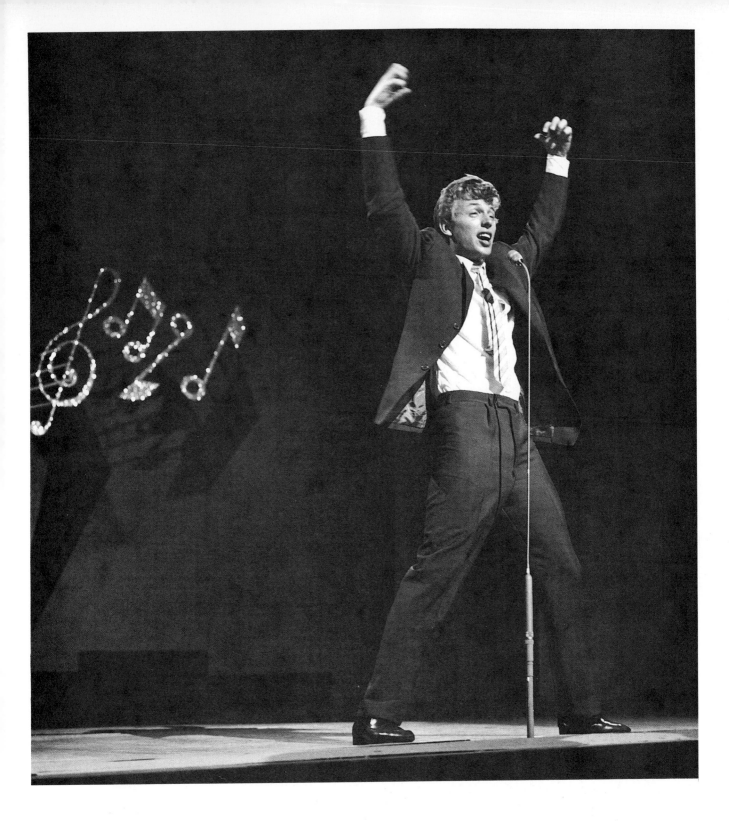

TOMMY STEELE (*Above*): Originally Thomas Hicks, and quite possibly the first British rock'n'roller – *Rock With The Caveman* (which he co-wrote) was released in 1956. His cover version of Guy Mitchell's *Singing The Blues* reached No. 1, but within a few years he had been converted into an all round entertainer. He went on to star in musical comedies like *Half A Sixpence* and *Finian's Rainbow*. **1958**

JERRY LEE LEWIS (*Left*): One of the true originals. When this photograph was taken Lewis was touring Britain – a tour which should have been triumphant, as *Great Balls Of Fire* had hit No. 1 a few months previously. But the British press discovered that Jerry was married to his thirteen-year-old cousin, and he was hounded from the country, his career effectively ended for a while in the USA as well as in Britain. Jerry Lee Lewis survived, to produce great records to this day and, despite serious illness, he is still going. **1958**

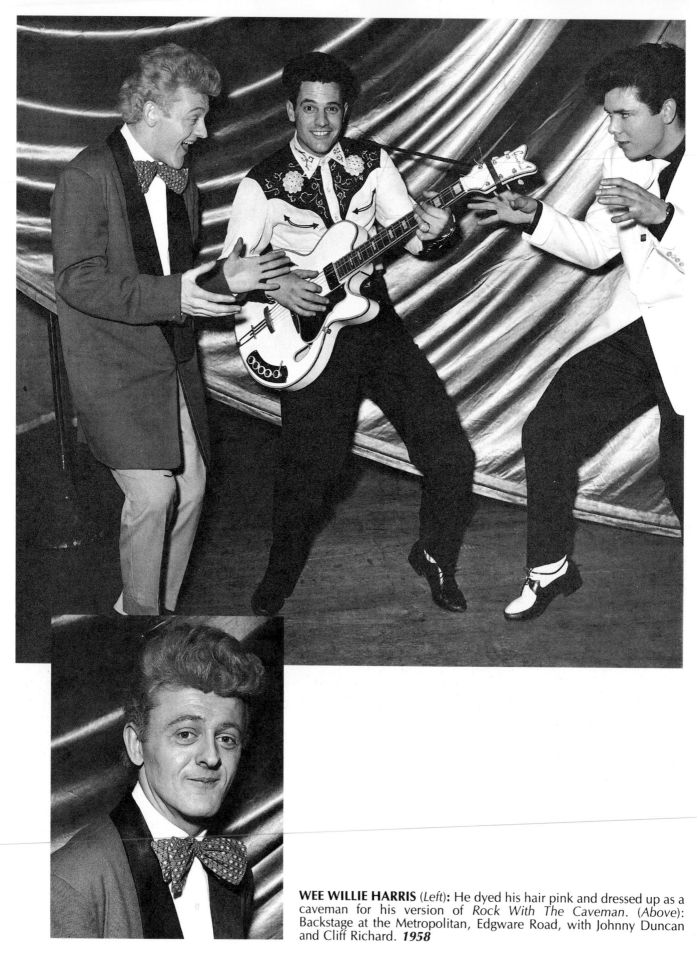

WEE WILLIE HARRIS (*Left*)**:** He dyed his hair pink and dressed up as a caveman for his version of *Rock With The Caveman*. (*Above*): Backstage at the Metropolitan, Edgware Road, with Johnny Duncan and Cliff Richard. *1958*

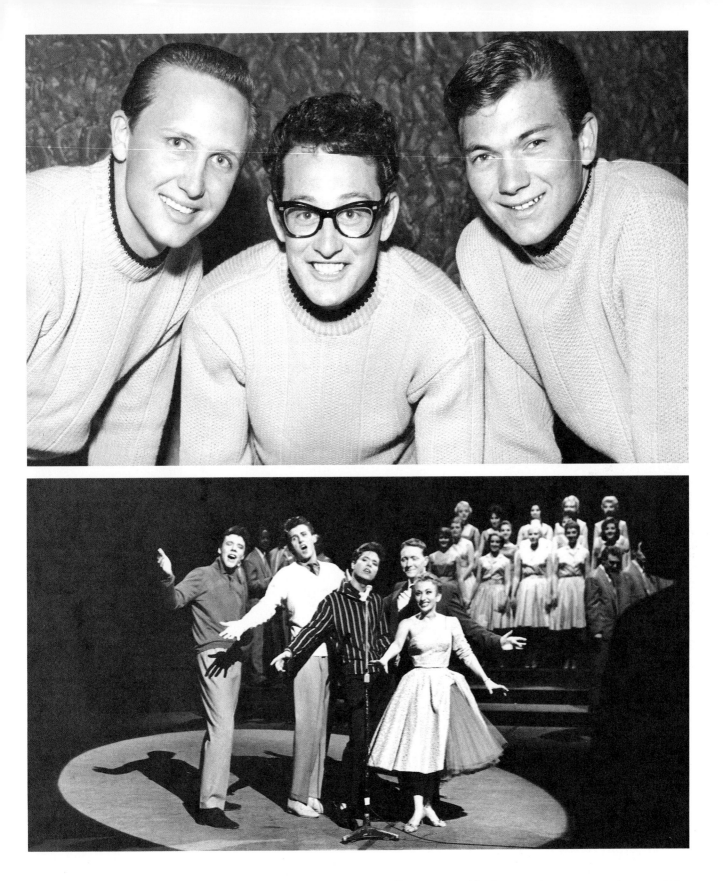

BUDDY HOLLY AND THE CRICKETS (*Above*): After Presley, Holly was arguably the most important performer of the rock'n'roll era. Shown here with the Crickets, Jerry Allison and Joe Mauldin, during his British tour of March 1958. In February 1959, he died in a plane crash, aged 22. *1958* **OH BOY!** (*Below*): Jack Good's *Oh Boy!* was the most important rock TV show of the fifties, and a springboard for the new British rockers. Seen here on the stage of the Hackney Empire: Marty Wilde, Vince Eager, Cliff Richard, bandleader 'Lord Rockingham' and organist Cherry Weiner. In the background can be glimpsed the Vernon Girls and the Dallas Boys. *1958*

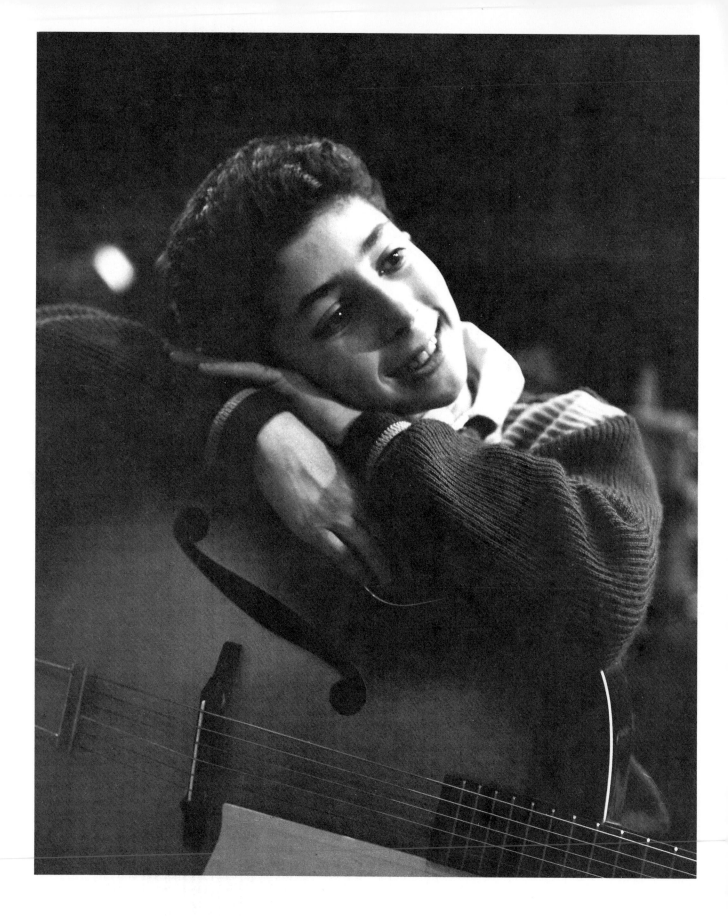

LAURIE LONDON: Fourteen-year-old Laurie London was discovered in the audience at the Earls Court Radio Show. His recording of *He's Got The Whole World In His Hands* was a hit in the USA as well as in Britain. *1958*

CONNIE FRANCIS: Between 1958 and the arrival of the Beatles, Connie Francis was *the* girl singer of mainstream pop. She reached No. 1 twice, with *Who's Sorry Now* and *Stupid Cupid*. *1958*

MARVIN RAINWATER: An American Indian from Wichita who scored a No. 1 in 1958 with *Whole Lotta Woman*. *1958*

TERRY DENE: Dene came to fame via the Two I's coffee bar in Soho, and enjoyed brief success with *A White Sport Coat* before being called up for National Service. *1958*

THE PONI-TAILS: Toni Cistone, LaVerne Novak and Patti McCabe formed the Poni-Tails while still in High School in Cleveland, Ohio. *Born Too Late* reached No. 5. *1959*

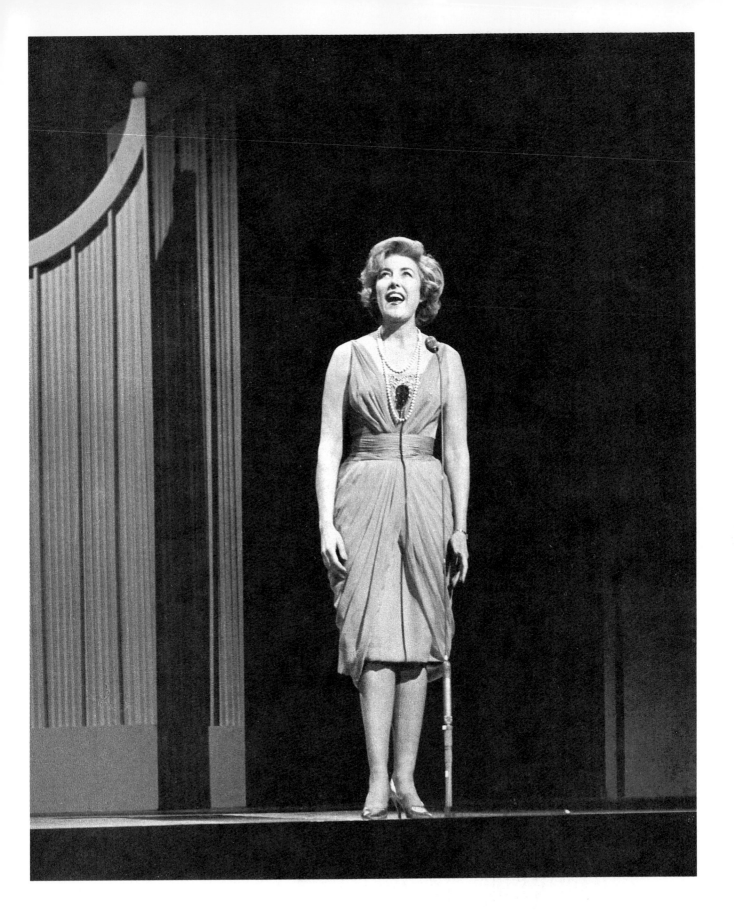

DAME VERA LYNN: The 'forces' sweetheart', who travelled as far as Burma with ENSA to entertain the troops. One of her many hit records – *Auf Wiedersein*, reached No. 1 in America and No. 1 in Britain in August 1952. *My Son, My Son* reached No. 1 in 1954, and her recordings are still in demand today. *1958*

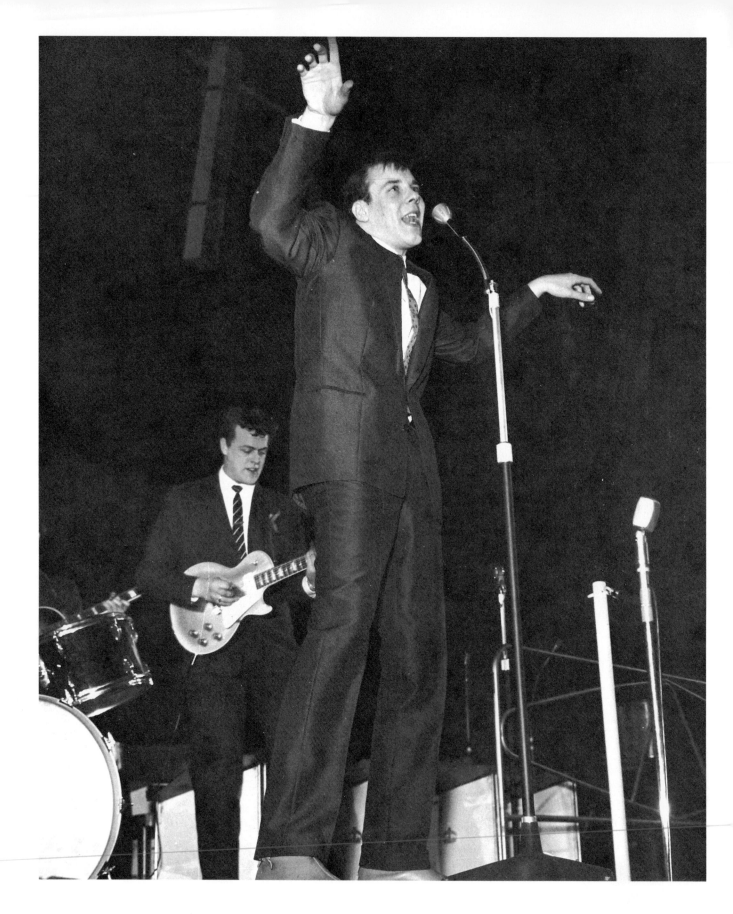

MARTY WILDE: Protégé of manager Larry Parnes – best remembered for giving his artists highly improbable names – Marty Wilde was originally Reg Smith. A resident of the *Oh Boy!* show, he scored his biggest hits with cover versions of songs by American artists: *Endless Sleep, Donna, A Teenager In Love*. He married one of the Vernon Girls and produced a famous offspring. *1959*

VINCE EAGER: Another singer from Larry Parnes' stable, who was unable to repeat the success of Marty Wilde and Billy Fury. *1959*

RUSS CONWAY: Real name Trevor Stanford. His piano instrumentals proved popular throughout the late fifties and early sixties – *Sidesaddle* and *Roulette* both went to No. 1 in 1959. *1959*

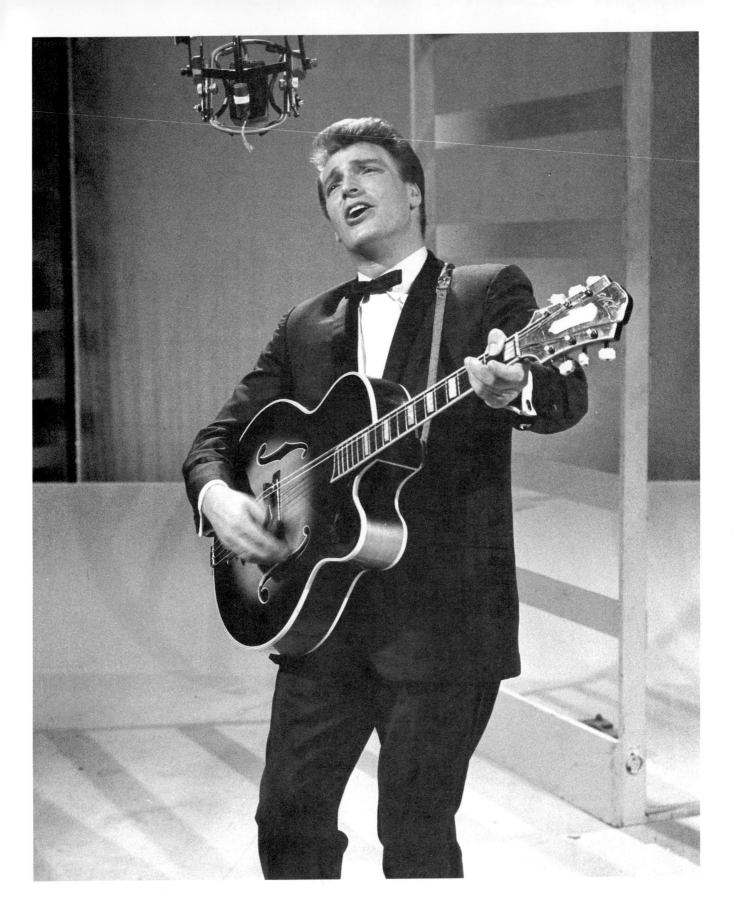

FRANK IFIELD: He was born in Britain, and grew up in Australia. Ifield was a balladeer who knew how to yodel, and *I Remember You* was the first of four chart toppers during 1962—3. Today he enjoys some success as a country singer. *1959*

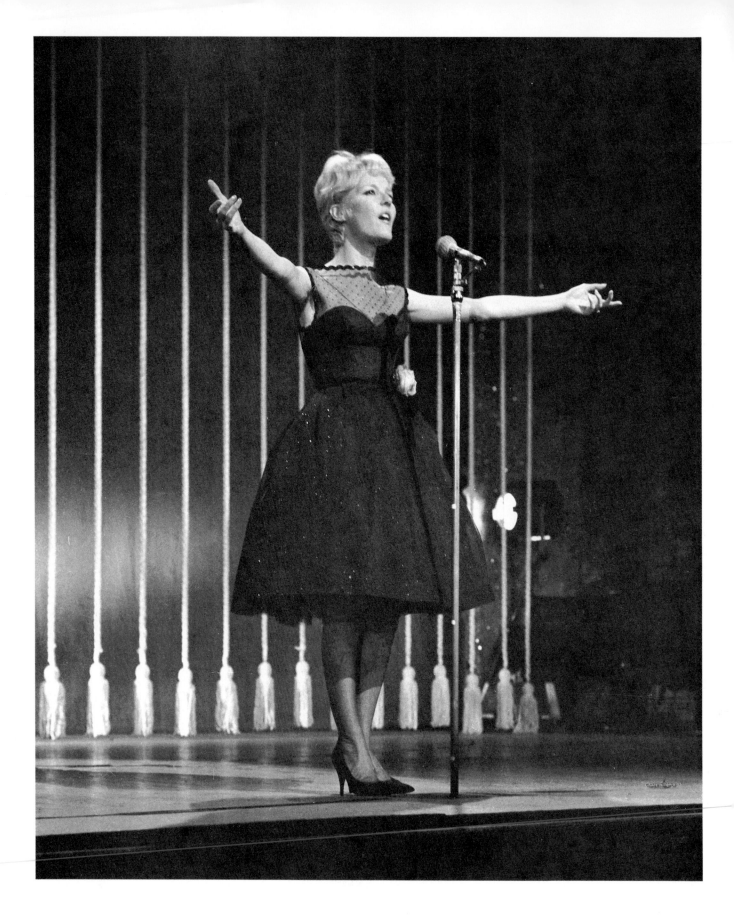

PETULA CLARKE: An actress from the age of twelve, she enjoyed minor chart success throughout the fifties, before reaching No. 1 in 1961 with *Sailor*. Her musical career in the sixties was somewhat more successful, thanks largely to the songwriting team of Tony Hatch and Jackie Trent. *1960*

MARION RYAN: A singer with the Ray Ellington Quartet, she found Top 10 success with *Love Me Forever* in 1958. Her sons, Barry and Paul, had Frank Sinatra as their godfather. *1959*

CRAIG DOUGLAS: His *Only Sixteen* reached No. 1, followed by a string of ballads. But his pop career was over by 1963, and he moved on to sing in nightclubs. *1959*

BOBBY DARIN: Reached No. 1 in 1959 with *Dream Lover*, but his next record *Mack The Knife* (which also reached No. 1) was a drastic change of style. His direction veered between pop and Sinatra-style ballads, and after the Beatles emerged he concentrated more on a film career. He died in 1973, aged 37. *1959*

THE KING BROTHERS AND KAYE SISTERS (*Above*)**:** Tony, Sheila, Denis, Shan, Mike and Carole at the Prince of Wales Theatre, London – two vocal groups who specialized in covers of American hits. Denis King later became a writer of TV theme tunes. **1959**

CLIFF RICHARD (*Opposite, above*)**:** Rehearsing with the Shadows. (*Below*)**:** The Shadows perform at the Wembley Pollwinners Concert. **1958**

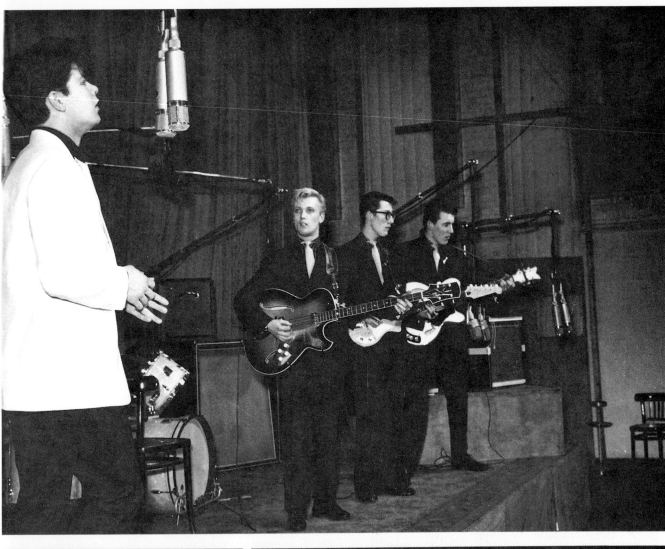

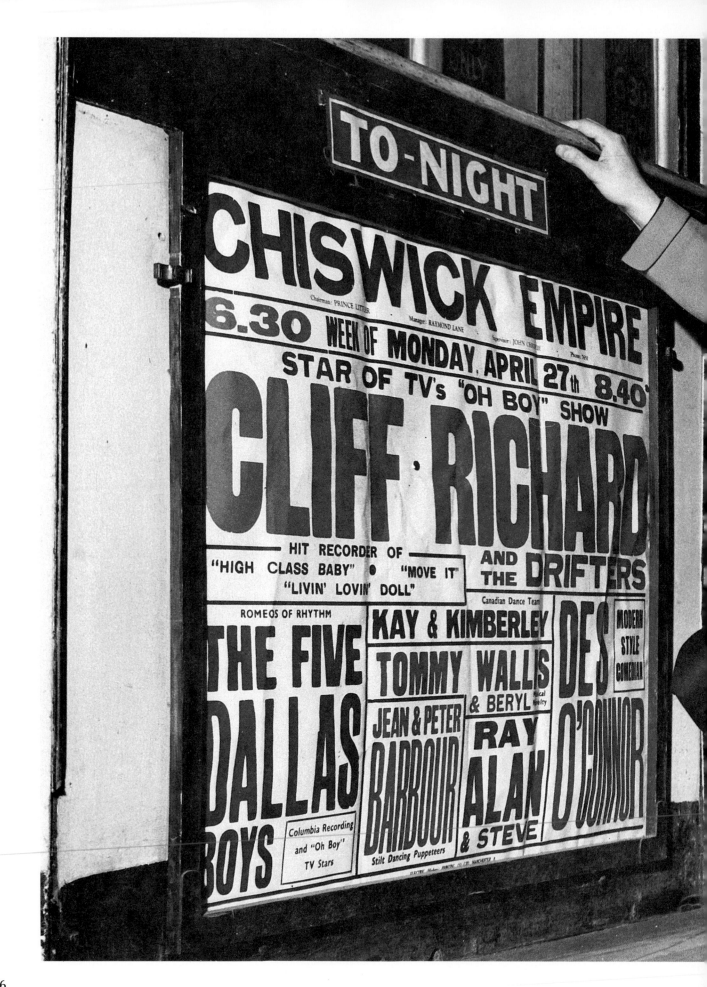

56

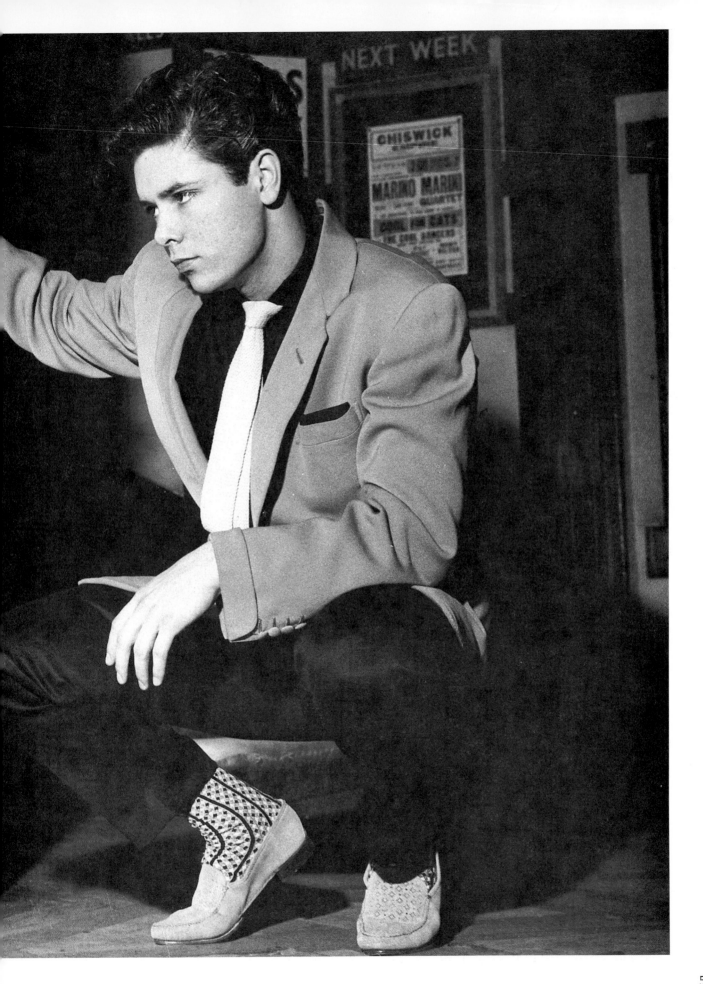

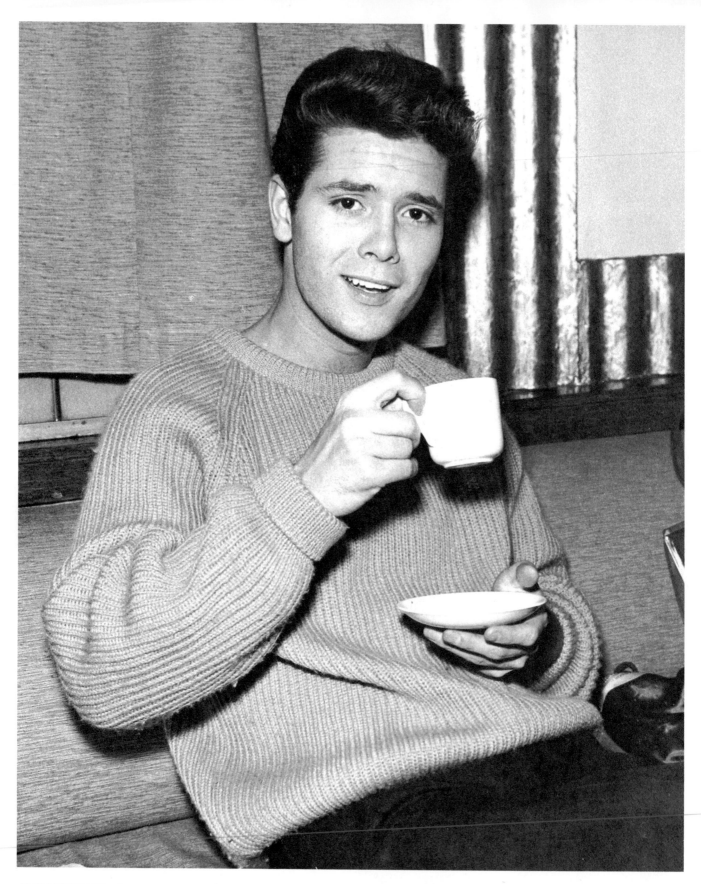

CLIFF RICHARD (*Previous page and opposite*)**:** Harry Webb became Cliff Richard in 1958, by which time he already had his own rock/skiffle group, the Drifters (later the Shadows). Within two weeks of his first appearance on *Oh Boy!*, his first single, *Move It*, entered the charts, reaching No. 2. He has been going for 25 years now, has had 10 No. 1s and more chart entries in England than anybody apart from Elvis. Although his appeal never really translated to the USA, his influence on British pop is undeniable. ***1958–1960***

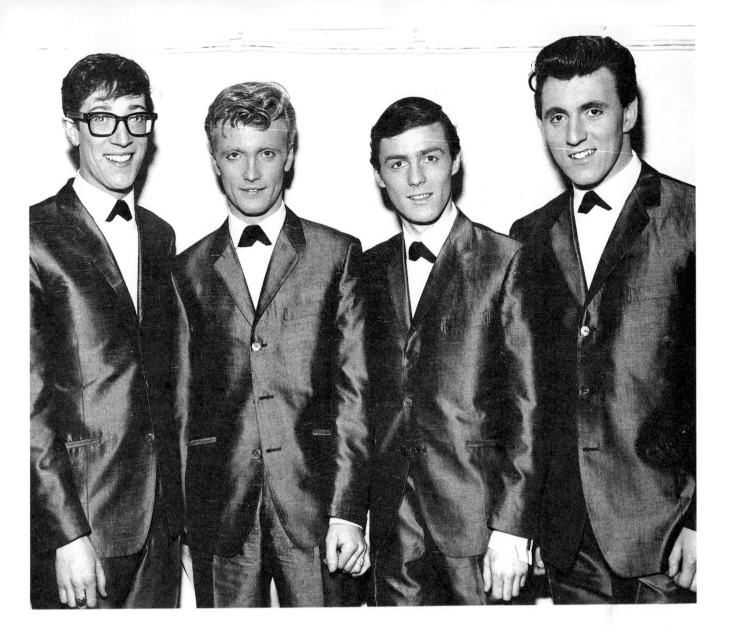

THE SHADOWS (*Above*)**:** Originally the Drifters, they changed their name to avoid confusion with the US vocal group. The original line-up backed Cliff Richard on his first single, *Move It*, and from then on they were inextricably associated with Cliff. In their own right they recorded a string of instrumental hits including five No. 1s – *Apache, Kon-Tiki, Wonderful Land, Dance On* and *Foot Tapper*. Pictured here is their best known incarnation: Hank Marvin, Jet Harris, Tony Meehan and Bruce Welch. *1960*

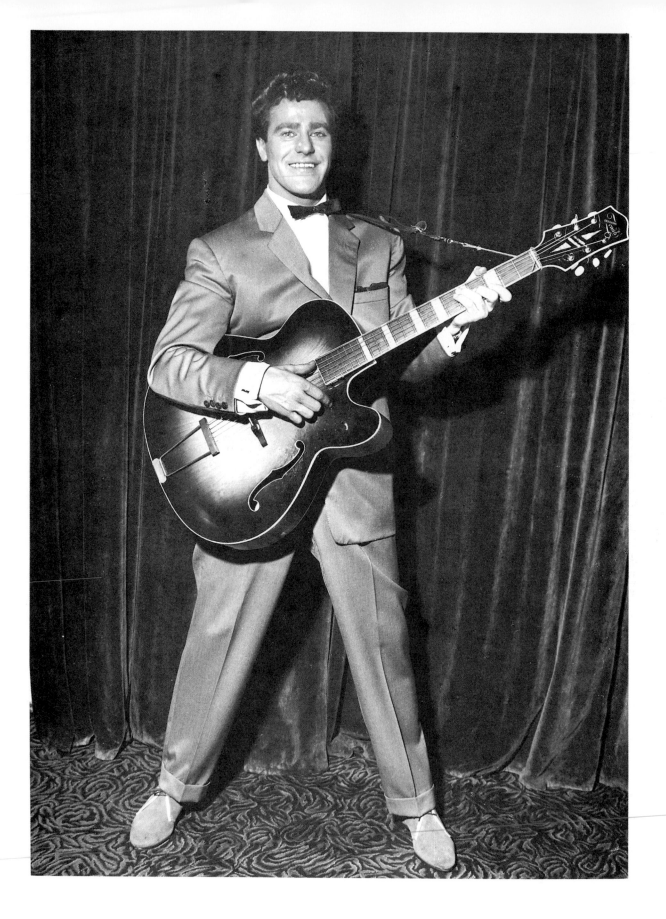

RUSS HAMILTON: A former Butlin Red Coat, his No. 2 hit, *We Will Make Love*, won the Ivor Novello Award for the most performed British song in 1957. *1958*

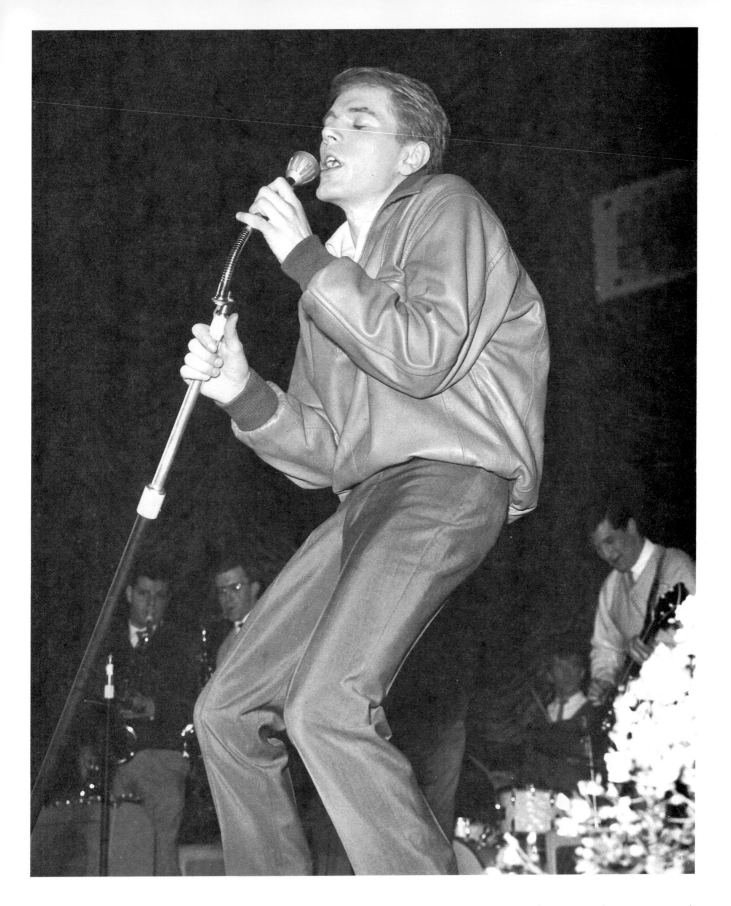

ADAM FAITH: Real name Terry Nelhams. A veteran of *6.5 Special*, he scored two No. 1 hits in rapid succession with *What Do You Want* and *Poor Me*. In the seventies, the title role in TV's *Budgie* consolidated his future as an actor, which has since earned him critical acclaim for his performances in *Stardust* and *McVicar*. He also found time to manage Leo Sayer. *1960*

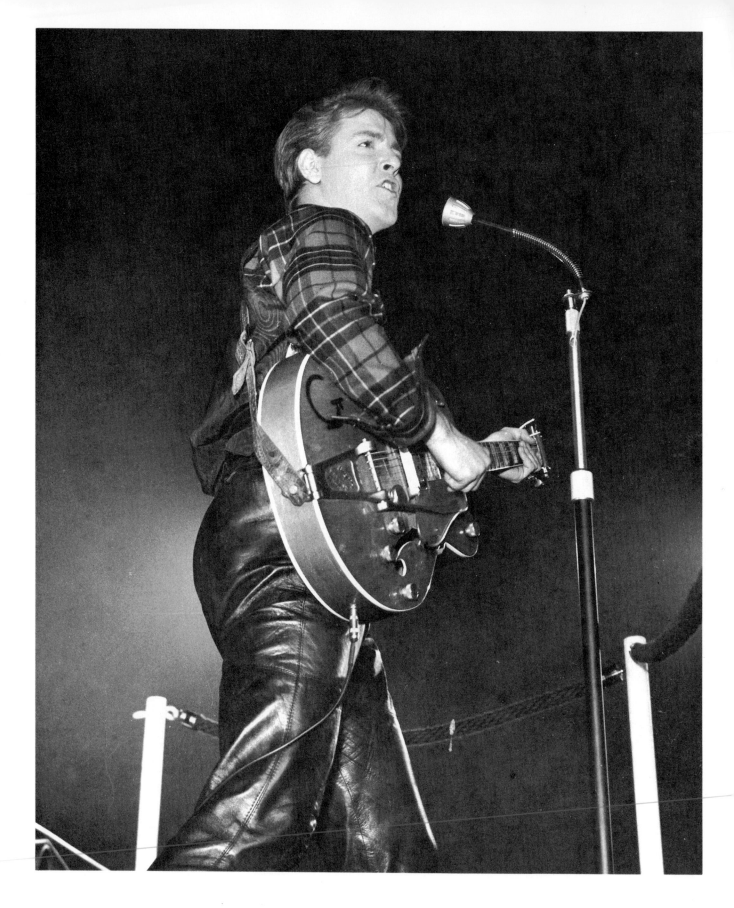

EDDIE COCHRAN: One of the most influential and creative of the early rock'n'rollers – his guitar style was considered revolutionary at the time. Photographed at the *New Musical Express* Pollwinners Concert in London, a few months before his death in a car crash in Wiltshire. *1960*

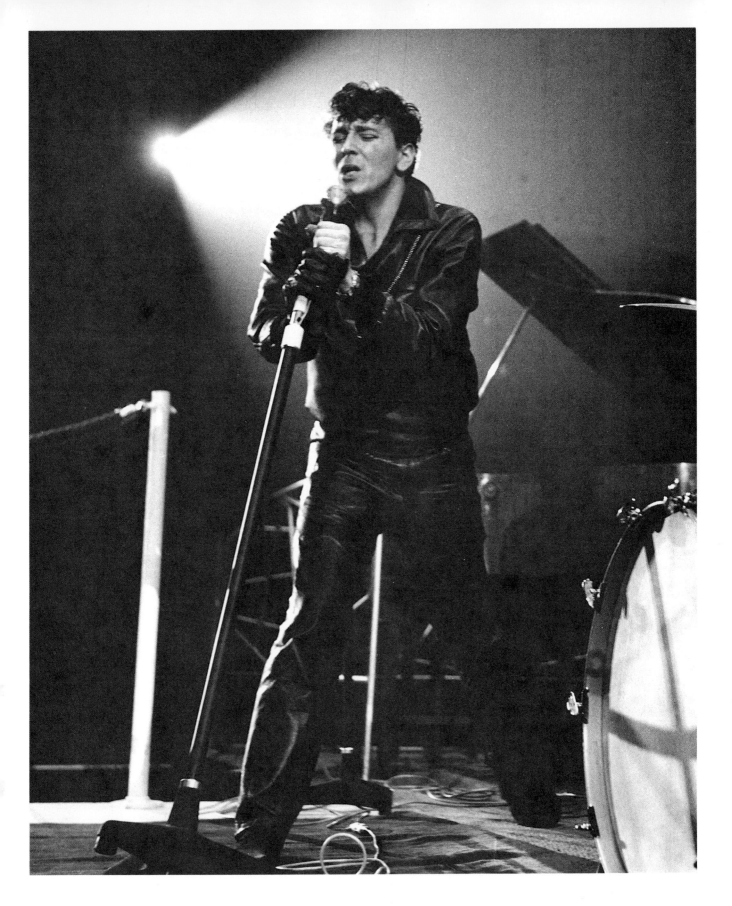

GENE VINCENT: Injured in a motorcycle accident at the age of eighteen, Vincent devoted himself to music. Best remembered for *Be Bop A Lula*, his soft bluesy voice was almost unique in rock. Photographed at the *New Musical Express* Pollwinners Concert, shortly before beginning a nationwide tour with Eddie Cochran. He was seriously injured in the car crash that killed Cochran, and the remainder of his career was highly erratic. He died in 1971, aged 36. ***1960***

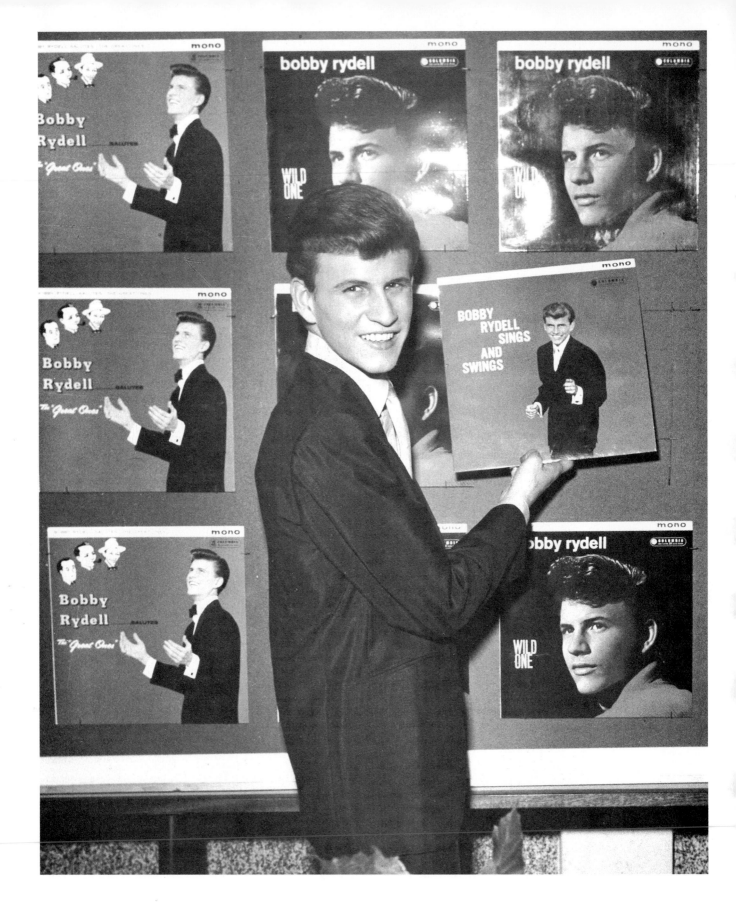

BOBBY RYDELL: Rydell was a member of the same Philadelphia 'Teen and Twenty Club' as Frankie Avalon and Fabian. He and Avalon were briefly members of a rock'n'roll group, Rocco and the Saints, before becoming clean cut teen idols of the early sixties. He reached the Top 10 once in 1960 with *Wild One*. **1960**

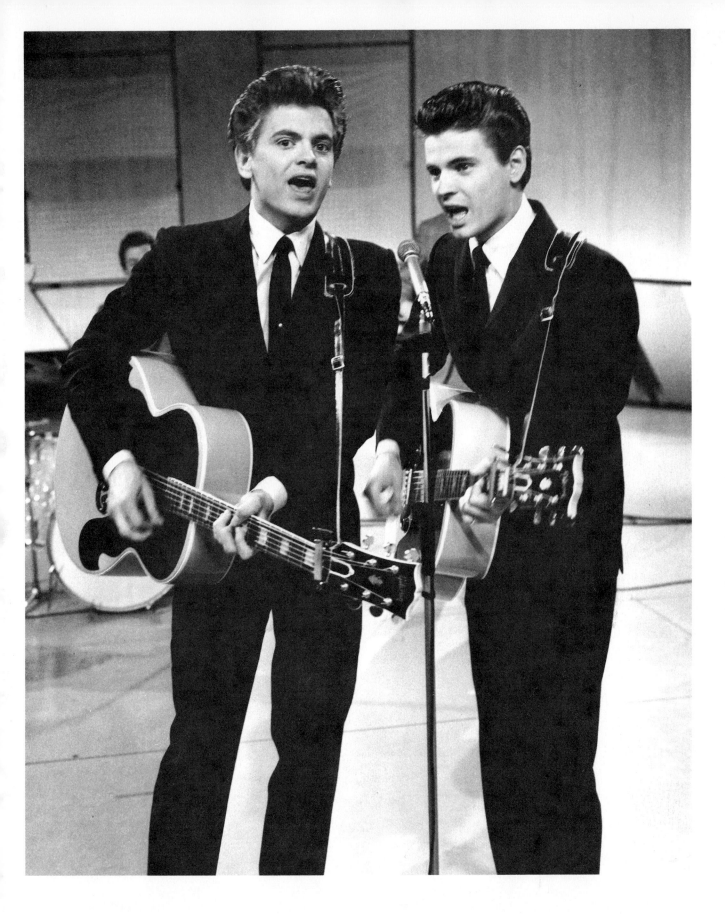

THE EVERLY BROTHERS: Photographed while recording a television show in London. The harmony vocals of Don and Phil Everly were often imitated, but never equalled. *1960*

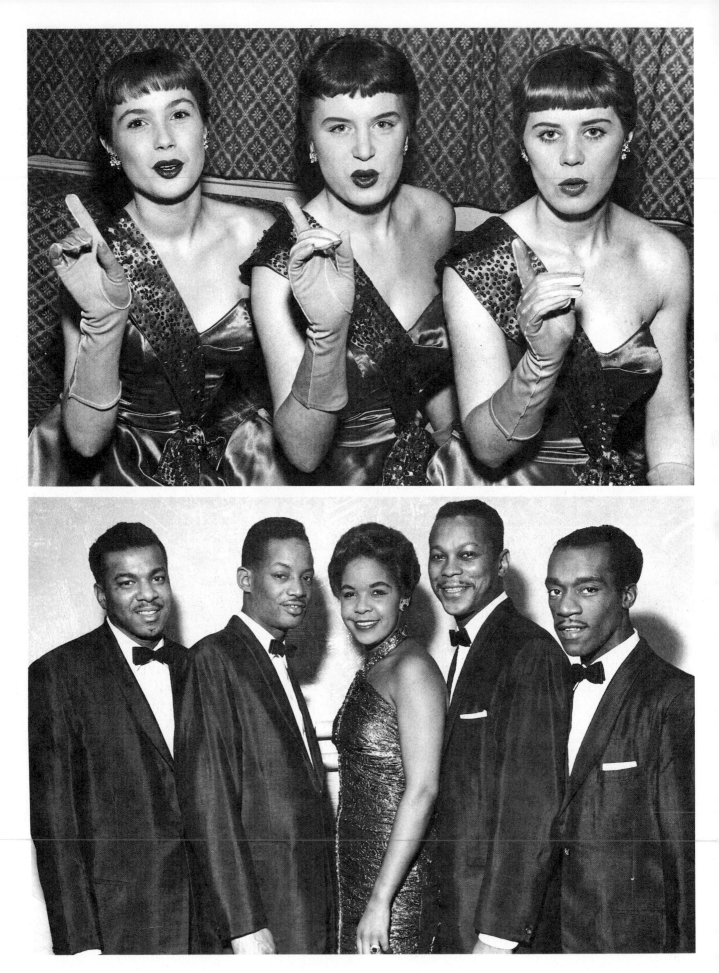

ANTHONY NEWLEY (*Above*): Originally an actor, the role of a rock'n'roller called up for National Service (*Idle On Parade*) launched his singing career. After chart success with ballads such as *Why?* and *Do You Mind* – both of which reached No. 1, Newley began a career as a songwriter, co-writing the musical *Stop The World, I Want To Get Off*. *1960*

THE KAYE SISTERS (*Left, above*)**:** Their cover version of *Paper Roses* reached No. 7 in 1960. *1960* **THE PLATTERS** (*Left, below*)**:** Closer in style to the Inkspots than to street level doo-wop, the Platters found favour with adults and teenagers alike: their version of the standard *Smoke Gets In Your Eyes* reached No. 1 in 1959. *1959*

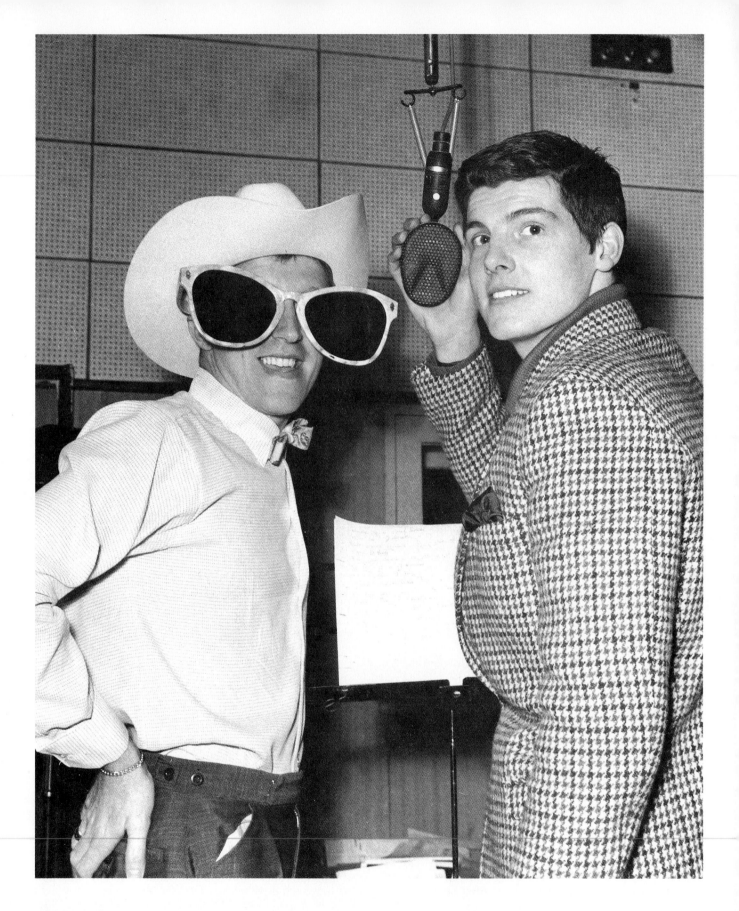

JESS CONRAD: Disc jockey Kenny Everett's listing of the twenty worst records of all time contains no less than three Conrad records – a good enough reason for Conrad to change to an acting career. He distinguished himself in the West End production of *Conduct Unbecoming*, and appears briefly in the Six Pistols' *Great Rock & Roll Swindle*. (Shown here with Jimmy Savile, at that time a Radio Luxembourg DJ.) *1960*

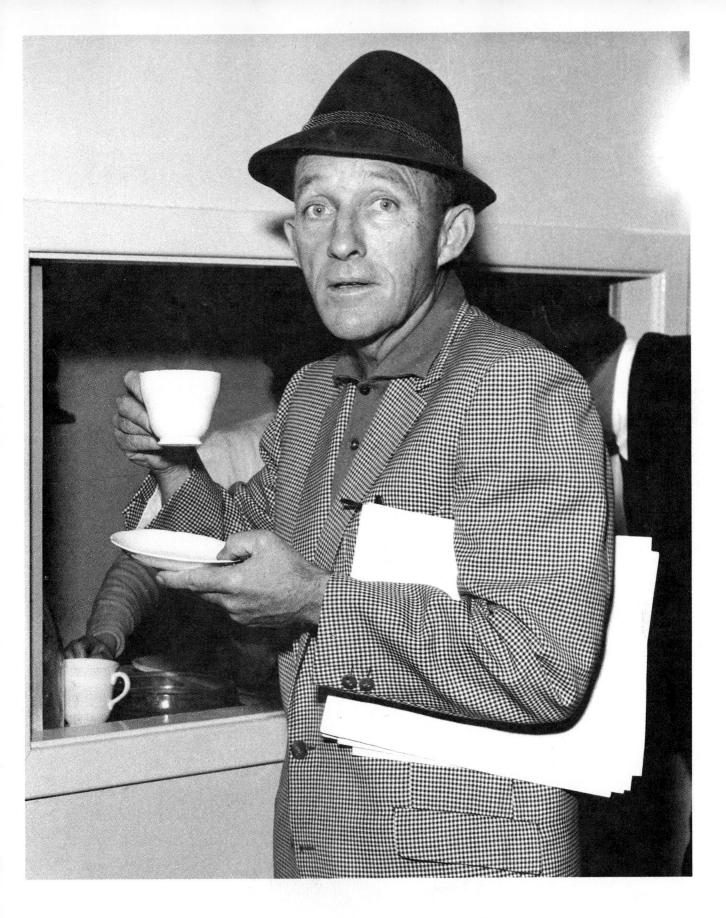

BING CROSBY: Seen here relaxing during a recording session with the Malcolm Lockyer Orchestra at Decca's recording studios in London. *1960*

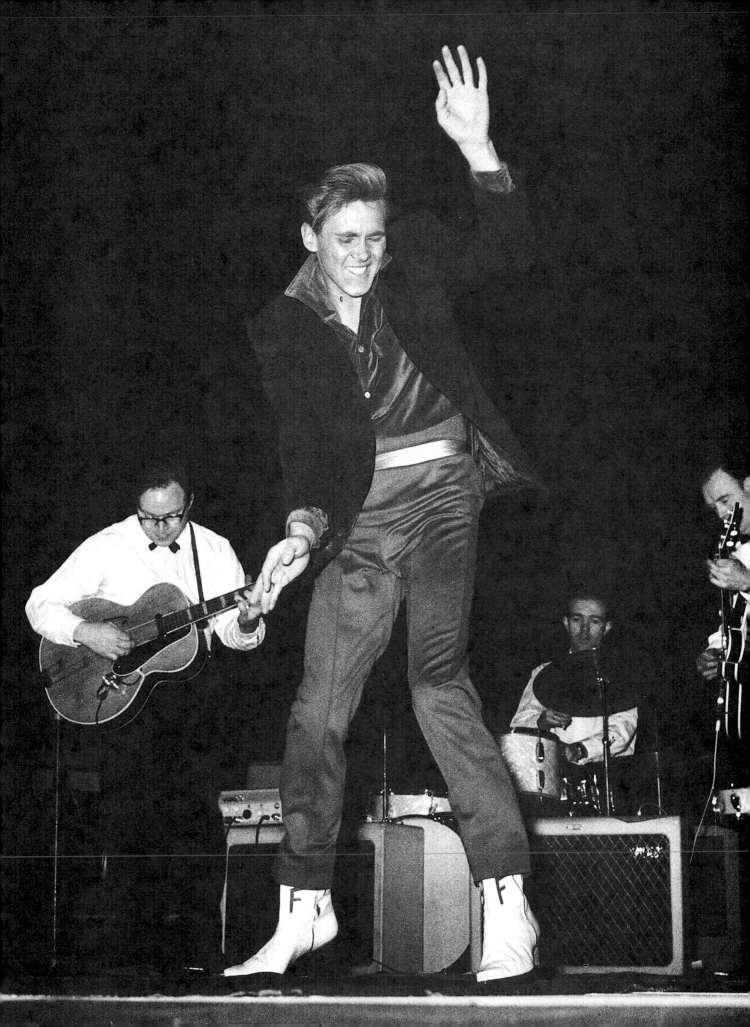

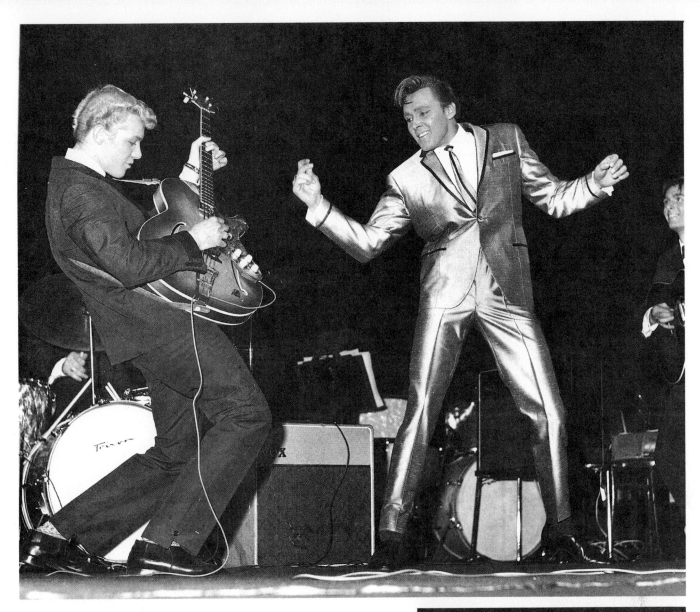

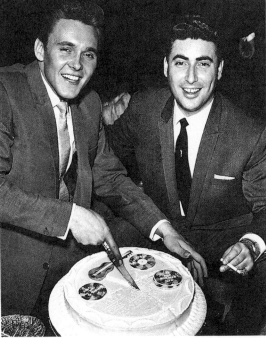

BILLY FURY (*Opposite*)**:** A Larry Parnes discovery, Ronald Wycherly was possibly the greatest rock'n'roll singer that Britain produced. He had nine Top 10 singles in the space of three years, and his *The Sound Of Fury* LP is an acknowledged classic. *1961* (*Above*): With the Tornadoes, featuring legendary bassist Heinz. *1961* (*Right*): With manager Parnes. *1962* Fury died in 1983, aged 42.

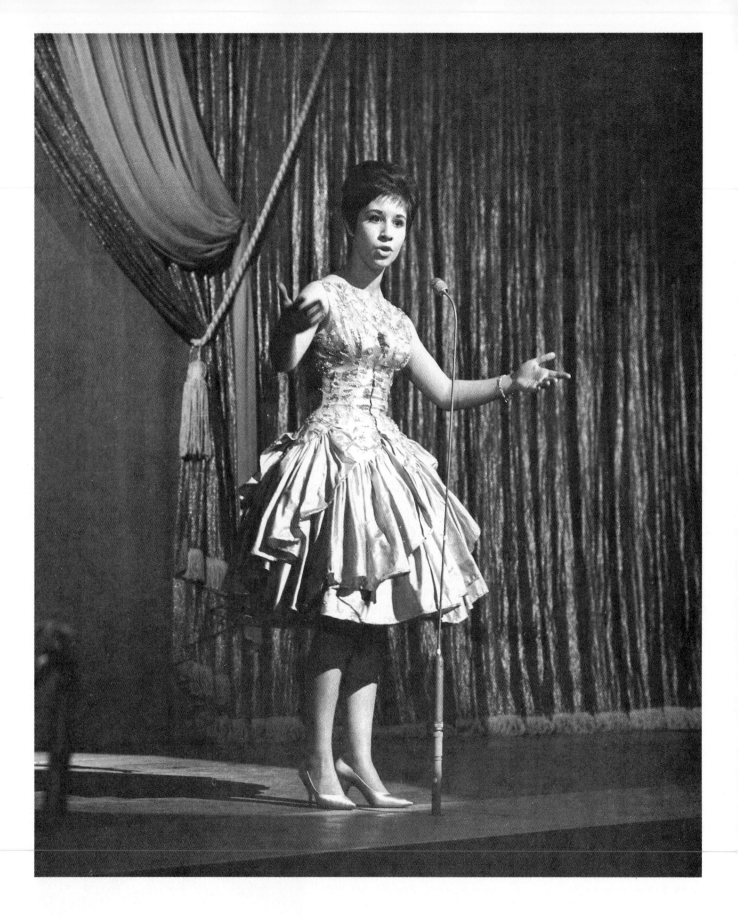

HELEN SHAPIRO: A child star (her first record was appropriately *Don't Treat Me Like A Child*), she is best remembered for her No. 1 hits, *You Don't Know* and *Walking Back To Happiness*. Her pop career did not survive the arrival of the Beatles, and she moved on to become a respected jazz vocalist. *1961*

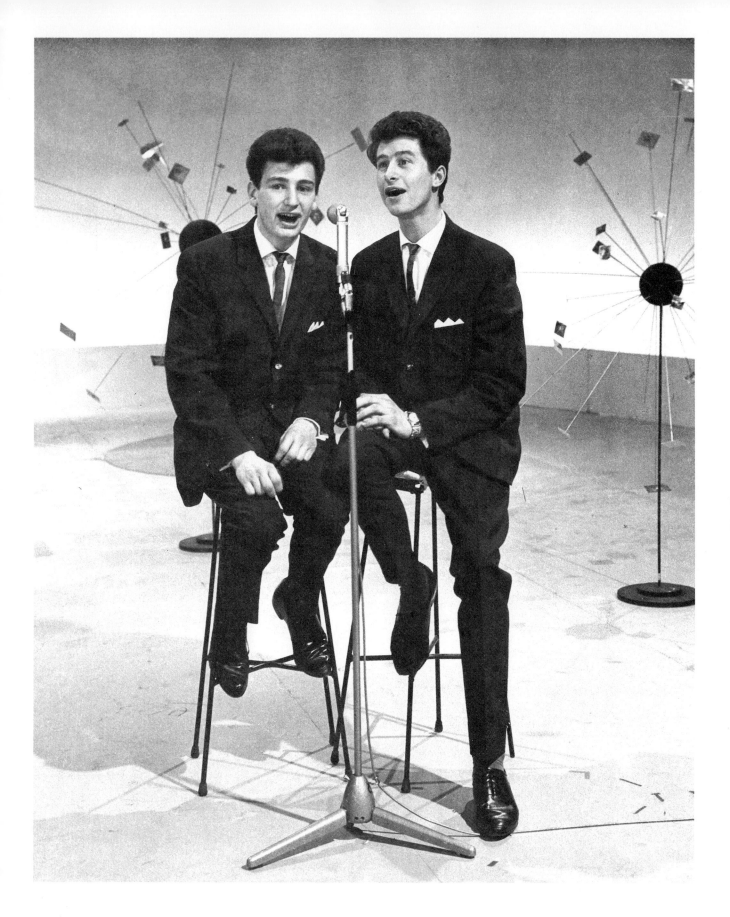

THE ALLISONS: *Are You Sure* reached No. 2 and won the Eurovision Song Contest in 1961. A year later, they disappeared. *1961*

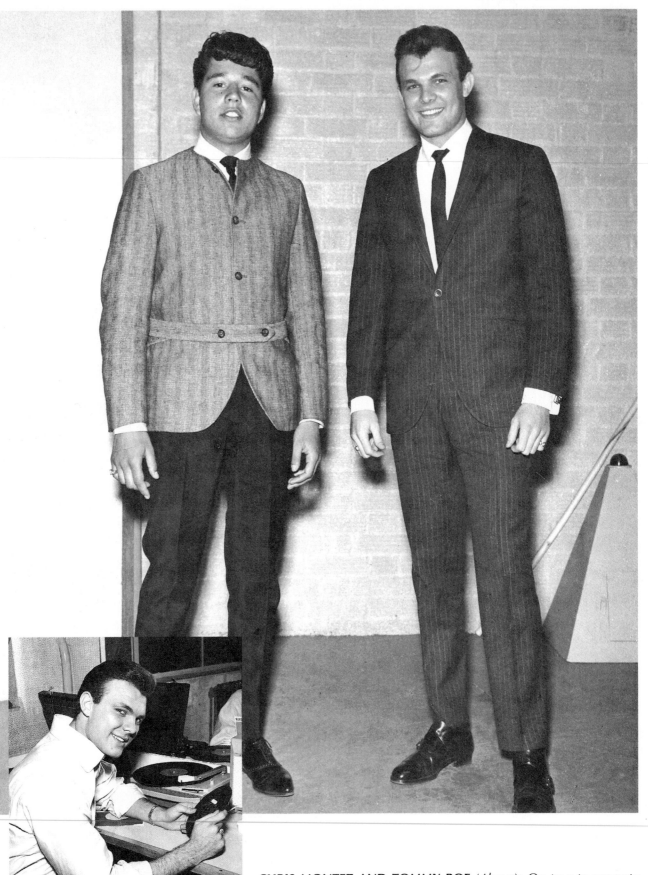

CHRIS MONTEZ AND TOMMY ROE (*Above*)**:** On tour to promote their current singles – Montez's classic *Let's Dance* and Roe's *Sheila* – both Top 10 hits. Montez went on to record MOR ballads like *The More I See You*, and Roe (left) scored a No. 1 in Britain and the USA in 1969 with *Dizzy*. *1962*

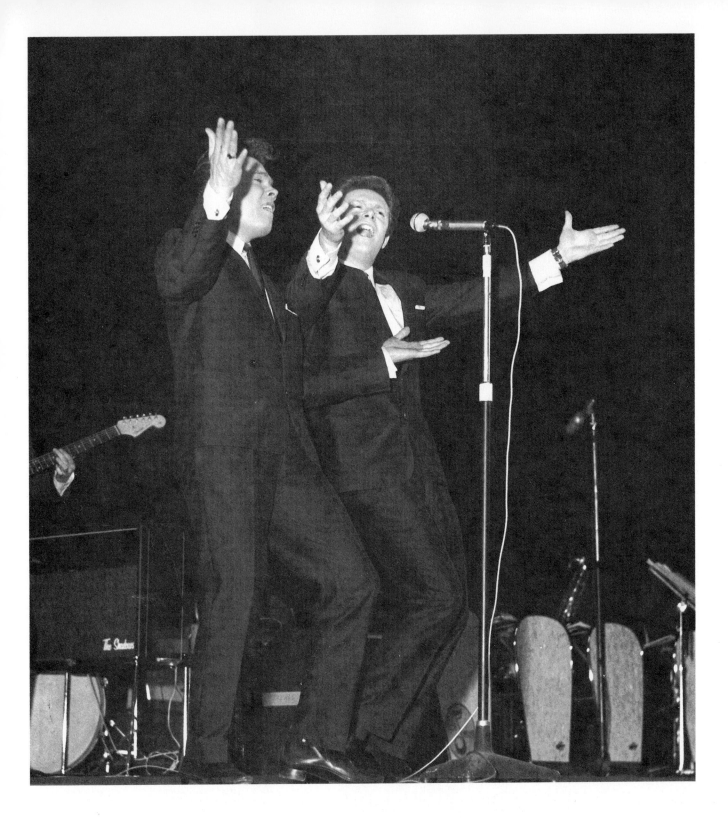

THE BROOK BROTHERS: Like the Allisons, a vocal duo with more than a passing debt to the Everlys. *Warpaint* reached No. 5. *1961*

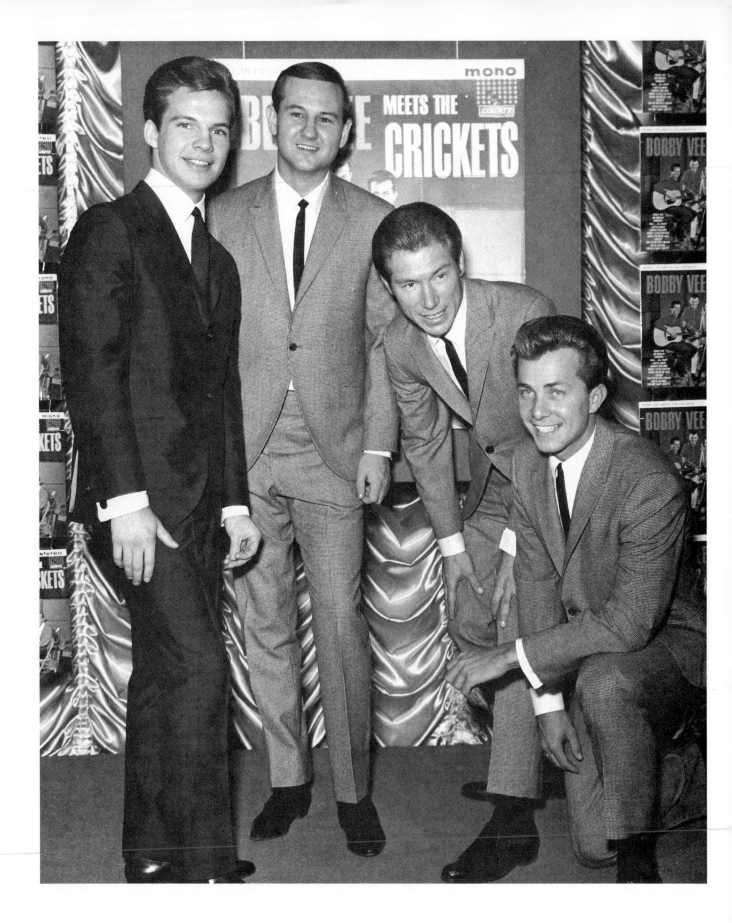

BOBBY VEE: Another singer from the pre-Beatles 'clean cut' phase of pop, who hit the Top 10 seven times between 1961 and 1963. Seen here on his 1962 British tour with Buddy Holly's band, the Crickets. *1962*

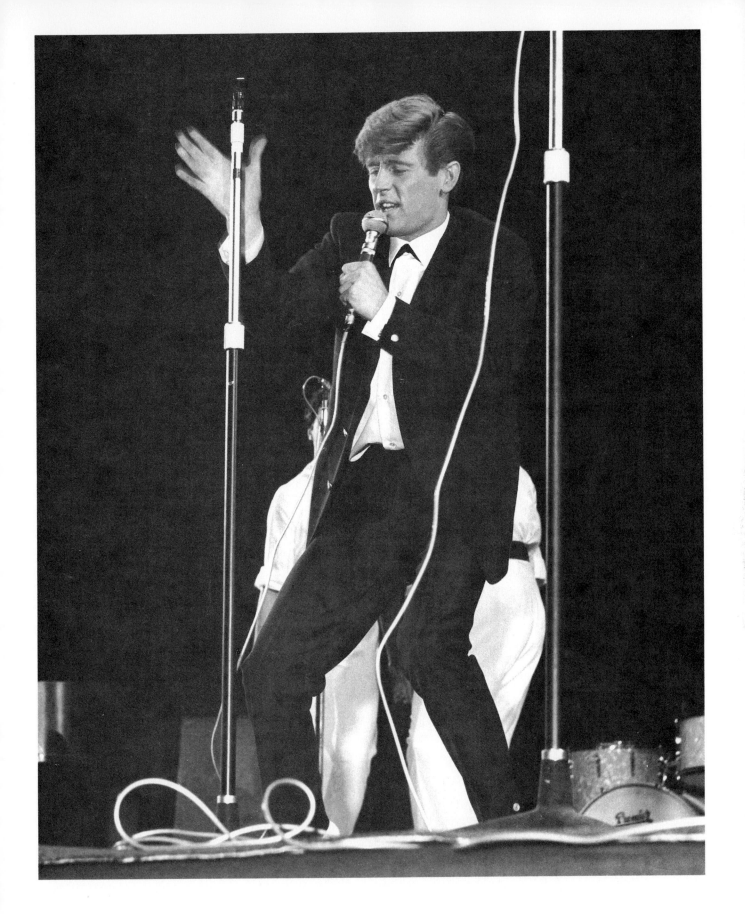

JOHN LEYTON: Originally an actor, he had a No. 1 hit with *Johnny Remember Me*. The follow-up, *Wild Wind* got to No. 2, but his following records did not fare as well and he returned to acting, appearing in *The Great Escape* and *Von Ryan's Express*. *1961*

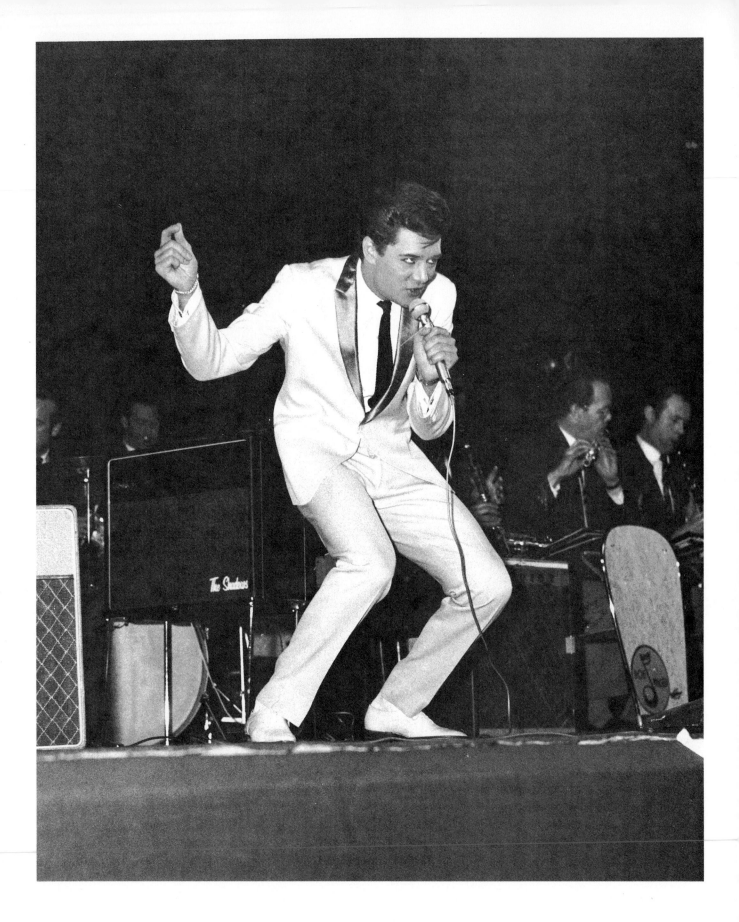

EDEN KANE: Richard Sarstedt, (elder brother to Peter and Robin), changed his name to Eden Kane and reached the Top 10 five times between 1961–4, including one No. 1, *Well I Ask You*. **1962**

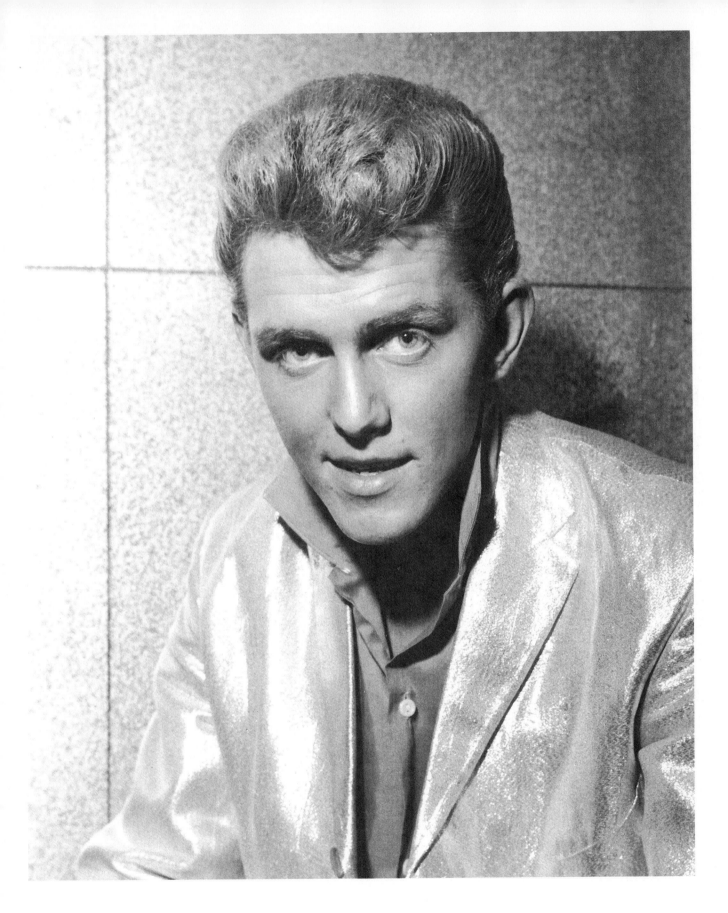

SHANE FENTON: Originally Bernard Jewry, later Alvin Stardust. Discovered via BBC Radio's 'Saturday Club', he and his group the Fentones enjoyed brief success in 1961–2 with *I'm A Moody Boy* and *Cindy's Birthday*, before his reincarnation in black leather eleven years later. *1962*

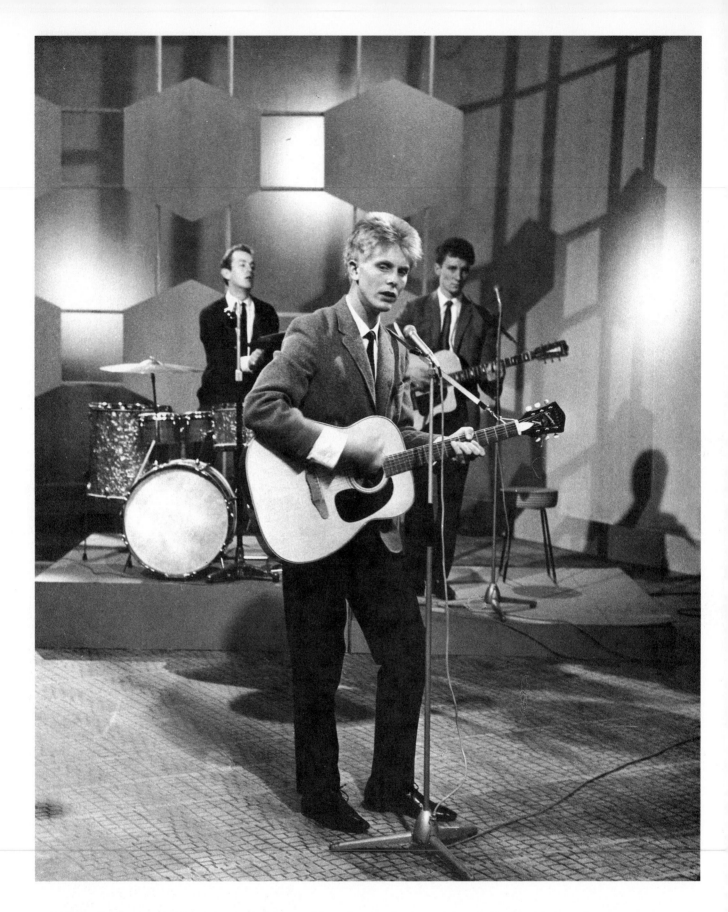

JOE BROWN: Discovered by Jack Good, he moved from being a backing musician on the *Oh Boy!* show to session work as a guitarist (for Billy Fury, among others), before embarking on his own recording career. He and his backing group, the Bruvvers, reached the Top 10 three times in 1962–3. He made several films, including *What A Crazy World* and *Three Hats For Lisa*, and occasionally surfaces today as a host on TV programmes. *1962*

SHIRLEY BASSEY: The stormy singer from Tiger Bay, photographed on stage and backstage at the London Palladium. She reached No. 1 twice, with *As I Love You* in 1959, and *Reach For The Stars/Climb Every Mountain* in 1961. *1963*

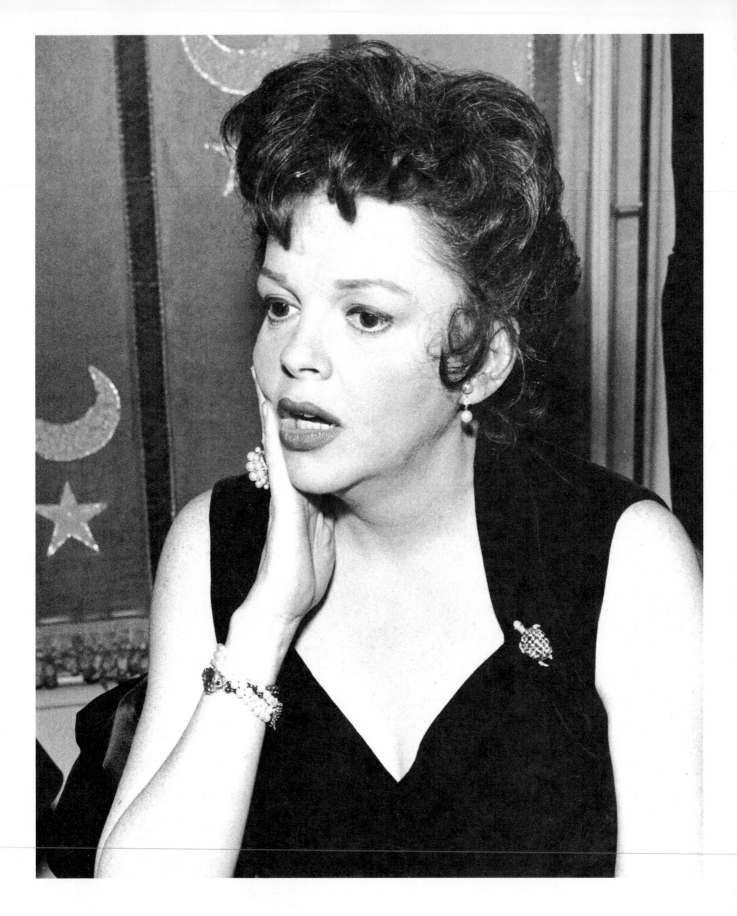

JUDY GARLAND: Photographed at the Dorchester Hotel prior to one of her last appearances in London. She died in 1969, aged 47. *1963*

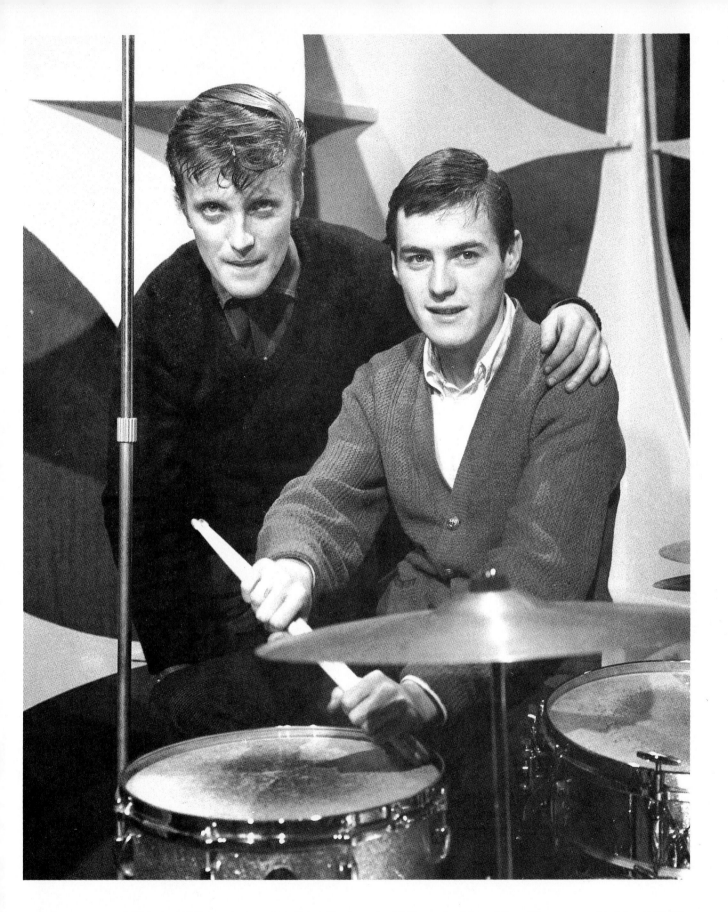

JET HARRIS AND TONY MEEHAN: Jet Harris left the Shadows in 1962, and achieved Top 20 success with *Man With The Golden Arm*. Tony Meehan who had recently left the Shadows, teamed up with him to produce three Shadows-style Top 5 hits in 1963 – *Diamonds*, *Scarlett O'Hara* and *Applejack*. Tony Meehan became a record producer, Harris disappeared.
1963

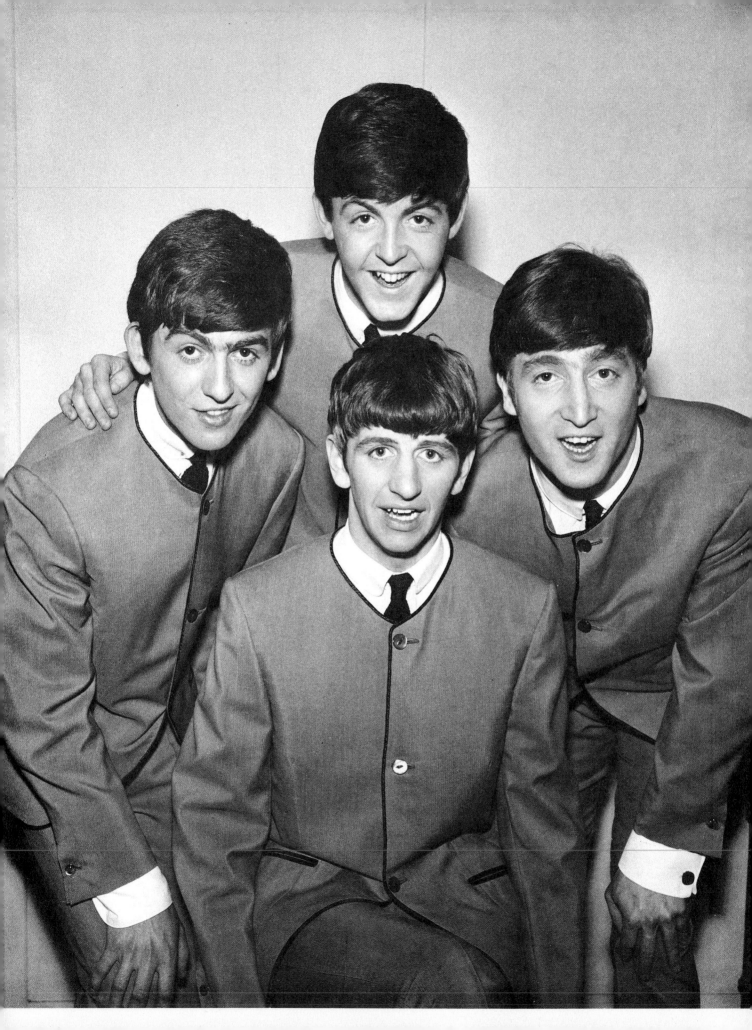

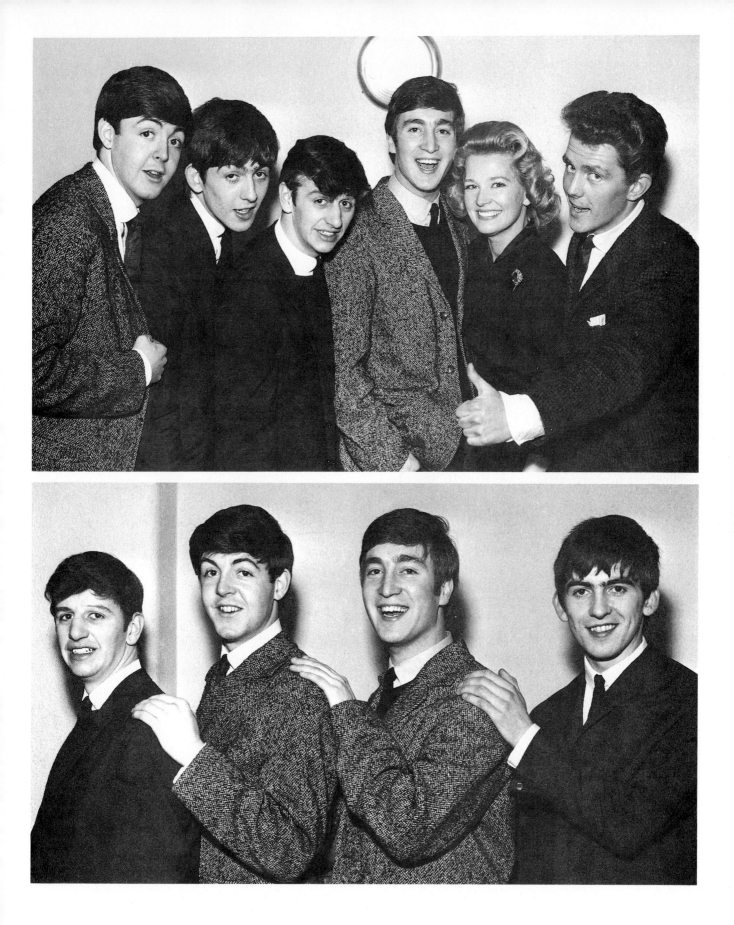

THE BEATLES (*Left*): *Love Me Do* was in the charts, but Ringo still wasn't sure about the haircut. *1962* *Above:* With Joan Reagan and Shane Fenton (later to be known as Alvin Stardust). *1962* *Below:* The Fab Four line up. *1962*

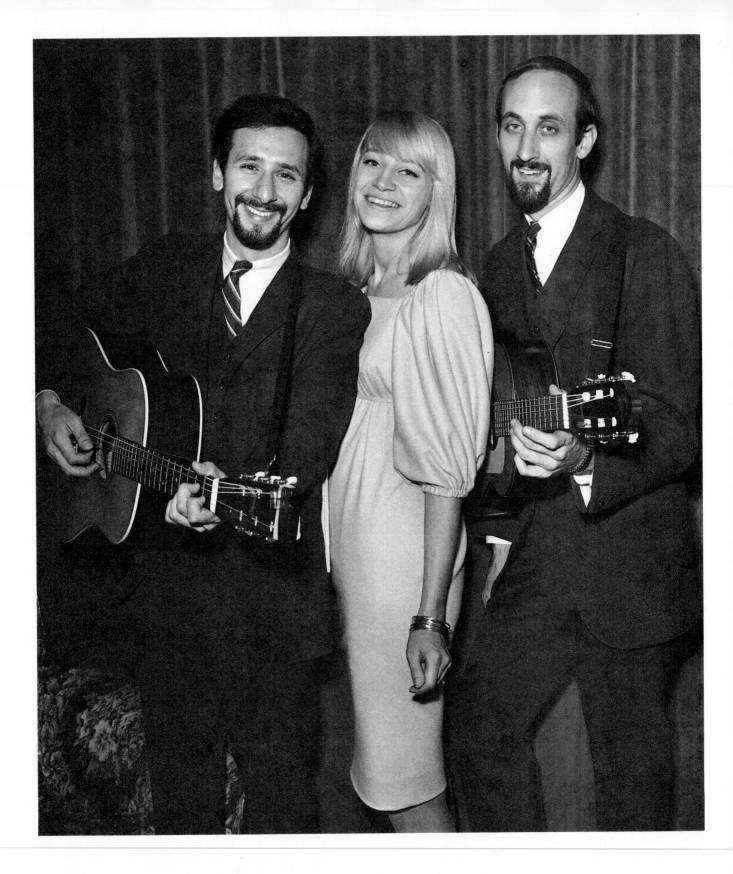

PETER, PAUL AND MARY: This folk trio took Bob Dylan's songs into the charts long before Dylan did. They disbanded in 1971, but reunited in 1982. *1963*

GERED MANKOWITZ

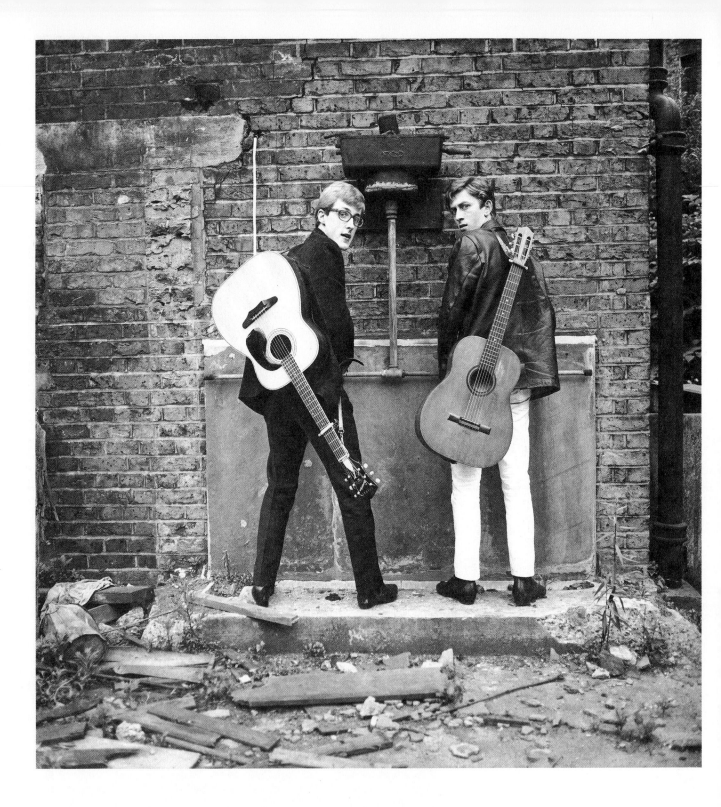

CHAD AND JEREMY: This pop duo were far more successful in America, where they had three Top 20 hits in the mid-sixties, than in their native Britain where only one record – *Yesterday's Gone* – made it into the Top 30. 'I couldn't get anyone to use this photo at the time – it was really considered outrageous and shocking. I suppose we knew at the time that it wouldn't be used – it was really done just for fun.' *1963*

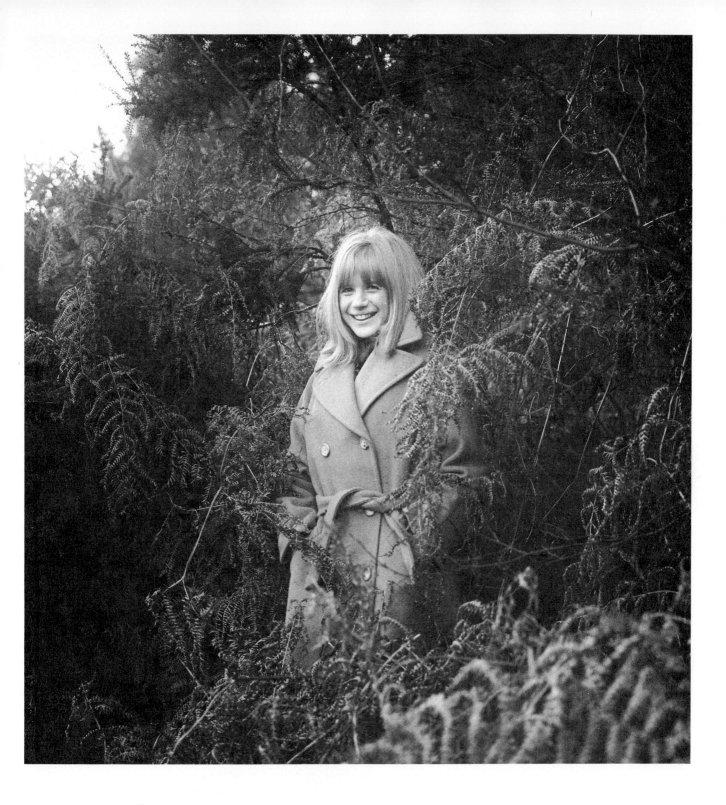

MARIANNE FAITHFULL: 'During this period, a lot of my photos were taken on location – not because I didn't have a studio, but simply out of spontaneity. She was driving down to a gig in Portsmouth, and we stopped off in an appropriate looking wooded area. It's a real favourite of mine, and it epitomizes the way she looked then.' *1964*

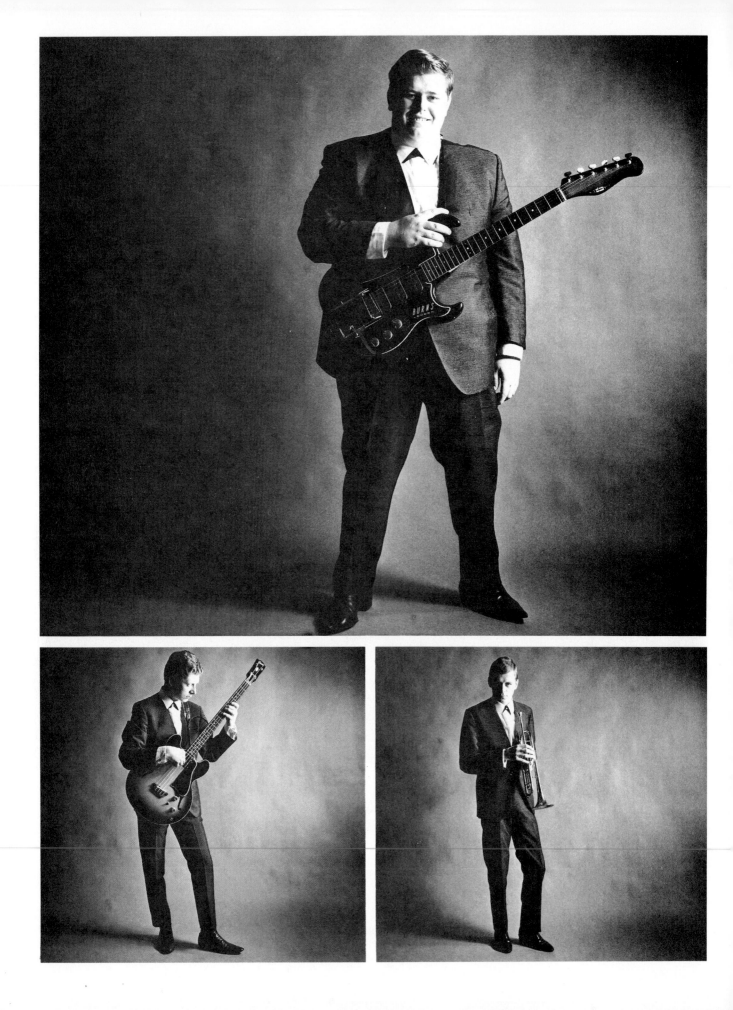

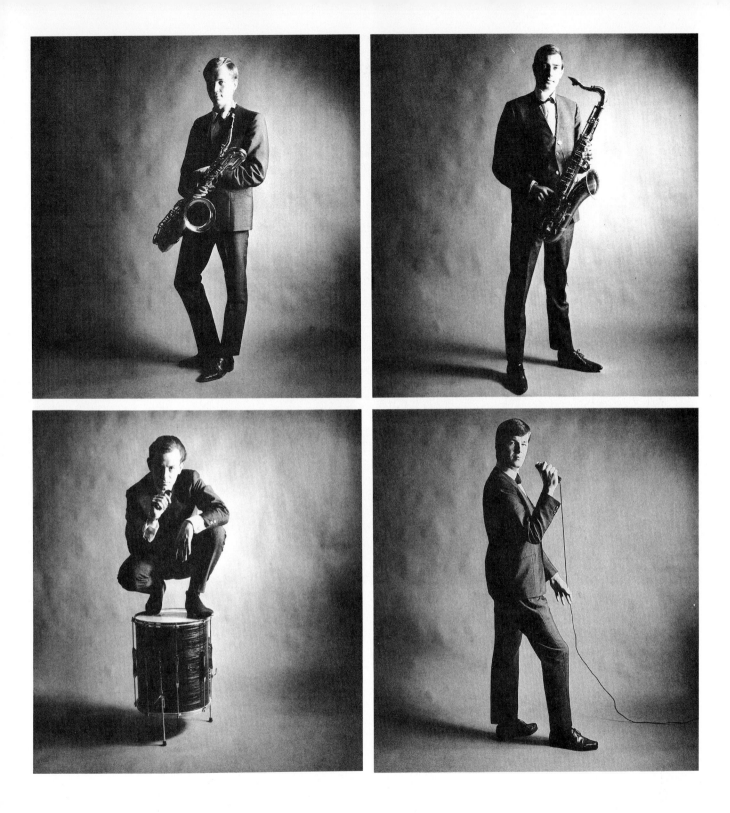

JOHN BARRY SEVEN: 'John Barry was already writing film music at this time, and was also the musical director of Ember Records, who gave me quite a bit of work. They were the first band I ever went on the road with – seedy hotels, brown ale and very hard work. This is me trying to photograph them in a very serious New York portrait style – serious musicians being taken seriously.' *1963*

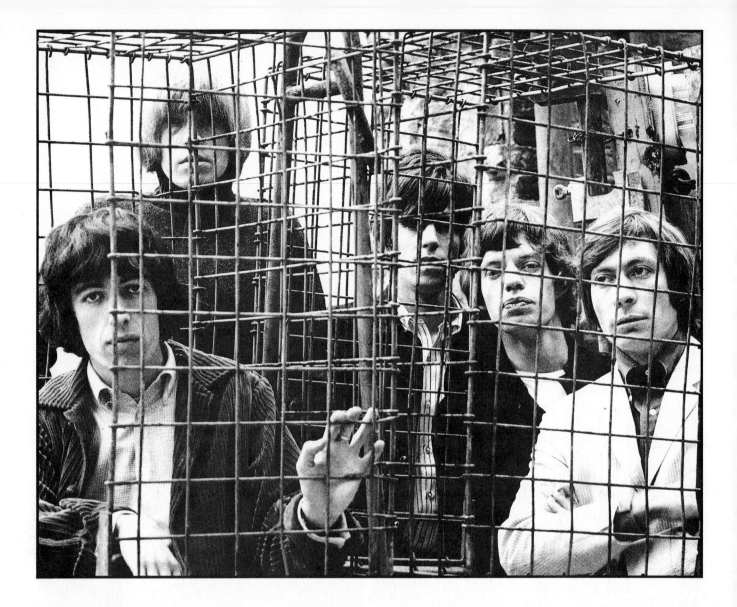

THE ROLLING STONES: 'This was the first session I did with the Stones, and the beginning of a very fruitful relationship which lasted for about three years. It was taken outside my studio at Masons Yard, and I put them in this "cage" to reflect the unruly, untameable image they had at that time. During the same session the cover shot for the *Out Of Our Heads* LP (*December's Children* in the USA) was taken.' **1965**

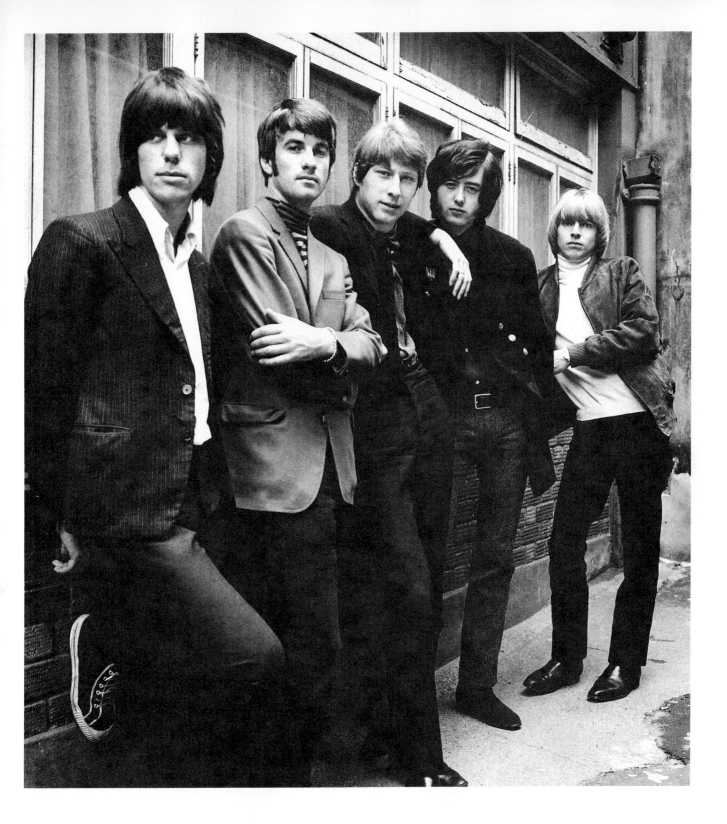

THE YARDBIRDS: 'Taken outside the Masons Yard studio. When I did studio sessions in those days, I often used to do some shots outside as well. Like the Stones photo – perhaps because some of the fashions have re-surfaced – I don't think this has dated at all.' *Left to right:* Jeff Beck, Jim McCarty, Chris Dreja, Jimmy Page, Keith Relf. *1965*

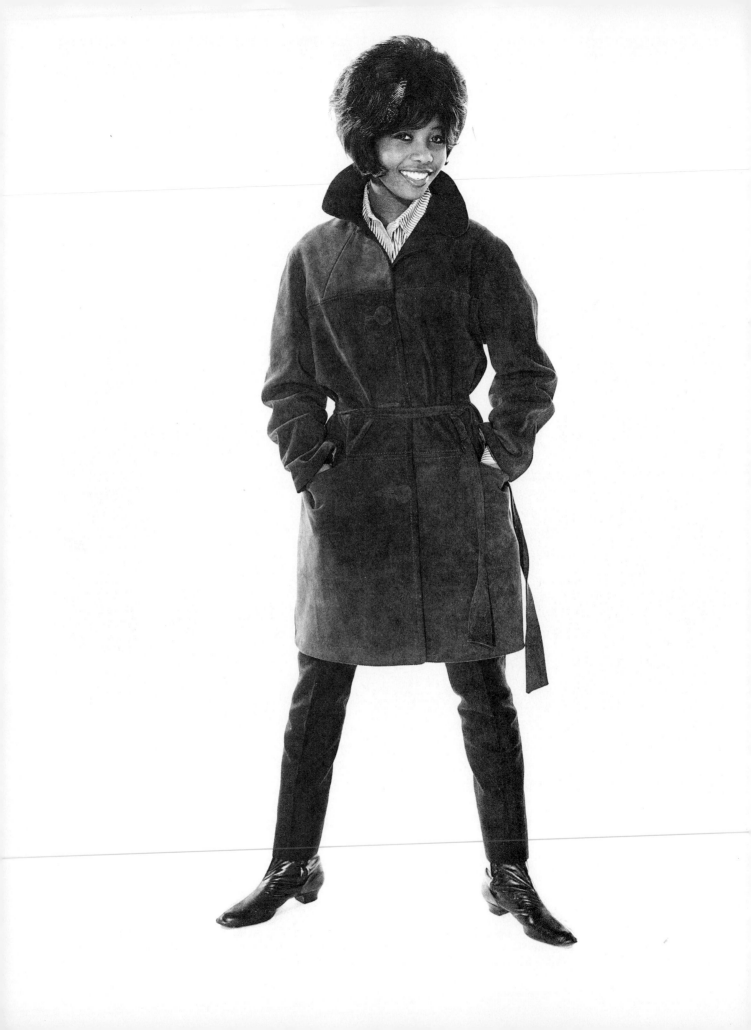

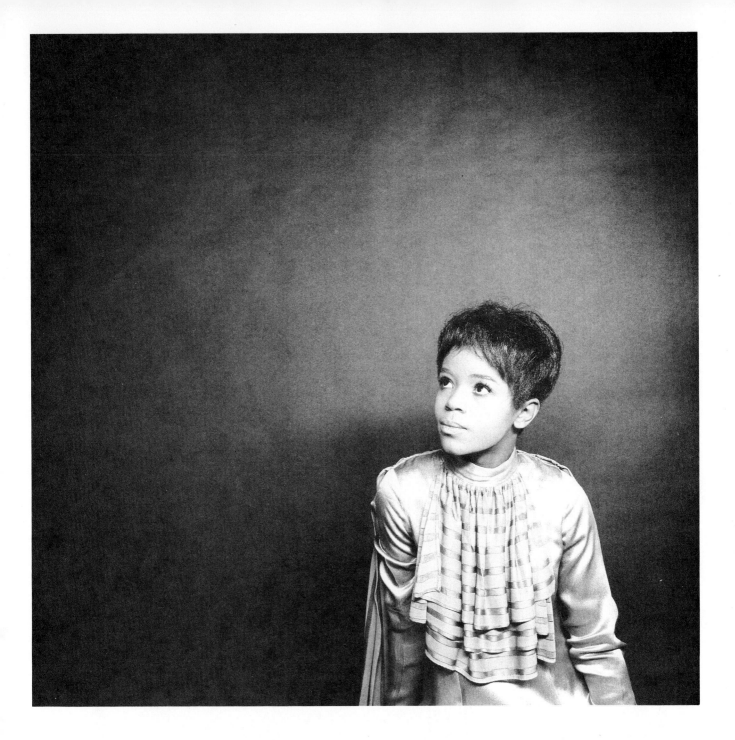

P. P. ARNOLD (*Above*): Just call her Angel of the Morning – she looked like one and sang like one. 'I'd known Pat Arnold since she arrived in Britain in 1966 as one of Ike and Tina Turner's Ikettes – they were doing a Rolling Stones UK tour. I coined the name "P. P." one night at Olympic studios, and it stuck. This photo is from the session for the *First Lady Of Immediate* album.' ***1967***

MILLIE (*Left*): 'This session was in the Masons Yard Studio, just after *My Boy Lollipop* became a hit. Millie lived in a flat in the Cromwell Road, opposite her manager, Chris Blackwell. I spent a lot of time there, as I was doing a lot of work for him then – and because Millie cooked the most amazing Jamaican food.' ***1964***

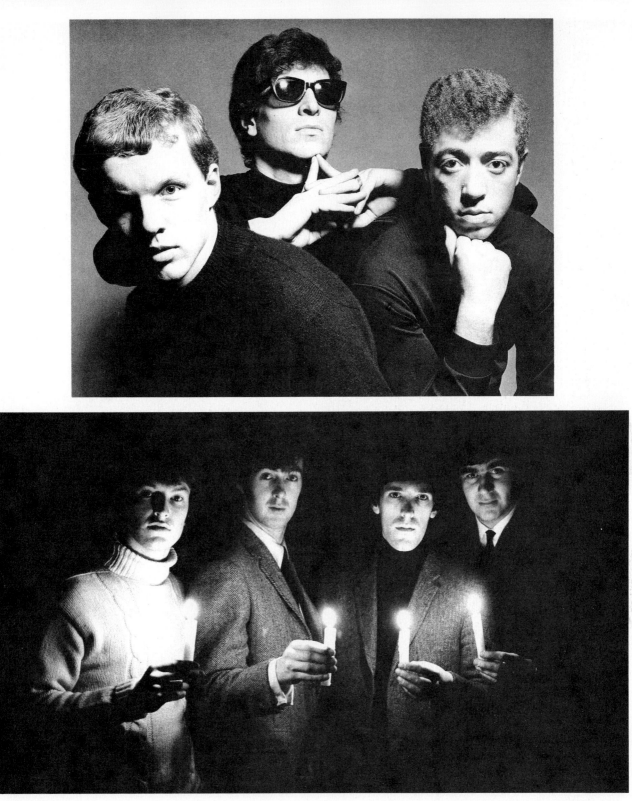

THE PEDDLARS (*Above*): A jazz trio who had a very big club reputation in London – they had a hit in 1969 with *Birth*. 'In terms of shape and lighting, this is very influenced by Richard Avedon.' *1966* **THE SPENCER DAVIS GROUP** (*Below*): Pioneers of British R&B, best remembered as the first showcase for Stevie Winwood (aged eighteen at the time of this photograph). 'Because I photographed them so often, we were always trying to come up with new ideas – I suppose that's the only reason for the candles, but I really like it. It was a bit of a breakthrough in getting unusual lighting accepted.' *1966*

JOE COCKER (*Left*): Perhaps best known for his version of the Beatles' *A Little Help From My Friends*, and his collaborations with Leon Russell, Cocker had been around as a minor figure on the blues/R&B scene for several years before finding success in the late sixties. 'I think this was his first photo session – he was still a gas fitter at the time. This sequence was completely spontaneous, and I think it really captures his friendly humorous nature.' *1966*

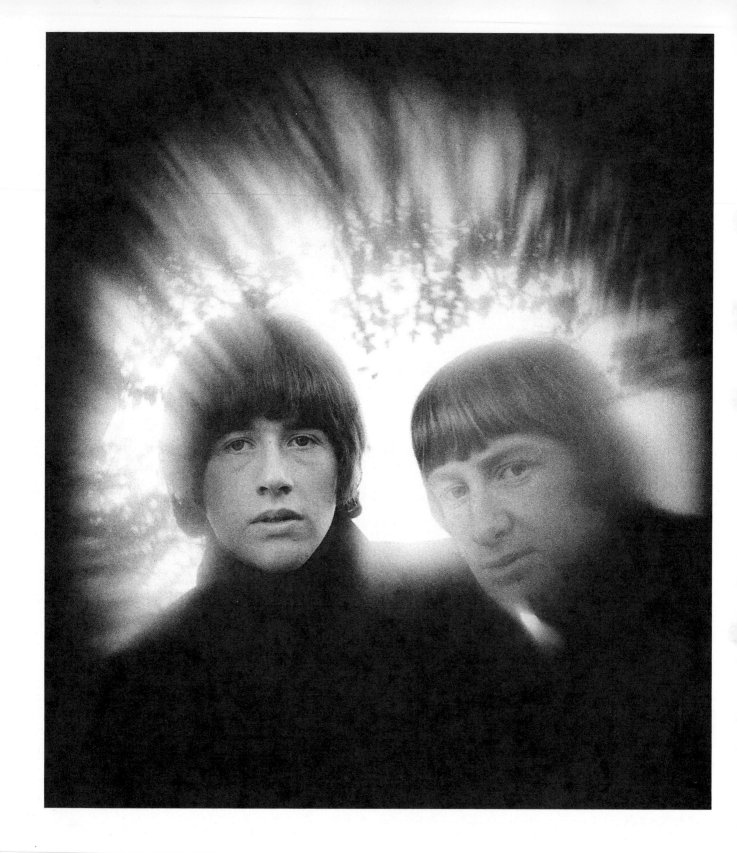

TWICE AS MUCH: David Skinner and Andrew Rose were a pop duo in the tradition of Peter and Gordon, who had one Top 30 hit in 1966 with a recording of the Jagger/Richards song, *Sittin' On A Fence*. 'They were a duo that Andrew Oldham discovered and signed to his Immediate label. They had a very ethereal, pretty feel. This was taken on Primrose Hill, using a screening device of glass and black card with Vaseline on the lens, to try and find a different mood.' *1967*

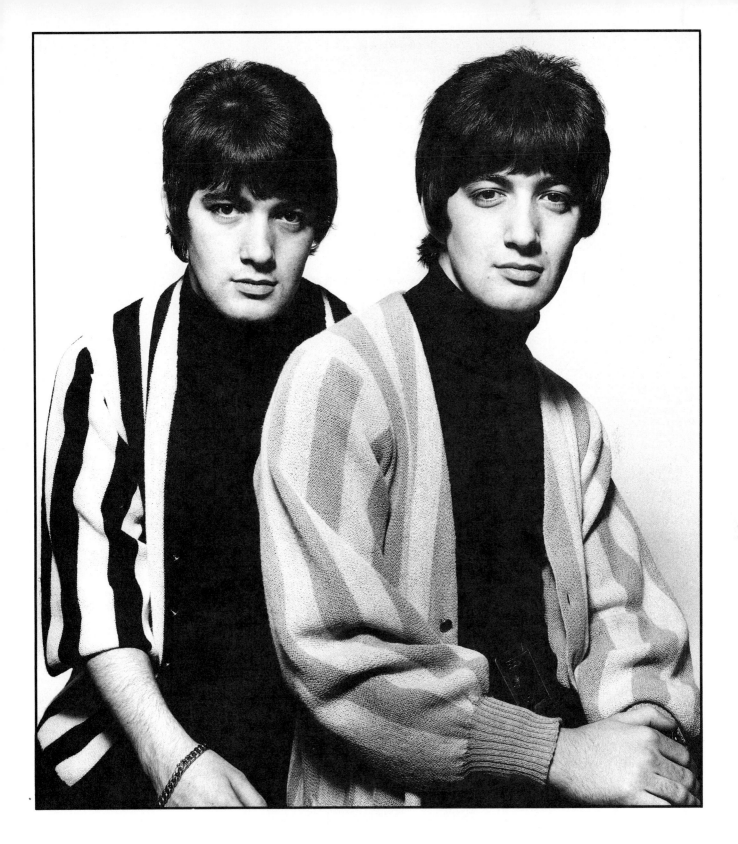

PAUL AND BARRY RYAN: The sons of Marion Ryan, who achieved Top 20 success with *Don't Bring Me Your Heartaches*, *Have Pity On The Boy* and *I Love Her*. 'This picture was very influenced by David Bailey's *Box Of Pin-Ups*, with the highly contrasting lighting. I think the sweaters look amazing.' *1967*

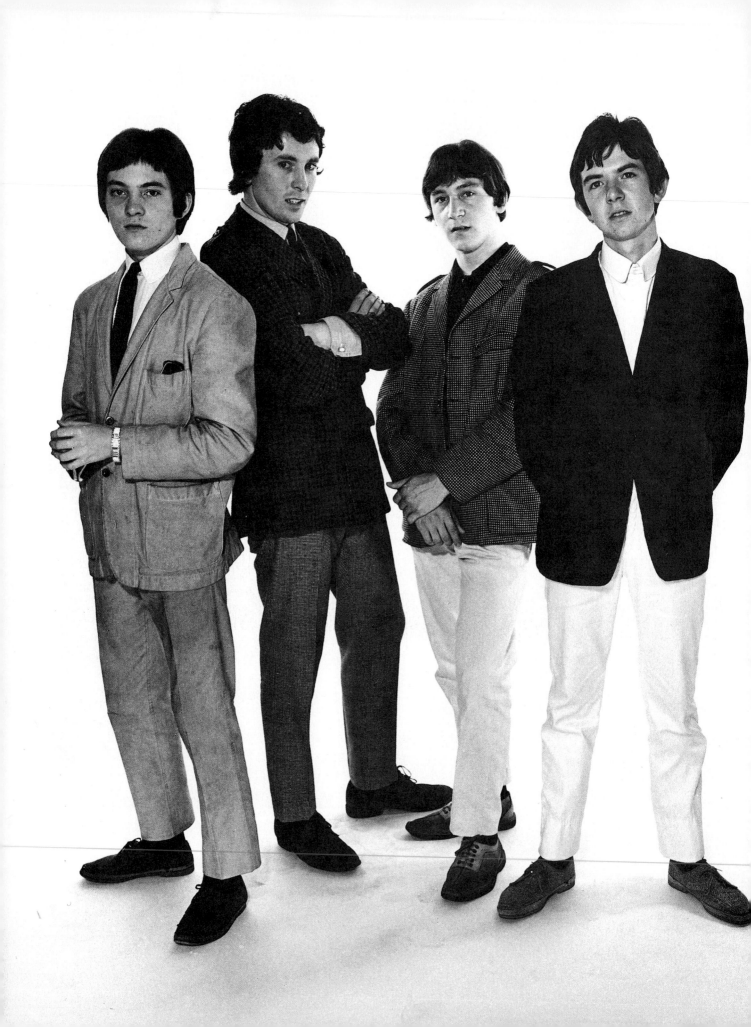

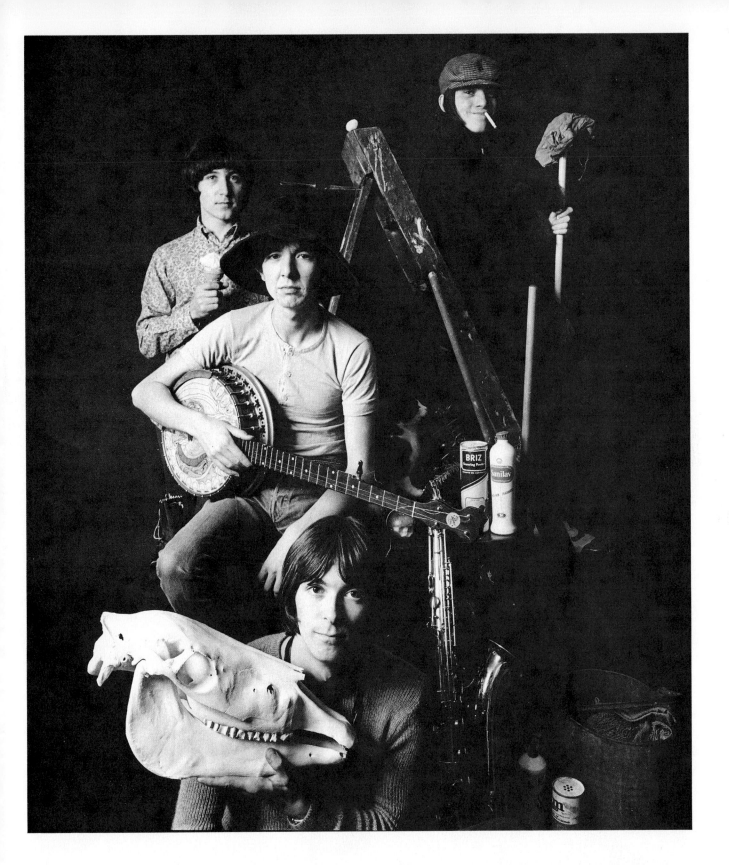

THE SMALL FACES (*Left and above*): 'The first photograph was taken very early on. They'd just signed to Decca and Jimmy Winston was on keyboards – Ian MacLagan hadn't joined them yet. It's a very awkward picture, which sums up how they felt and how I felt – it was a very early thing for all of us. *1963* The other picture I've chosen is . . . mad. I asked them to bring various things from their homes which they liked, which were visually interesting. Steve Marriott forgot to bring anything, but decided to dress up in things we found in my studio, and he developed this guise of a manic lavatory cleaner.' *1967*

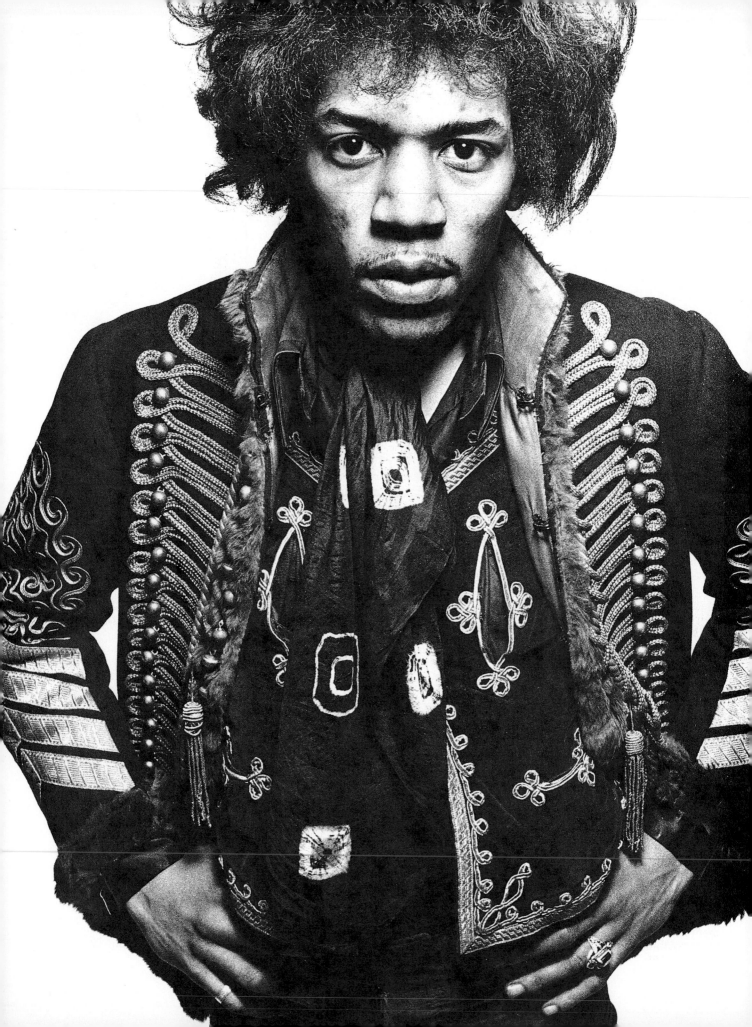

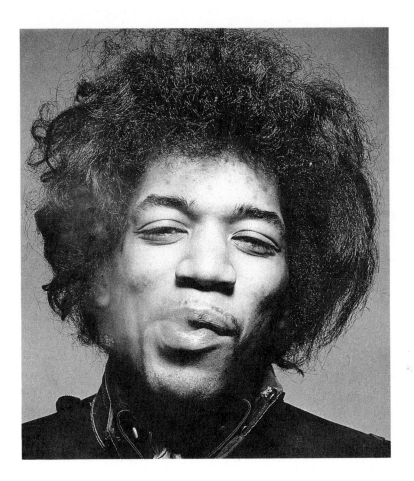

JIMI HENDRIX: 'Studio portraits. He was *so* exciting visually that the best photos of him were always the most simple. Every time we tried out a special effect or a crazy idea, it just didn't look like Jimi Hendrix.' *1967*

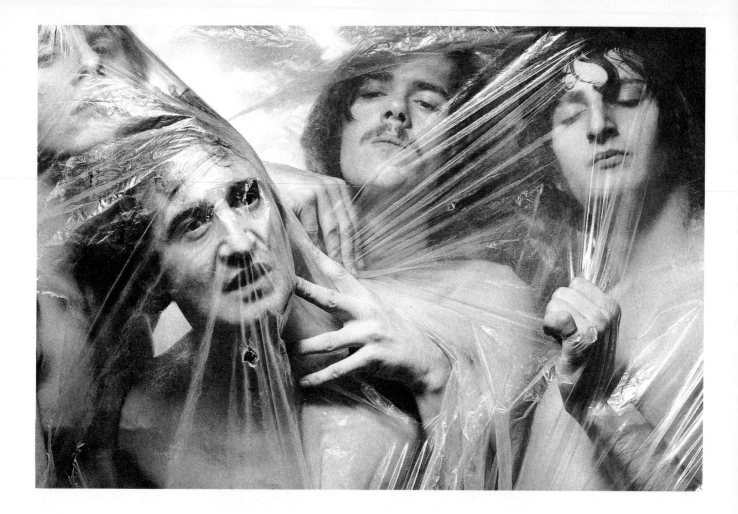

THE NICE: 'I first started working with the Nice when they were P. P. Arnold's backing group. With every photo I did of them, we set out to shock or disorientate people. This is from the cover session for their *Thoughts Of Emerlist Davjack* album. Wrapping them in plastic was to try and get a feeling of rebirth.' Left to right: Keith Emerson, Brian Davison, Lee Jackson, Dave O'List. *1968*

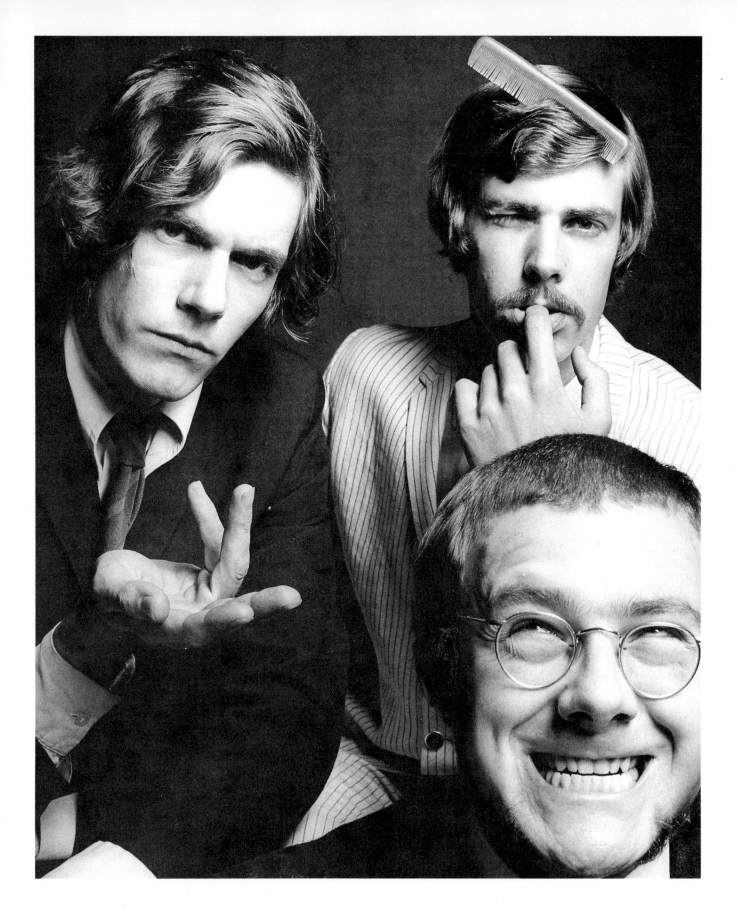

GILES, GILES AND FRIPP: 'This was a publicity session – they were absolute loonies, very eccentric. Bob Fripp was a completely lunatic experimental musician. They only made one record – I suppose they were really the forerunners of King Crimson.' *1967*

CHRIS FARLOWE: 'This was a promotional photograph for Chris's *Handbags And Glad Rags* single. At the time I was doing a lot of design work for Immediate Records, and we used a lot of – for the time – experimental stuff. I think this was actually used as an advert on the front page of the *New Musical Express*. I photographed Chris in his Islington homeland, to capture the feel of where he'd lived as a kid, which is reflected in the song.' *1968*

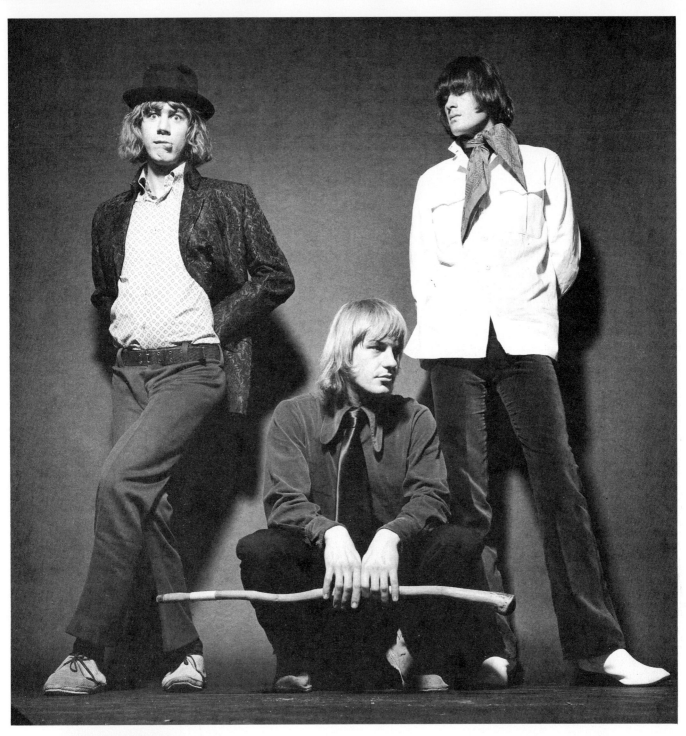

SOFT MACHINE (*Left to right*)**:** Kevin Ayers, Robert Wyatt, Mike Ratledge. 'This is typical of the sort of picture I was trying to do at the time – giving people room to respond, trying to get away from them looking at the camera all the time. This band always gave me something to work with. The other picture (left) features Andy Summers, during his brief sojourn with them.' *1967*

CAT STEVENS: After initial success with *Matthew And Son* and *I'm Gonna Get Me A Gun*, Cat Stevens was forced to retire from the music business for over a year because of severe illness. This photograph was taken in the early days of his comeback. 'This was taken in his flat, above his parents' restaurant in Shaftesbury Avenue. I wanted to get away from a studio portrait, which was how he was usually photographed.' *1969*

TRAFFIC: 'They were one of the earliest exponents of recording at home in the country. I tried to get the closeknit, family aspect of it all. It was used very large in *Rolling Stone* magazine, which pleased me at the time, as that was really something to aspire to.' Left to right: Jim Capaldi, Chris Wood, Dave Mason, Stevie Winwood. *1969*

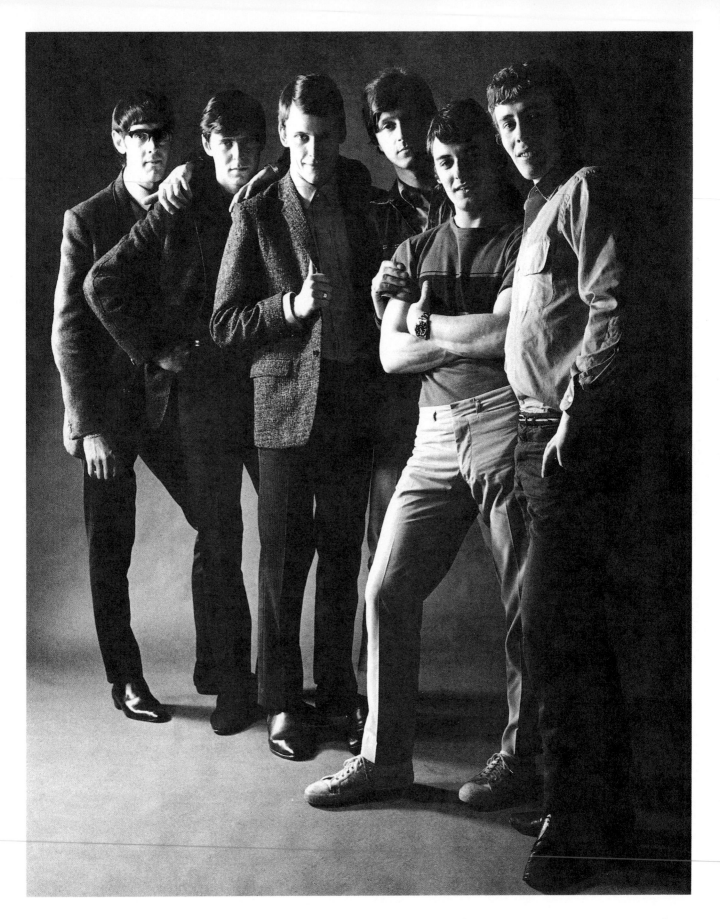

THE NASHVILLE TEENS: A British R&B group who acted as backing musicians for Jerry Lee Lewis on a 1964 tour – best remembered for their first Top 10 hit, *Tobacco Road*. 'They had a fantastic reputation for live performance. The big problem here was trying to get six people into my top floor studio, which was tiny.' *1969*

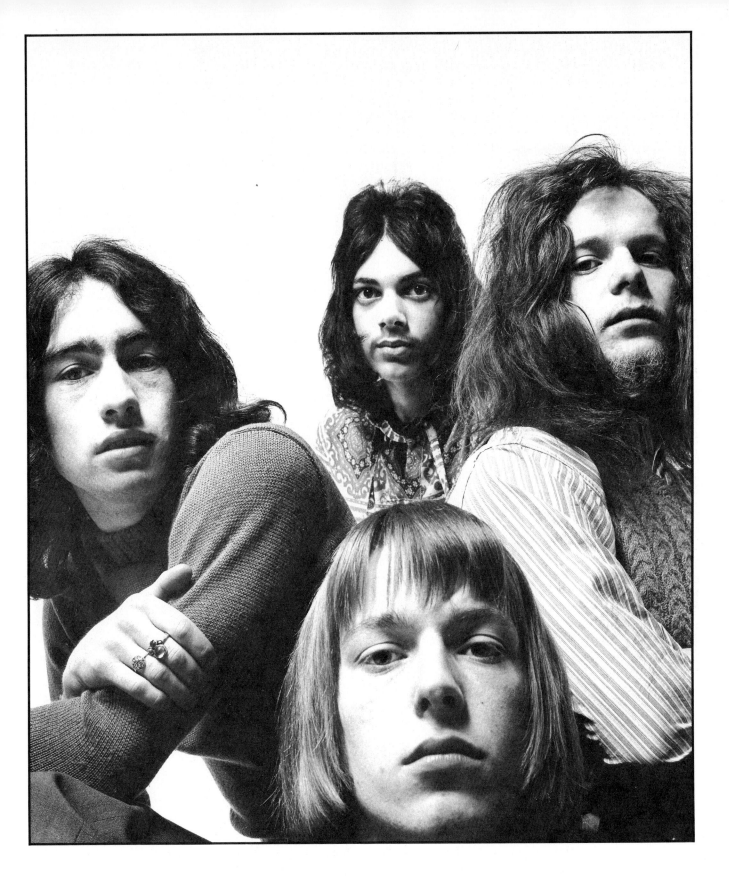

FREE: 'I'd been at school with the guitarist, Paul Kossoff, and it was very strange to photograph him as a pop star. This photo – because of the wide angle lens and distortion – was thought of as being *avant garde* and rather threatening at the time.' *1970*

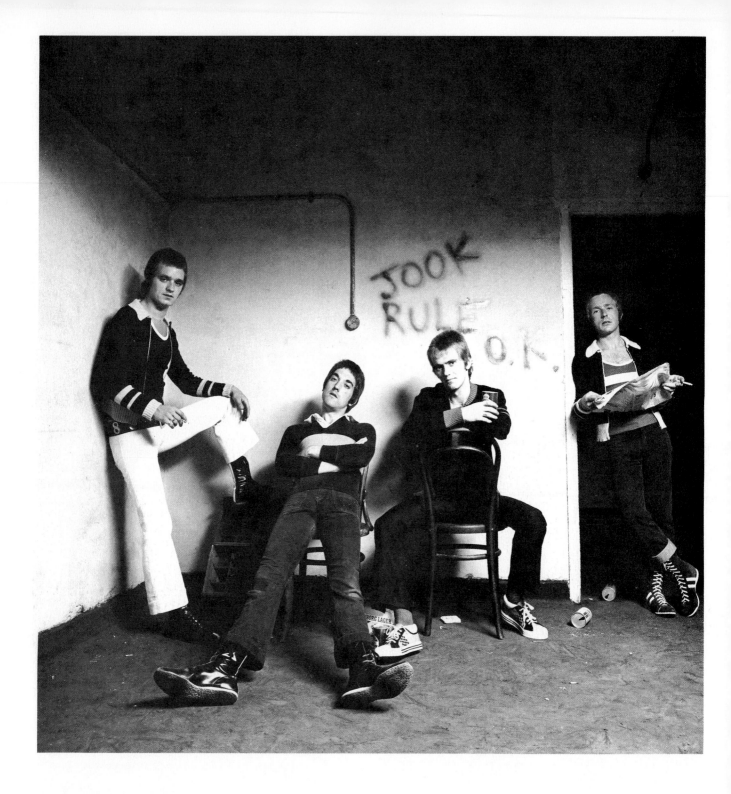

JOOK: 'This is a group that never made it, but their image was really ahead of its time — a stylish street look, slightly mod, very hard. The graffiti idea seems terribly dated now, but that was also ahead of the time. They could easily have been another Bay City Rollers, but the music just didn't capture the public imagination.' *1973*

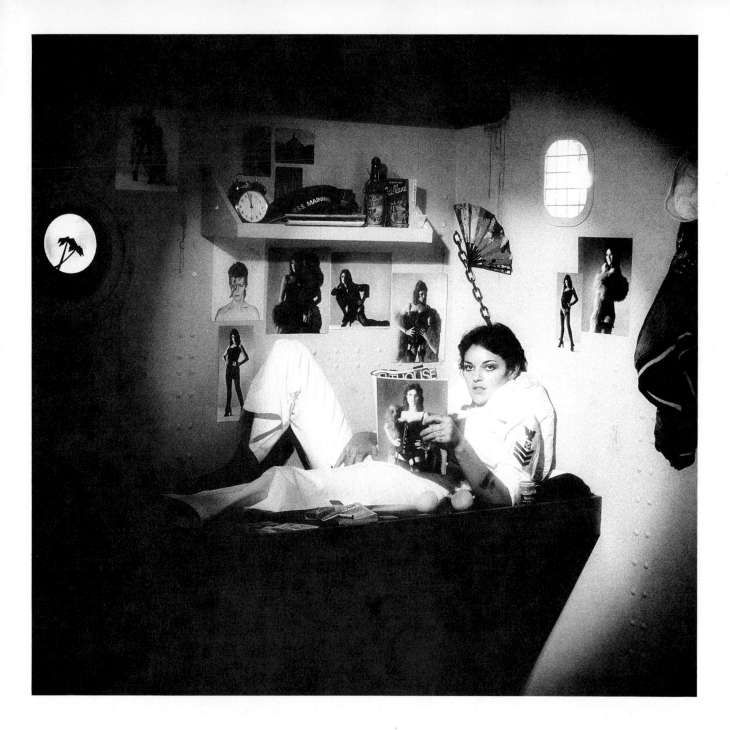

DANA GILLESPIE: 'She was being managed at the time by Mainman, David Bowie's management. She had a song out called *Weren't Born A Man*, hence this idea of her as a sailor looking at sexy pictures of . . . herself. There are lots of ''in'' references in the picture to David Bowie and Mainman.' *1973*

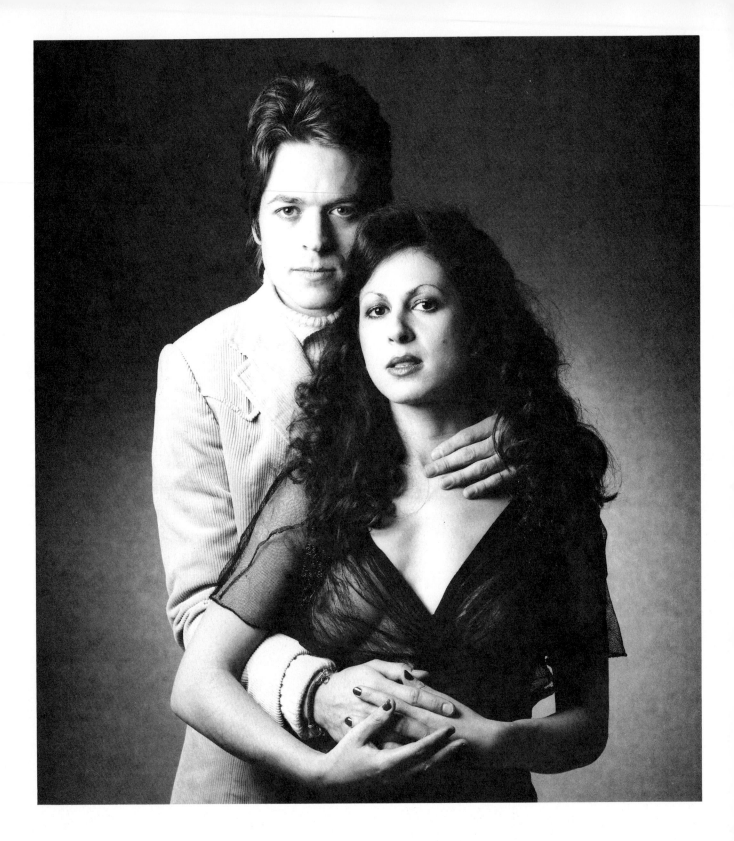

ROBERT PALMER AND ELKIE BROOKS (*Above*): 'This was while they were both in Vinegar Joe, and it was decided to do a session with just the two of them. I did a whole series of portraits, and this is my favourite.' *1973*

SUZI QUATRO (*Right*): 'This was for the *Can The Can* single. The impression I wanted to give was that the band were being supportive – that she was very sexy, but you would never risk going near her, because one of the band might beat you up.' *1973*

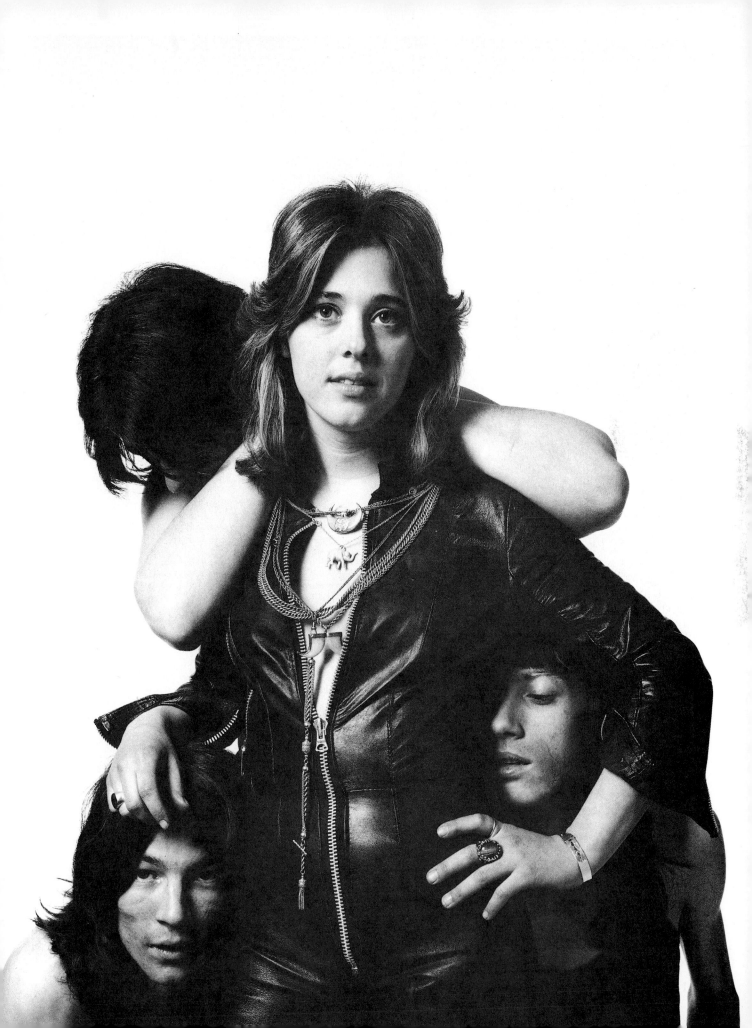

HUMBLE PIE: The band formed by Steve Marriott after he left the Small Faces. Founder member Peter Frampton left in 1971, and the band finally broke up shortly after these photographs were taken. 'They were very much against group photos, and they also didn't want to go to a lot of trouble. I decided to spend a day with them in Steve Marriott's house in Essex, where they were recording, to try and find four situations which somehow mirrored the individuals. They're all rather eccentric.' *1974*

ANDY FAIRWEATHER-LOW: Former lead singer with Amen Corner, who re-surfaced in the mid-seventies with two Top 10 hits, *Reggae Tune* and *Wide Eyed And Legless*. 'I'd worked a lot with Andy when he was in Amen Corner, and I wanted to get away from his earlier image. I think this picture really captures his sense of fun.' *1974 Thinking of Fabio. . . .*

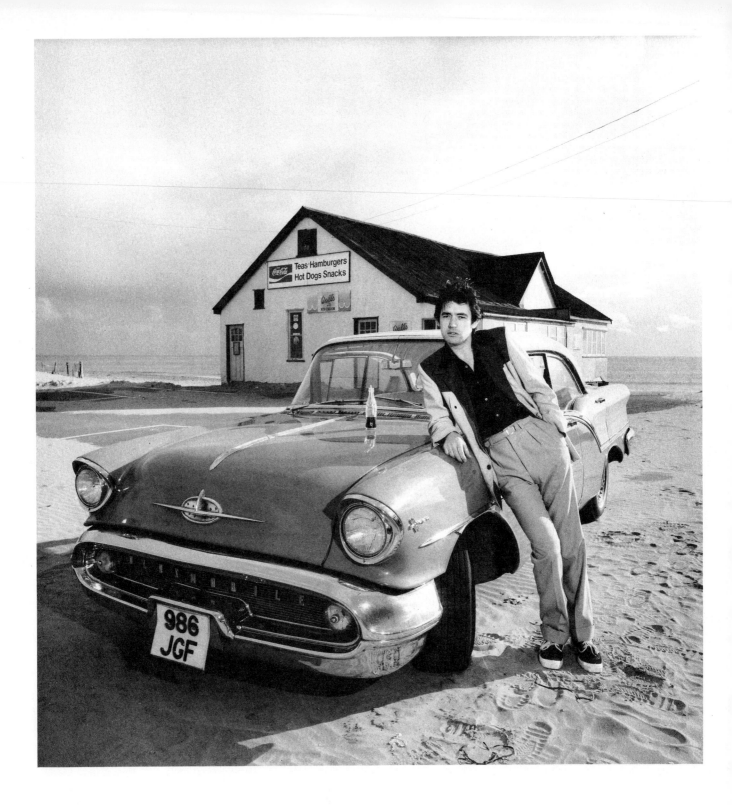

CHRIS SPEDDING: A highly respected session guitarist, who has played with artists as diverse as John Cale and the Wombles. Legend has it that he once turned down an invitation to join the Rolling Stones. 'Chris had this real James Dean, 1950s image. I found this location on the south coast, which could easily have been American – somewhere in New England. We left all of the ''Englishness'' in though, like the licence plates. The car used to be mine – I was into the fifties as well.' *1976*

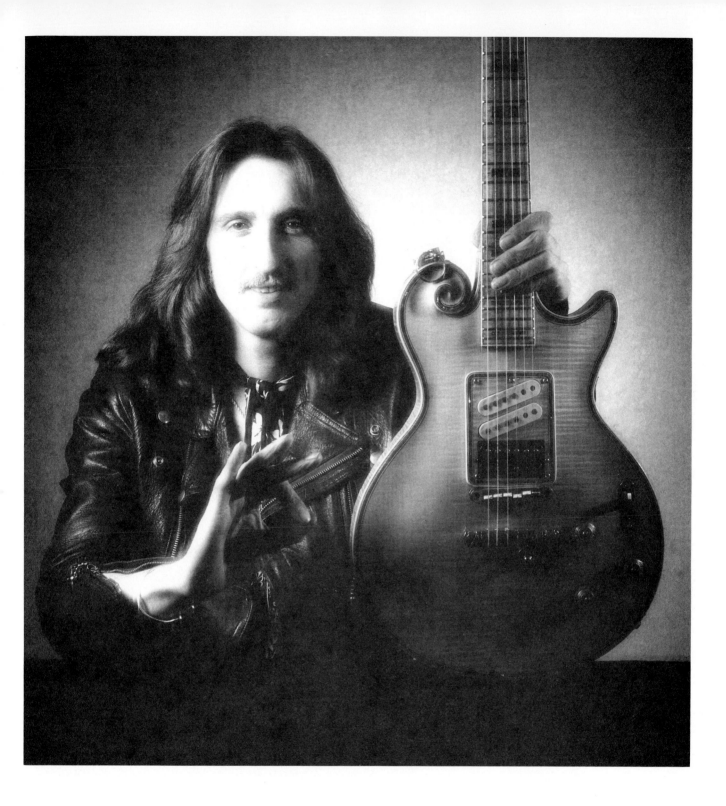

SPEEDY KEEN: A former chauffeur and roadie, Speedy Keen was the singer and writer for Thunderclap Newman, whose *Something In The Air* was a No. 1 hit in 1969. 'A portrait of a musician, and nothing more. It's almost more a portrait of his guitar.' *1976*

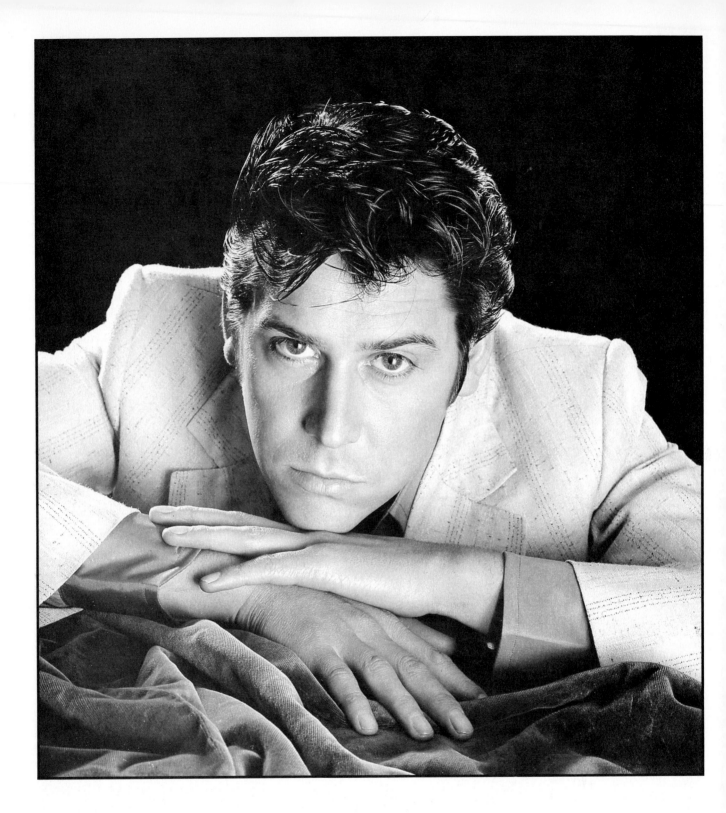

SHAKIN' STEVENS (*Above*): 'He was just making a name for himself in the stage show *Elvis*. As his image is that of a 1950s rock'n'roller, I went for a very chocolate-boxy, Fabian-type fifties portrait.' *1977*

BILLY IDOL (*Right*): 'Generation X summed up for me what poseur punk was all about – they had it down to a fine art. I decided to photograph them in a very static, classic way. I think this really captures the punk image – not the real street look, but what happened to it by the time it was coiffured, cosmeticized and marketed.' *1978*

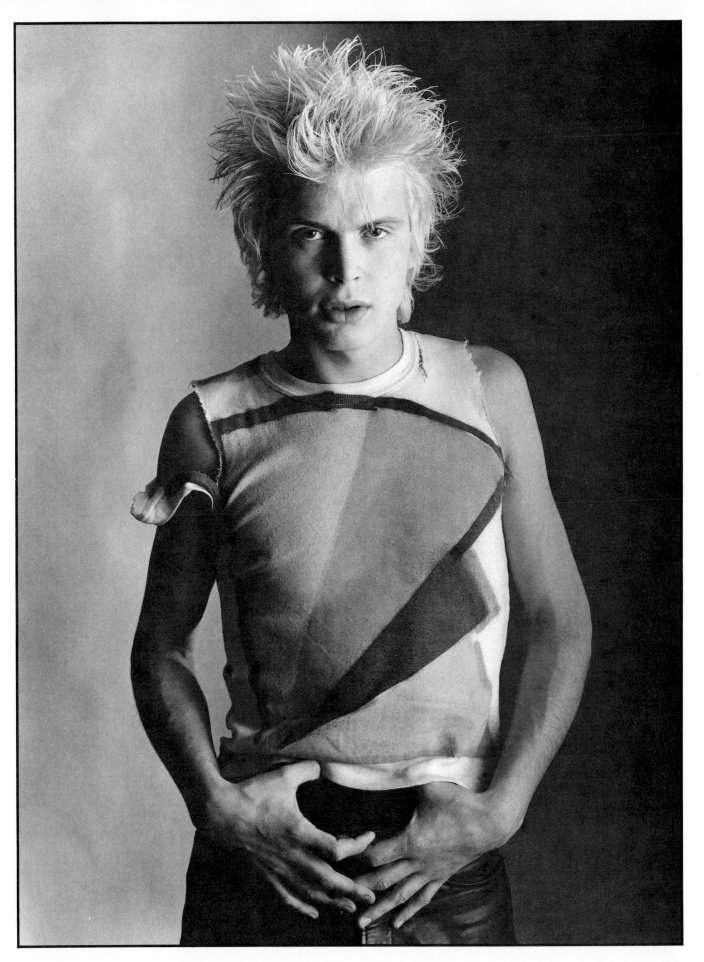

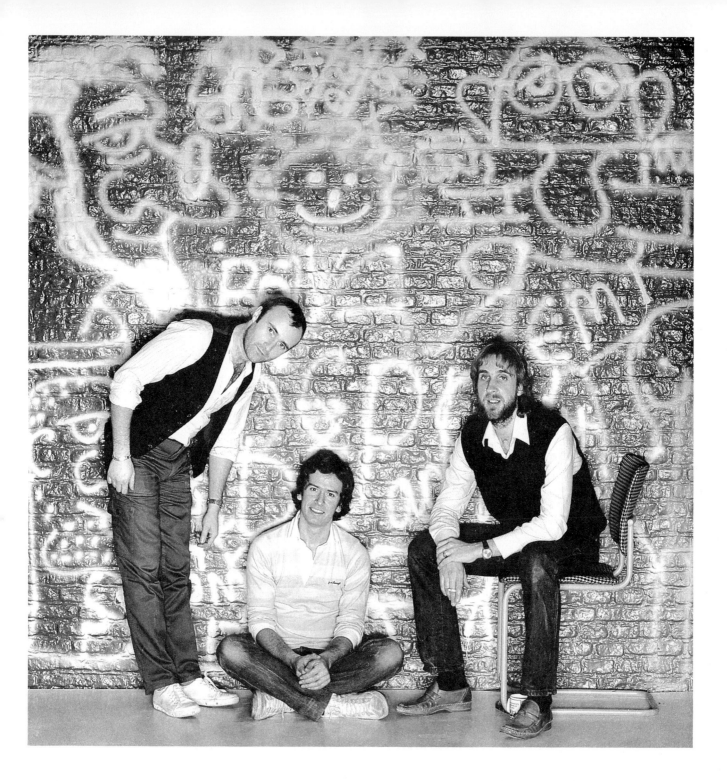

GENESIS (*Above*)**:** 'One of the problems of photographing groups who are very well established and have been photographed many, many times is to create a situation that they find interesting and amusing. It's very difficult to do because they tend to be jaded, having done it so many times. On this occasion, I gave them some aerosol paint and told them to graffitti the brick wall background – anything they wanted, bearing in mind that it was for a publicity shot. They enjoyed doing it, and it gave me a unique background.' *1982*

ROY HARPER (*Left*)**:** The folk singer who numbered some of rock's biggest names among his backing musicians – Jimmy Page, Ronnie Lane, the Nice. Pink Floyd invited him to handle vocals on one track for *Wish You Were Here*, and he survived more serious illnesses than most people thought possible. 'I wanted to capture something of the experience in his face – he has amazing eyes. I think it's a really strong portrait, very simple.' *1980*

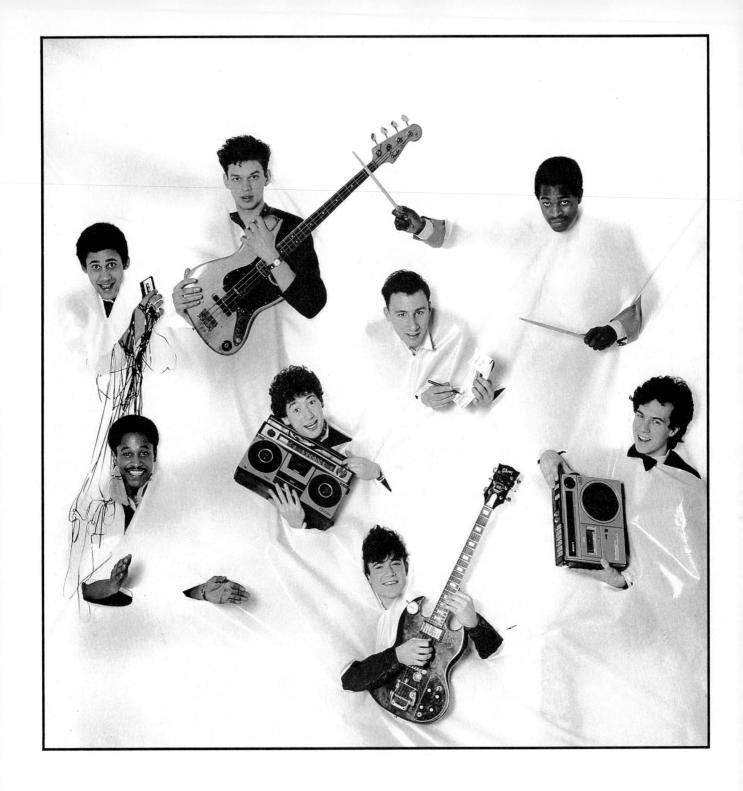

FUNKAPOLITAN: 'Up-market British funk – a really fun young band with a strong cliquey London following. This was taken for *Harpers & Queen* magazine. The problem was finding an interesting way to give them all equal space, and this was my solution. It would never have worked if they hadn't been so responsive.' *1981*

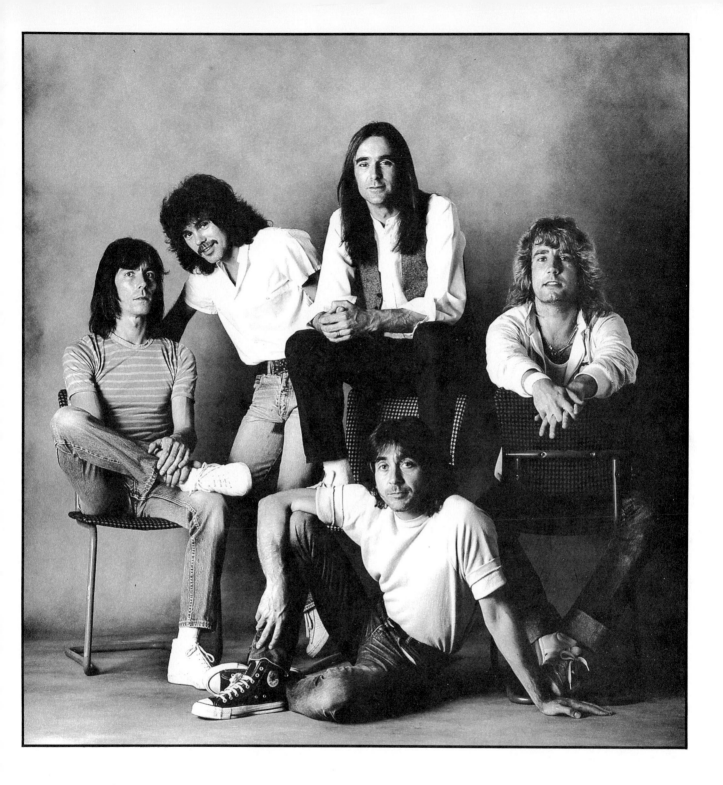

STATUS QUO: A 20th anniversary portrait. 'Another solution to photographing established bands is to just go for a very classic portrait. This isn't that far removed from what I was doing fifteen years ago, but with much higher quality . . . more dignity.' *1982*

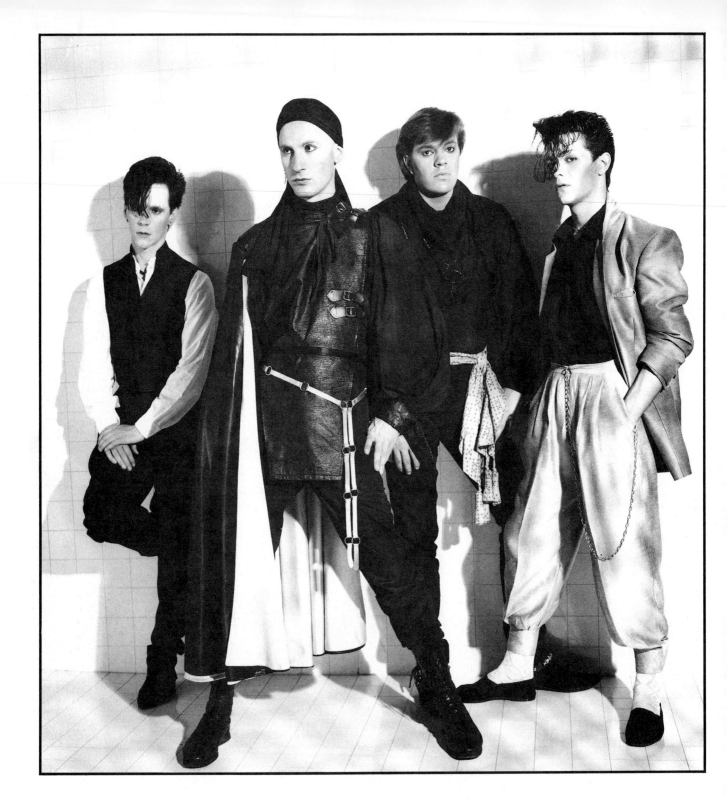

CLASSIX NOUVEAUX: New Romanticism, or buckles without the swash. They reached the Top 20 once, with *Is It A Dream* in 1982. 'The problem with this era of fashion, and with bands like this, where everybody is very concerned with their own personal style, is that there's no united image – everyone's trying to outdo each other.' *1981*

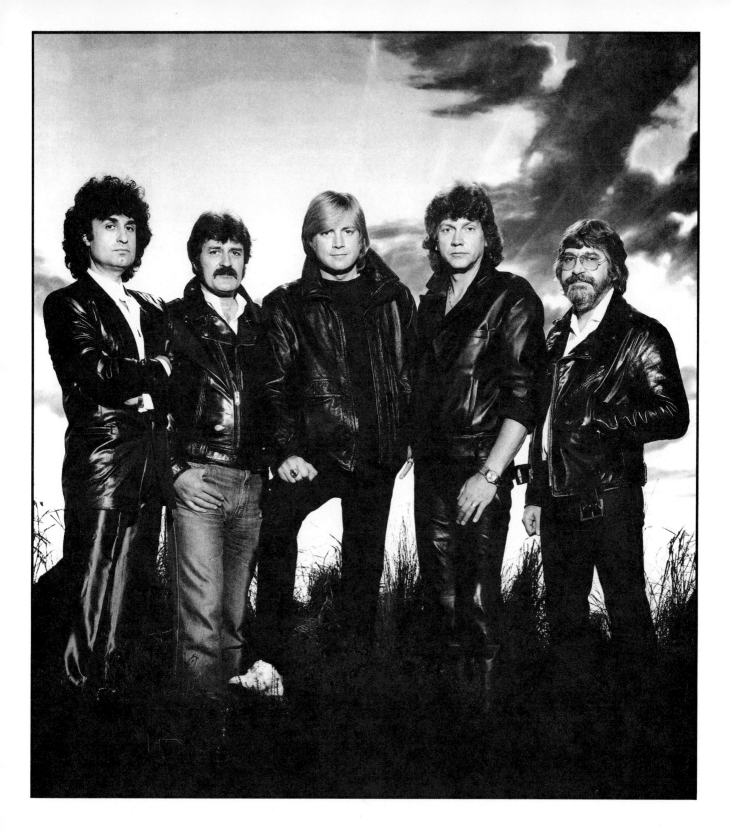

THE MOODY BLUES: Almost permanently unfashionable, although *Nights In White Satin* made the Top 20 three times – in 1967, 1972 and 1979. Somebody must like it. 'I wanted a moody portrait, with a vaguely heroic, we've-been-here-forever feel to it. I came up with this rather theatrical sky.' *1983*

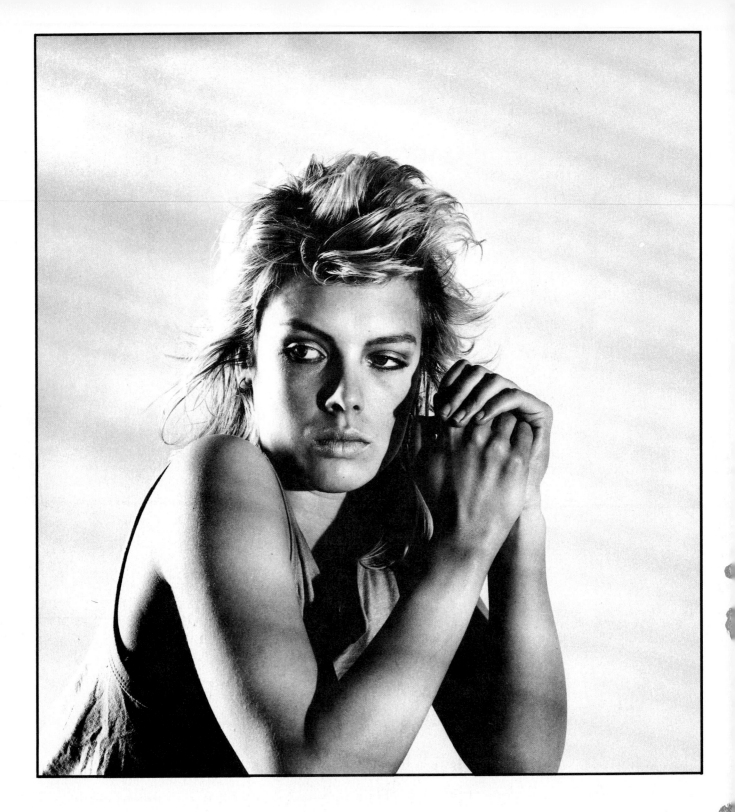

KIM WILDE (*Above*): Daughter of Marty Wilde and protégé of Mickie Most. Her first two singles (both written by brother Ricky) made the Top 10. 'She has a very stylish, attractive, sultry quality. This was taken for the sleeve of her *Cambodia* single, and I tried to capture the hot, clammy atmosphere of a Saigon bedroom – the shadow on the wall is supposed to be that of a fan.' *1981*

THE ROLLING STONES (*Right*)**:** 'The cover photo for *Between The Buttons*, taken on Primrose Hill after an all-night recording session, at about five in the morning. This was really the only time it could be done, as the Stones always recorded at night and were inaccessible during the day. I was experimenting with new techniques to get slightly distorting effects, and here I used Vaseline on the lens to get a misty feel.' *1967*

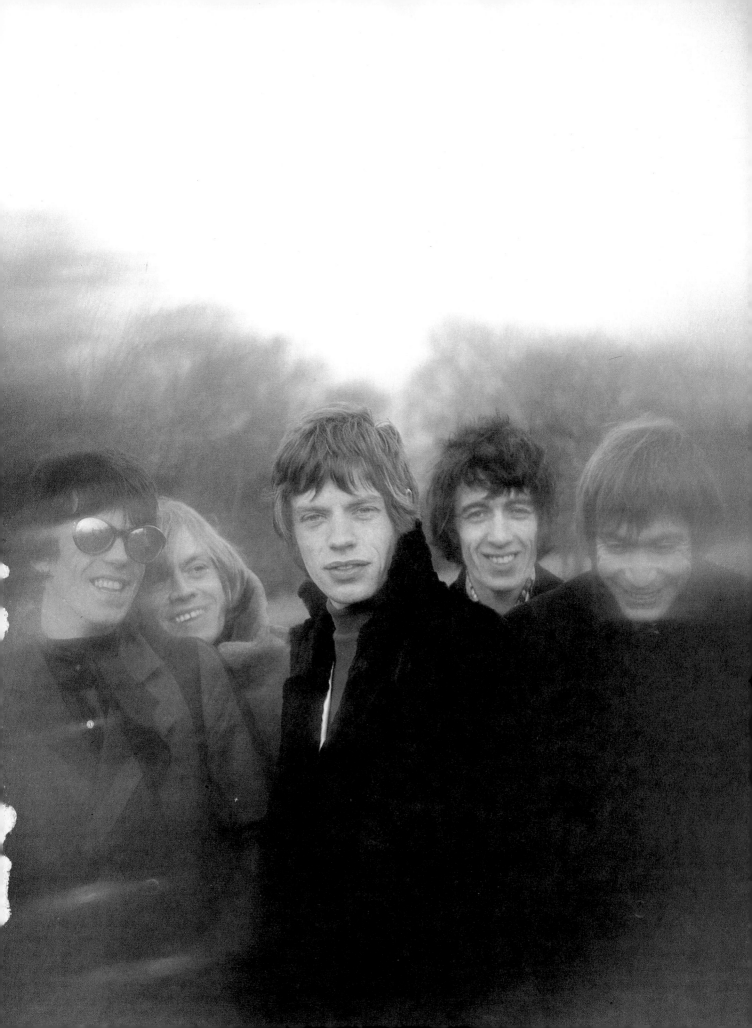

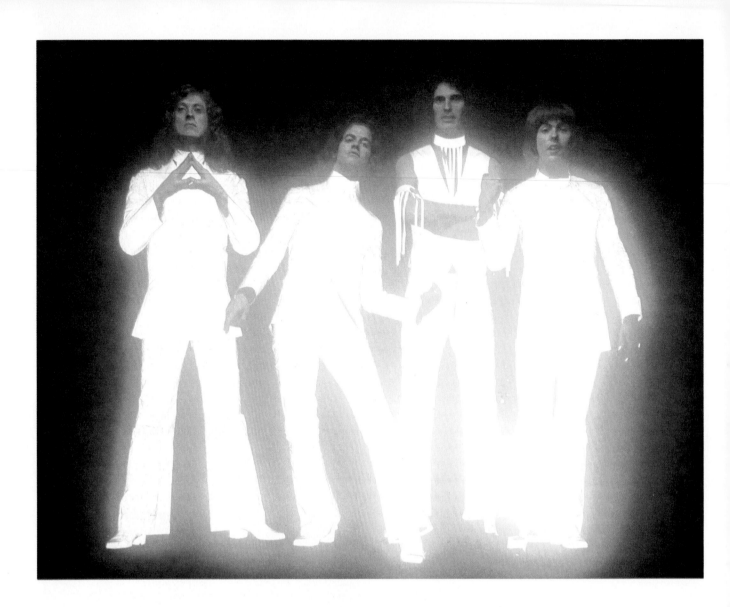

SLADE (*Above*): 'I photographed Slade many times – this was really at the peak of their success. It was part of the promotion for their film, *Flame*. We had the suits made specially out of front projection material – very tiny glass beads that were sprayed onto material. It reflects back 100% of any light bounced off it.' ***1975***

MUD/ALVIN STARDUST/GARY GLITTER (*Right, clockwise*)**:** 'This was a strange period, because the images these performers presented were such ludicrous theatrical displays – everything was a performance. They'd all wear scaled-down versions of their stage gear for everyday use, but it wasn't like a lot of today's bands, where their images extend into their everyday look. *This* era had nothing to do with fashion – it was just pure showbiz. Everything was taken to extremes – like five inch platform soles. It was ridiculous, but there was a kind of glamour to it. The Gary Glitter picture was done at Pinewood film studios. It was a really tacky idea, sort of bad 1940s musical schlock, and it was tremendous fun to do – I was Busby Berkeley for a day. All these artists were talented singers who'd found these characters to act out. It was an awful period for ''good music'', but a great period for pop.' ***1974***

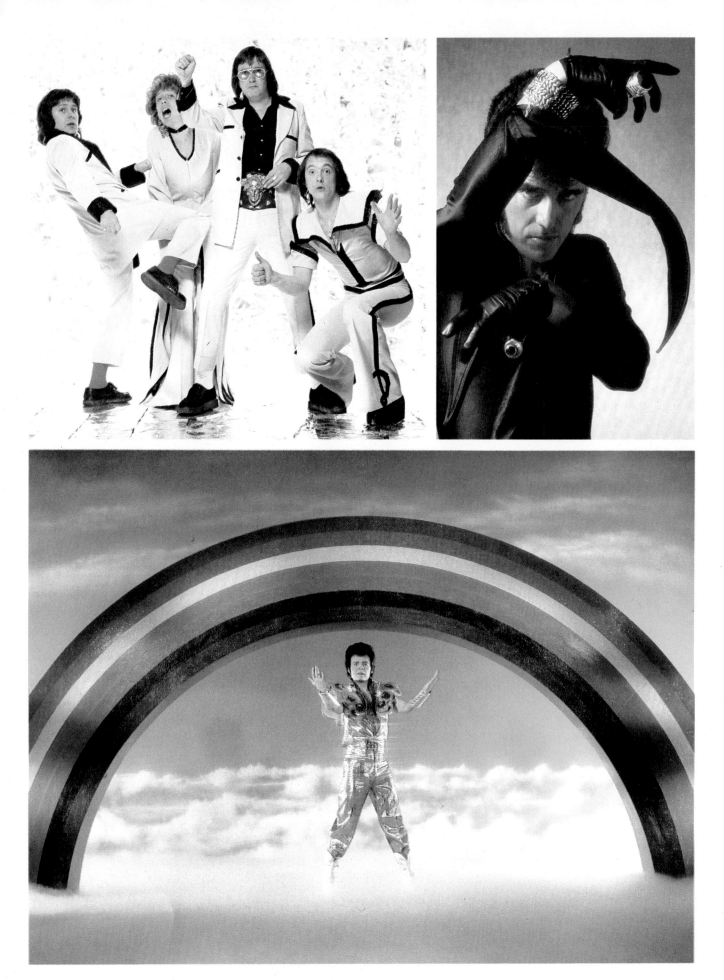

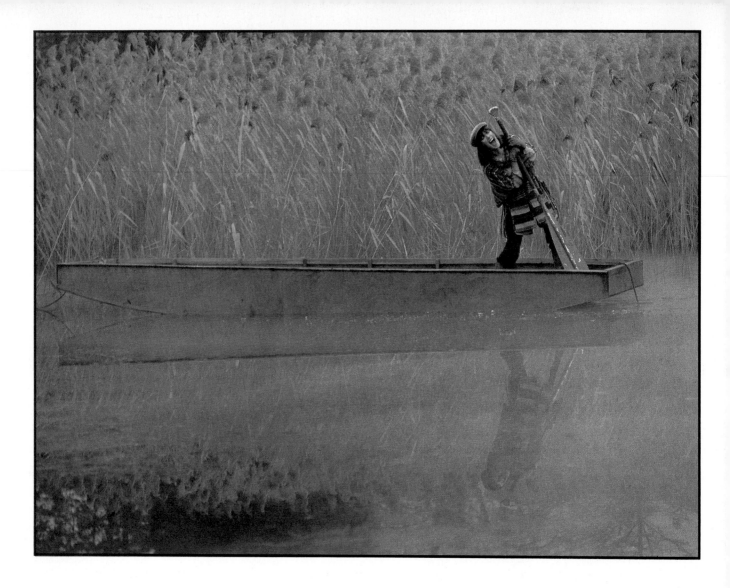

KIKI DEE (*Above*)**:** The first British girl singer to record for Tamla Motown. In 1976 she scored a No. 1 hit by duetting with Elton John on *Don't Go Breaking My Heart*. 'This was taken by Elton John's house in Windsor. It was very carefully worked out. We had to smash the ice, as the whole lake was iced over, and then we added the smoke in the reeds behind, which gives the picture a lovely misty feeling. I was on the bank, a couple of hundred feet away.' *1976*

ELTON JOHN (*Right*)**:** 'This was done for *Elton John's Greatest Hits Volume II*, and it's a visual joke, ie a greatest hits album, and he's missing. We had various sporting ideas based on the same joke, but decided on cricket because Elton was into that at the time. He could only spare a couple of hours, so the background was added later. The black silhouette of the village was painted on glass, with the sky sprayed on card behind that.' *1976*

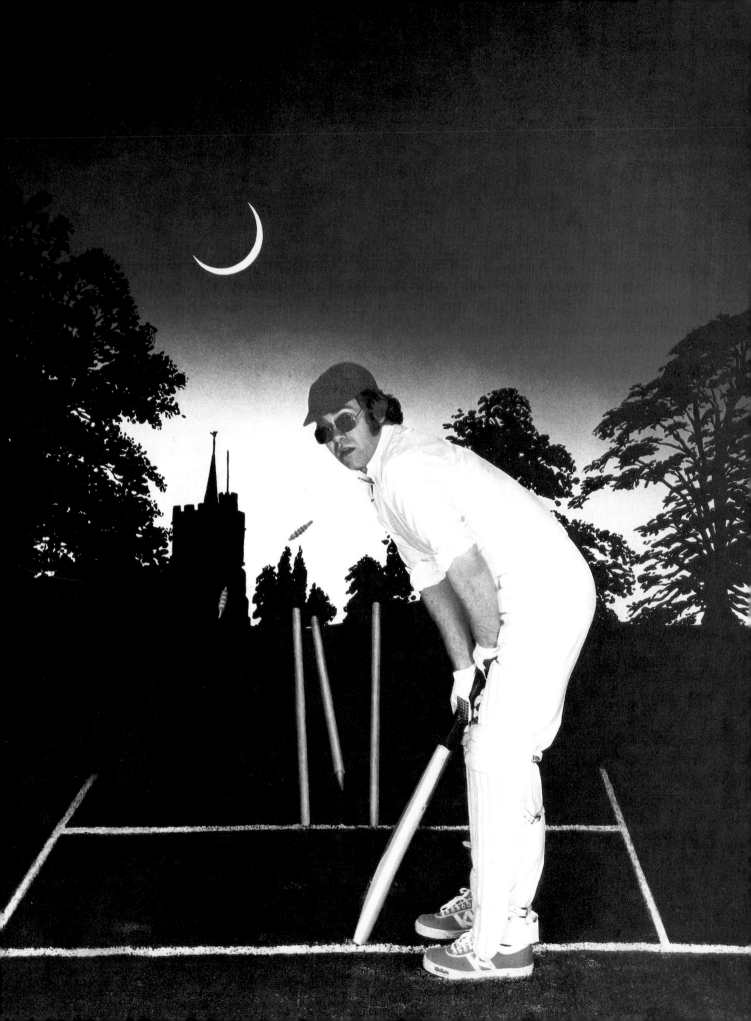

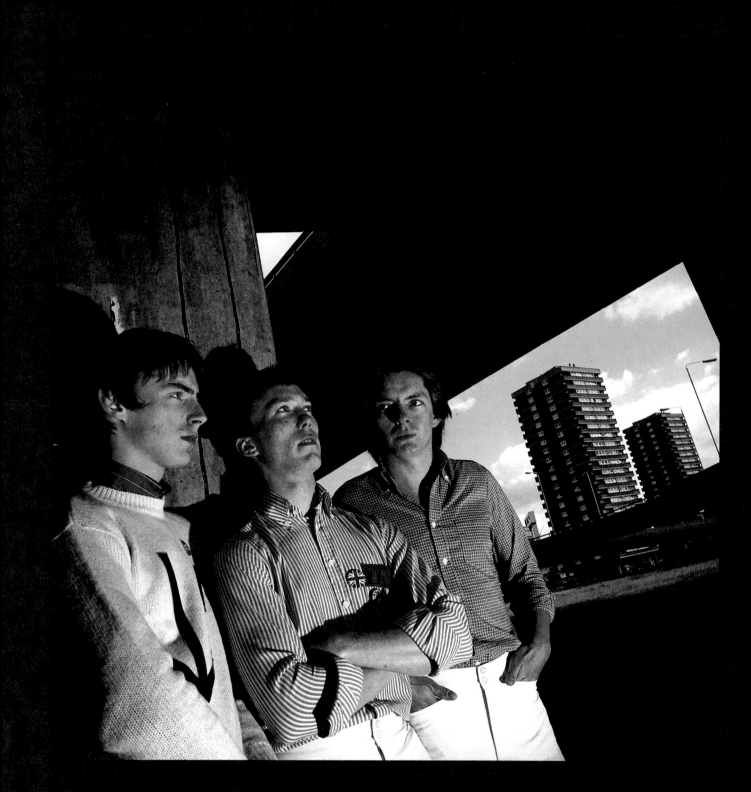

THE JAM (*Above*): 'This was the cover shot for their *This Is The Modern World* album. It was a time when everyone was particularly conscious of the horrors of tower blocks and the urban jungle. I wanted a location that showed the dominance of concrete, and I found this one in West London.' *1977*

DOCTORS OF MADNESS (*Opposite, above*): 'There was a lot of interest in them for a while, particularly because of Richard Strange. We did this on the roof of an old cinema in South London which they were using as a rehearsal studio. From the roof you could see almost the whole of the London skyline. I wanted to get a feeling of the curvature of the Earth, as if their legs were embedded in the ground. A slightly strange picture, but I like it very much – I think it reflects the time.' *1977*

PETE WINGFIELD (*Opposite, below*): 'He only ever had one hit, *Eighteen With A Bullet*, but he's very well known as a producer, session musician and songwriter – a backroom boy. This was taken under the motorway at Shepherd's Bush, for an album that was never released. Getting rid of a burning piano is a nightmare!' *1976*

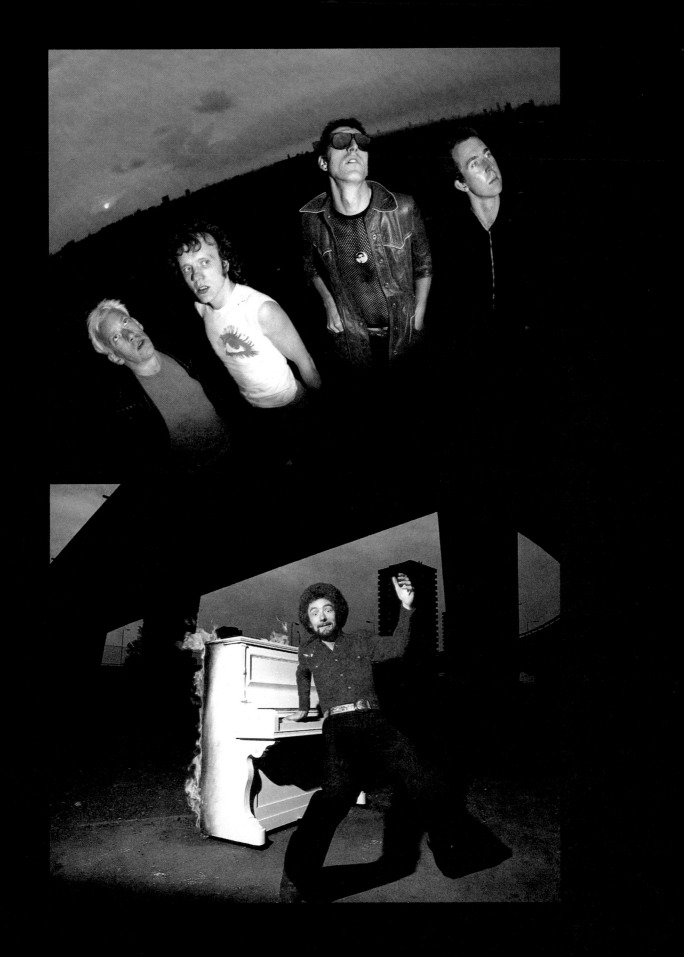

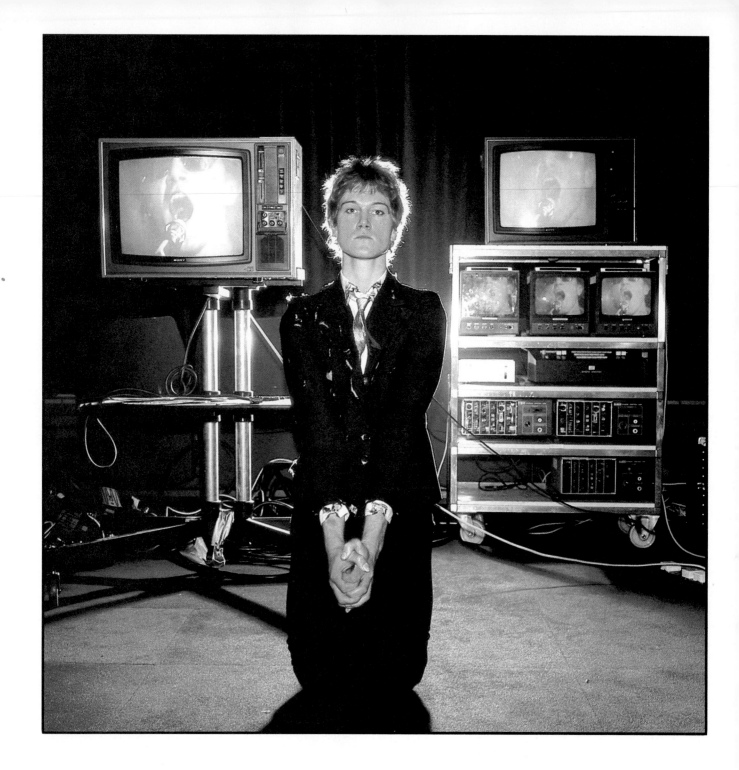

JOHN FOXX: Founder member of Ultravox, later replaced by Midge Ure. 'The background reflects his songs, which have a rather electronic sound and are very concerned with the machine age, and it's a nice contrast with his own image – the burnt and torn punk fashion.' *1977*

MAGAZINE: 'I wanted to do a portrait that was somewhat disturbing, that reflected the sense of discomfort that their music generated. The setting is just a series of layers of tabletops. I think the overall effect was very successful.' *1978*

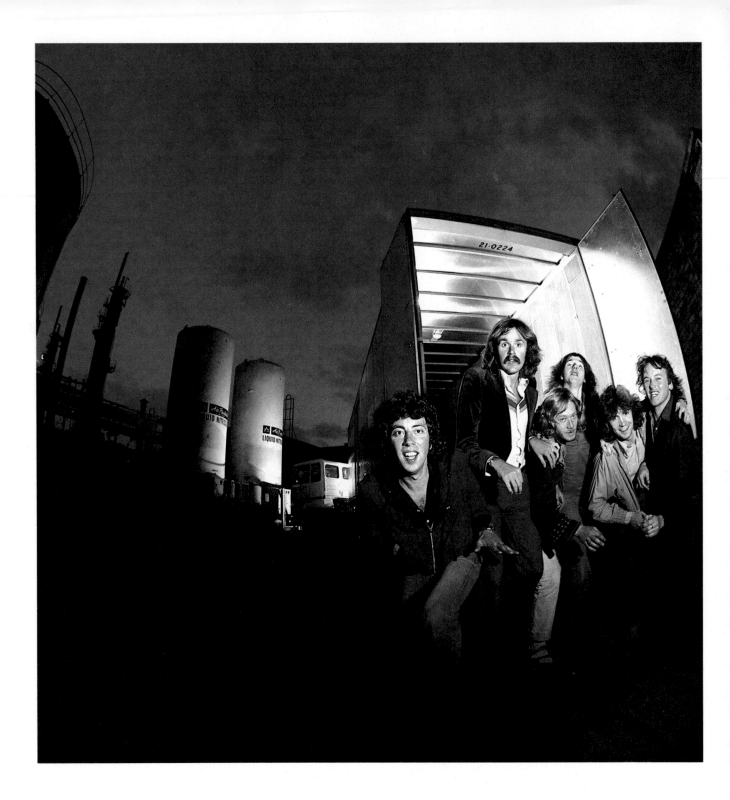

10CC: Between 1972 and 1976, 10CC notched up eight Top 10 hits, including two No. 1s – *Rubber Bullets* and *I'm Not In Love*. Following the departure of founder members Kevin Godly and Lol Creme in 1976, they again reached No. 1 with *Dreadlock Holiday*. 'This photograph was done quite late at night, using a very wide angle lens. It was enormously difficult to do, because everything – the people, the inside of the truck – had to be lit separately.' *1977*

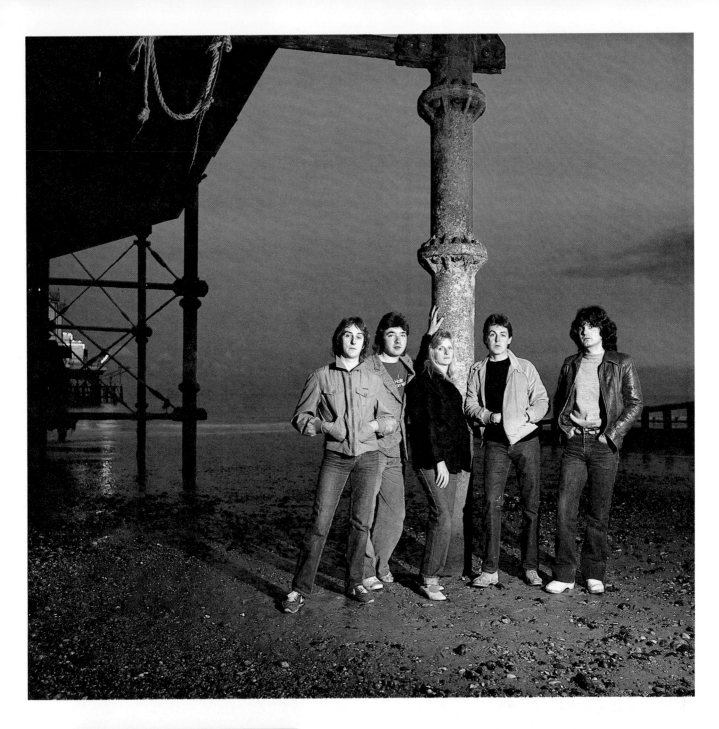

WINGS: 'Although I knew McCartney socially in the sixties, I never got to photograph the Beatles, so I was quite pleased when this chance came to photograph Wings for their tour programme. This was taken in Eastbourne – they'd taken over a theatre to rehearse down there for a couple of weeks. Shot quite late in the day, and lit with flash.' *1979*

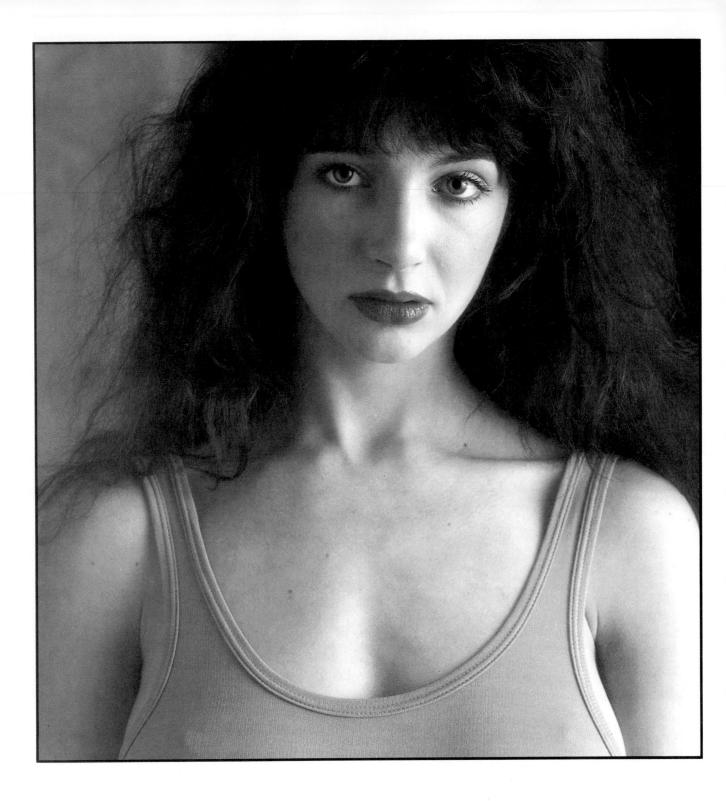

KATE BUSH: 'When I first heard *Wuthering Heights*, I knew that if it got *any* airplay, people would want to hear it again – and that's how I approached the first photo session . . . that if people saw her once, they'd want to see her again. That's exactly what happened – to the record and to this photograph – people wanted more. I photographed her a lot after this, and she was always able to conjure up different aspects of herself (*right*), but I don't think I ever quite re-captured the magic of the first picture. It's really simple, and it really works.' *1978*

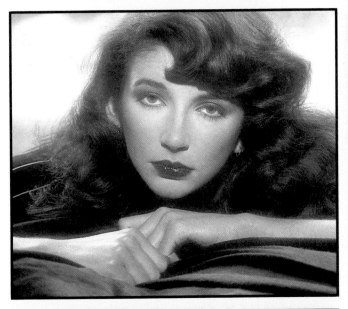

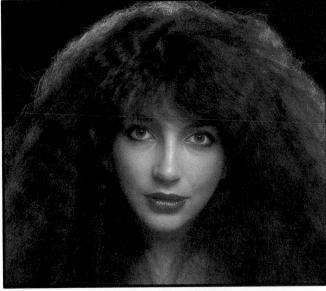

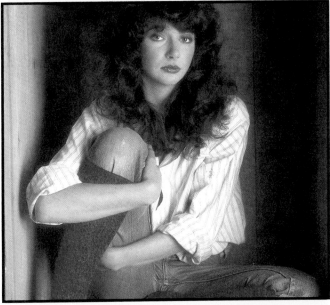

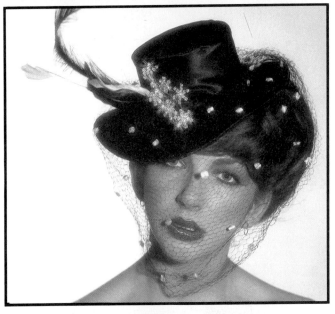

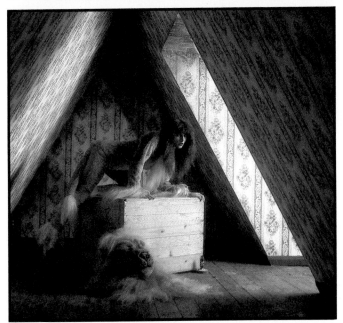

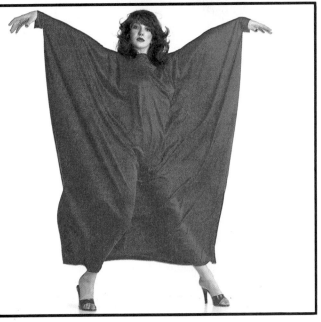

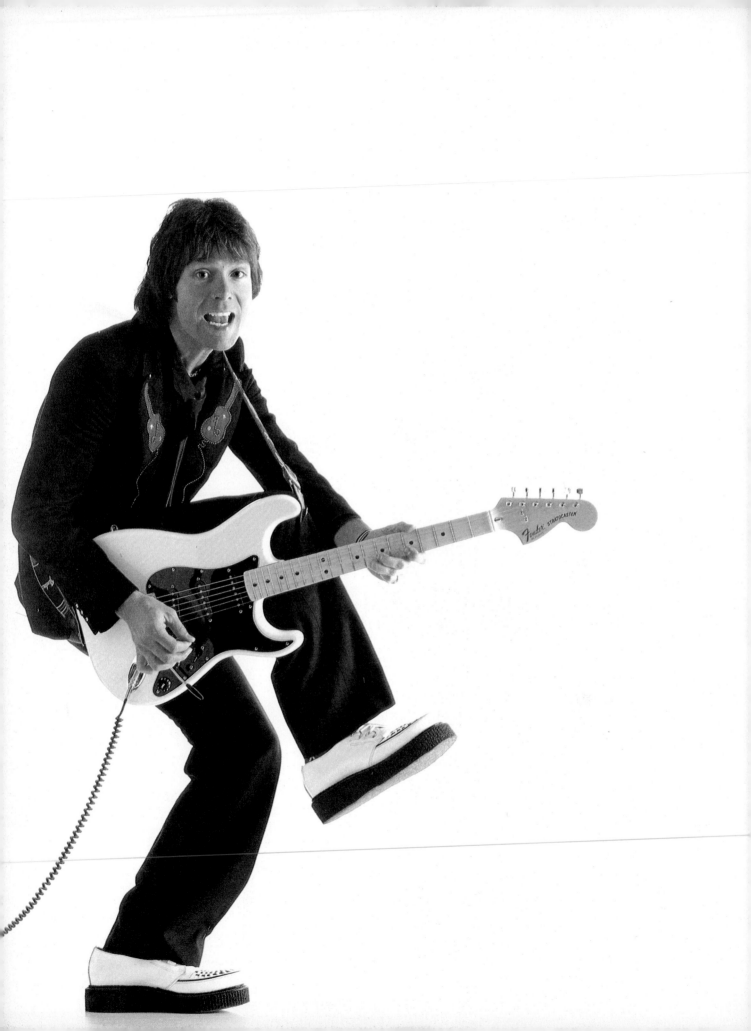

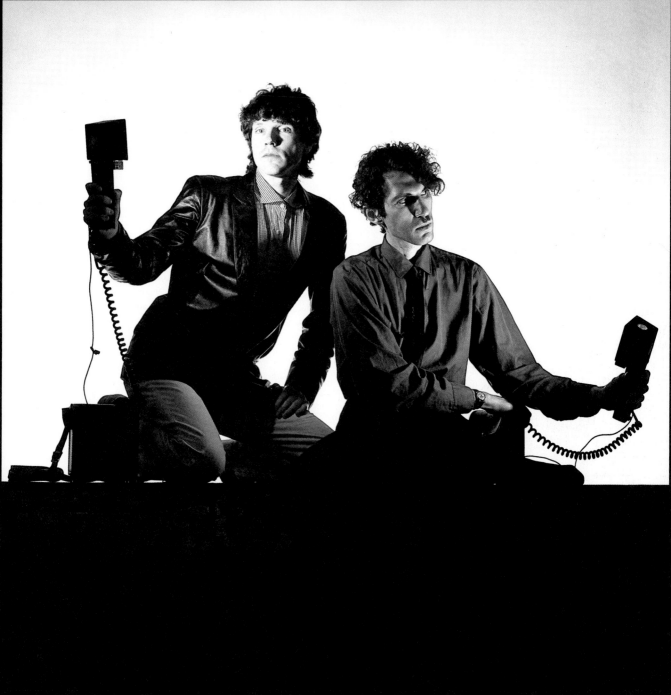

SPARKS (*Above*): Brothers Ron and Russell Mael left their native America for Britain in 1974, and scored an immediate hit with *This Town Ain't Big Enough For The Both Of Us*. More recently they made the Top 10 with *Beat The Clock*. 'I wanted them to control the light source, so I gave them hand flashes, which I told them to move around as they wanted, while I controlled the flash from my camera. I did a whole series – I found this one a very interesting shape.' *1979*

CLIFF RICHARD (*Left*): 'What strikes everyone about Cliff is how youthful he looks – of all the older English performers, Cliff just seems to go on forever; he's an English institution. So I tried to portray him as the ever-youthful rock'n'roller, duckwalking onwards. He's incredibly professional to work with.' *1979*

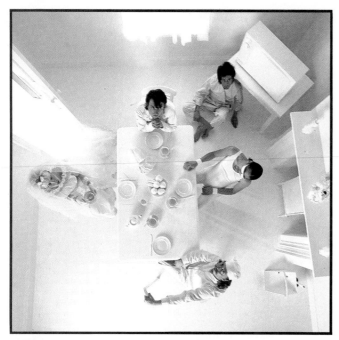
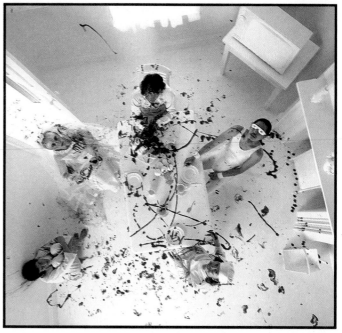
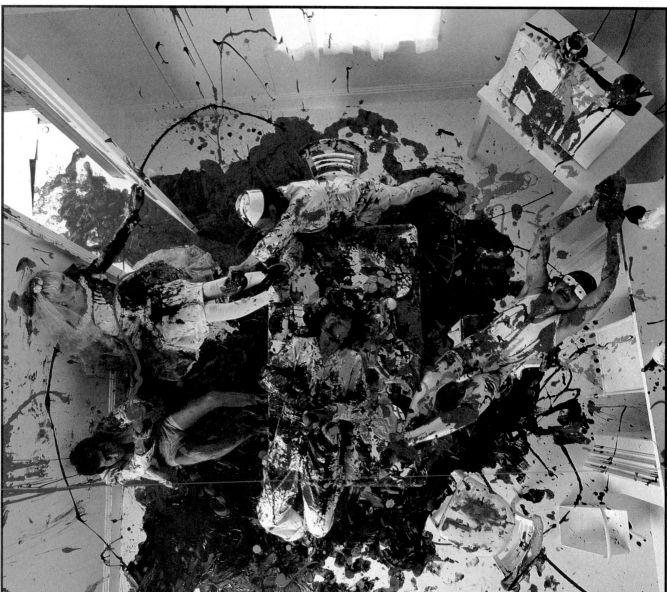

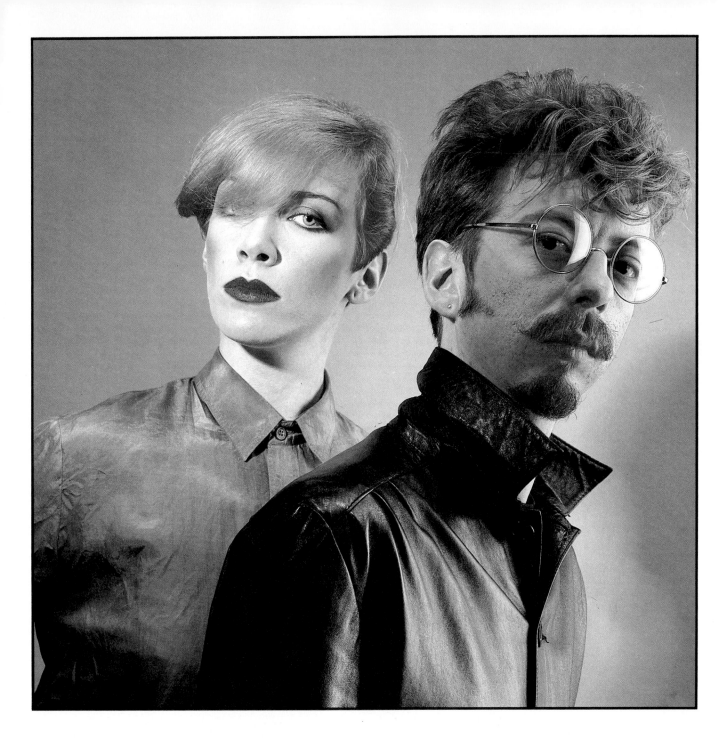

EURYTHMICS (*Above*): 'I did a lot of work with Dave Stewart and Annie Lennox after the Tourists broke up. They were really struggling for a bit – doing very good things, but without any record sales – but they've recently become enormously successful.' *1982*

THE TOURISTS (*Left*): 'When I was asked to do a cover for their album, there was a vague idea of using a white room. From that came the idea of shooting it from above, and eventually, of spraying it with paint. The set was very complicated, and it was an absolutely insane session. I was lying on my stomach, twelve feet above them. I gave them these non-toxic paints, and the idea was that they would introduce colour in a way that was realistic – the banana would become yellow, the apple green, and so on. What happened was that they lost control quite rapidly, and I had to stop them whenever I liked the way it was looking. We reached the point of the middle photo of the sequence, which was like a living Jackson Pollock, and everybody was convinced that this was the album cover. You could see that everything was originally white, and yet there was enough colour for the concept to be clear. After that I just said "go", and they went totally apeshit – there was paint everywhere. In the final shot there is actually somebody lying on the table, but he's almost entirely camouflaged.' *1979*

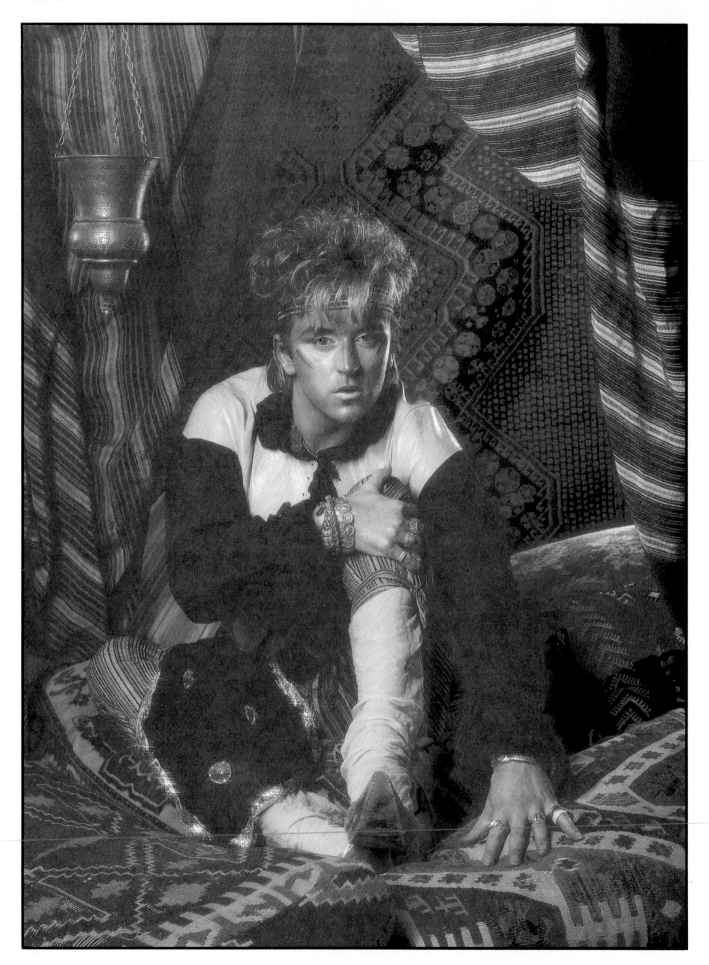

DURAN DURAN (*Above*): 'This was done specially for the exhibition, as my ''tip for the top'' picture. They were really just starting to make a name for themselves, and it was obvious that they were going to be huge. I've photographed them several times since, for record covers and posters.' ***1981***

STEVE STRANGE (*Left*): The original Blitz Kid. Club owner, sometime member of Visage, and face about town. 'This was taken specifically for the exhibition. I rang him up beforehand, to ask him what he was going to wear, and he told me he'd be wearing a sort of Aladdin/Sinbad type outfit, so I put this tent set together. I like it because it's very theatrical, and not how he normally looks, which is very stark and modernistic.' ***1981***

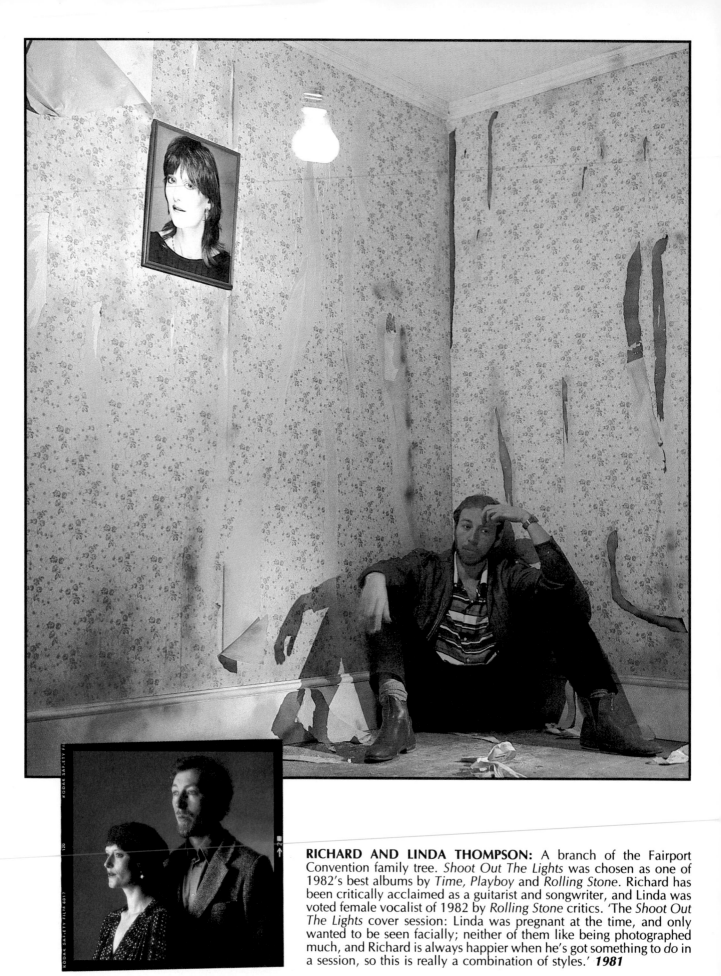

RICHARD AND LINDA THOMPSON: A branch of the Fairport Convention family tree. *Shoot Out The Lights* was chosen as one of 1982's best albums by *Time, Playboy* and *Rolling Stone*. Richard has been critically acclaimed as a guitarist and songwriter, and Linda was voted female vocalist of 1982 by *Rolling Stone* critics. 'The *Shoot Out The Lights* cover session: Linda was pregnant at the time, and only wanted to be seen facially; neither of them like being photographed much, and Richard is always happier when he's got something to *do* in a session, so this is really a combination of styles.' *1981*

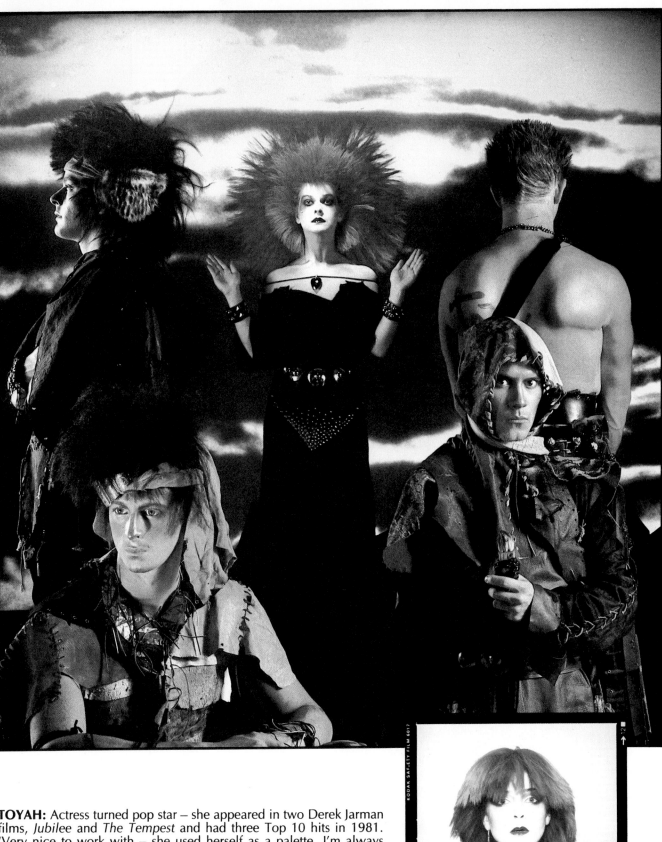

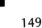

TOYAH: Actress turned pop star – she appeared in two Derek Jarman films, *Jubilee* and *The Tempest* and had three Top 10 hits in 1981. 'Very nice to work with – she used herself as a palette. I'm always delighted to work with someone this image conscious, because you know you're going to get something from them. She dominates this shot, even though the rest of the band are in it. I wanted lighting that was slightly surreal, and there were lots of technical problems – depth of field, trying to keep the lighting from weakening the strength of the background. I suppose the fashions were pre-*Blade Runner* holocaust-survivor chic.' *1981*

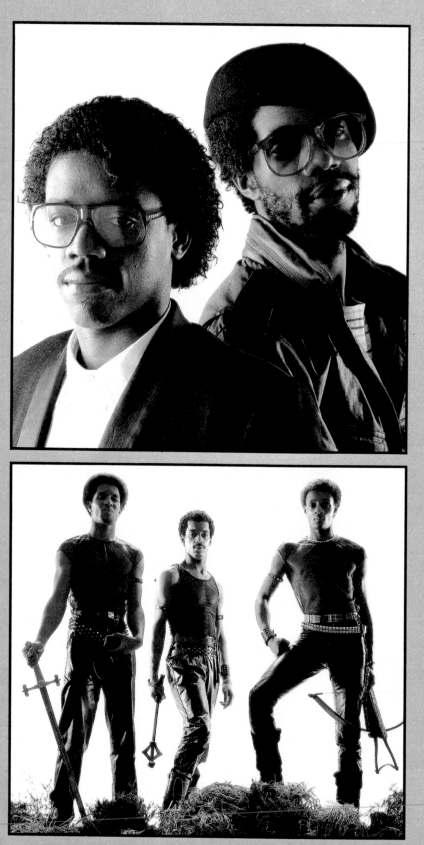

LINX (*Above*): British funk at its best, but with only one Top 10 hit, *Intuition*. They broke up in 1982. 'We spent ages trying to come up with a complicated idea, and discarding all of them.' *1981*

BEGGAR & CO (*Below*): Low level British funk; despite associations with Spandau Ballet, they made the Top 20 only once, with (*Somebody*) *Help Me Out*. 'Very theatrical, almost Arthurian legend time.' *1981*

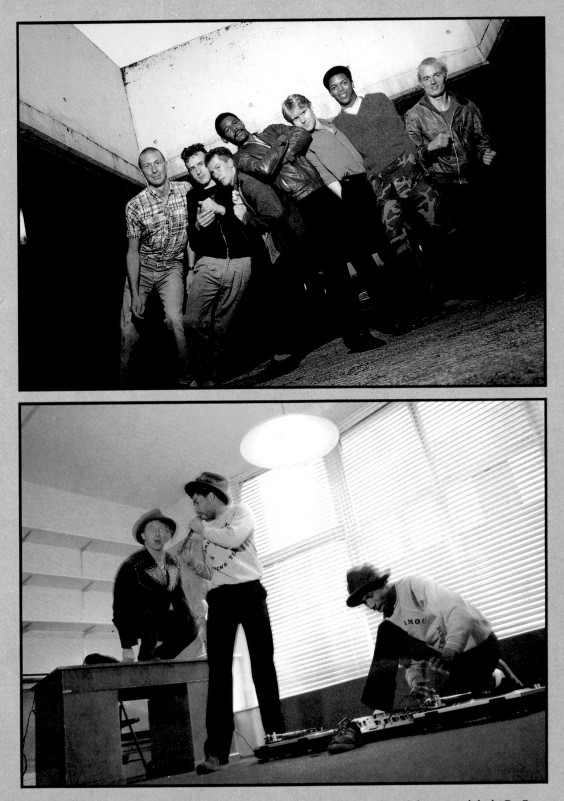

THE BEAT (*Above*): The Beat emerged from the 2-Tone stable to found their own label, Go Feet, and produce three excellent albums before disbanding in 1983. 'One of the problems these days with photographing a group of this size is the danger of a comparison with Madness, just because of the shape of the group. One of the ways to animate a photograph is to try and get the people responding to each other in a controlled way.' *1982*

MALCOLM McLAREN (*Above*): As manager of the Sex Pistols, he took the record industry to the cleaners twice (or was it three times?) in the same year. Since then, he's advocated home taping, promoted Bow Wow Wow with teenage nudity, and generally annoyed a lot of people. He also found time to produce a highly enjoyable album of dance music from around the world. 'An extraordinary genius — he was a performer even as a manager.' *1982*

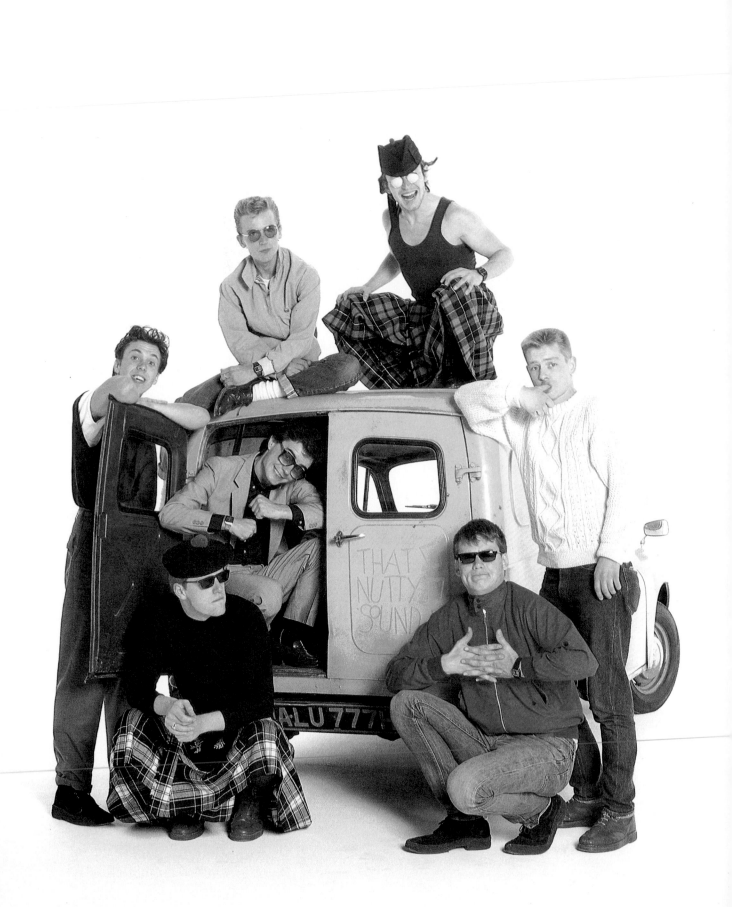

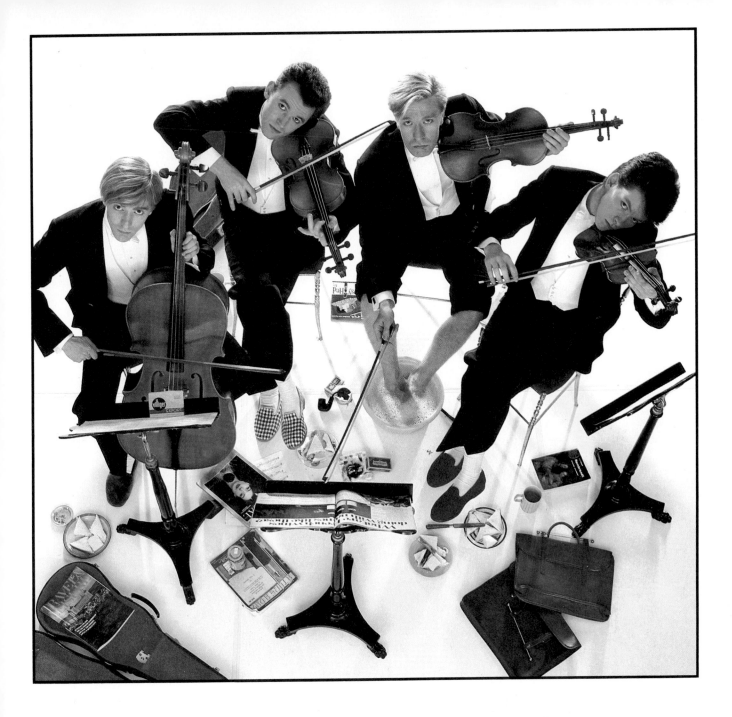

ABC (*Above and right*): Their consciously stylish approach to pop brought them three Top 10 singles and a successful album, *The Lexicon Of Love*, in 1982. 'A great band to work with – they have very good ideas. They're very serious, very concerned with detail. Every session I've done with them has produced a picture I'm really happy about.' *1982*

MADNESS (*Left*): Originally part of the 2-Tone roster, and seldom out of the Top 10 since 1979. In terms of British chart success, *the* most popular band around. 'I think they're magical visually, very good at throwing shapes, and they worked really hard. The moment they got in front of the camera, they *were* Madness.' *1981*

BILLY FURY: 'I'd actually been a tremendous fan of Fury's for years, ever since the *Oh Boy!* show. I went to photograph him backstage at Hammersmith Odeon – he was very nervous about the concert. I was kept waiting for hours to see him – the only reason I stayed was because I didn't think I would get another chance to photograph him. It was only a few months before he died.' *1982*

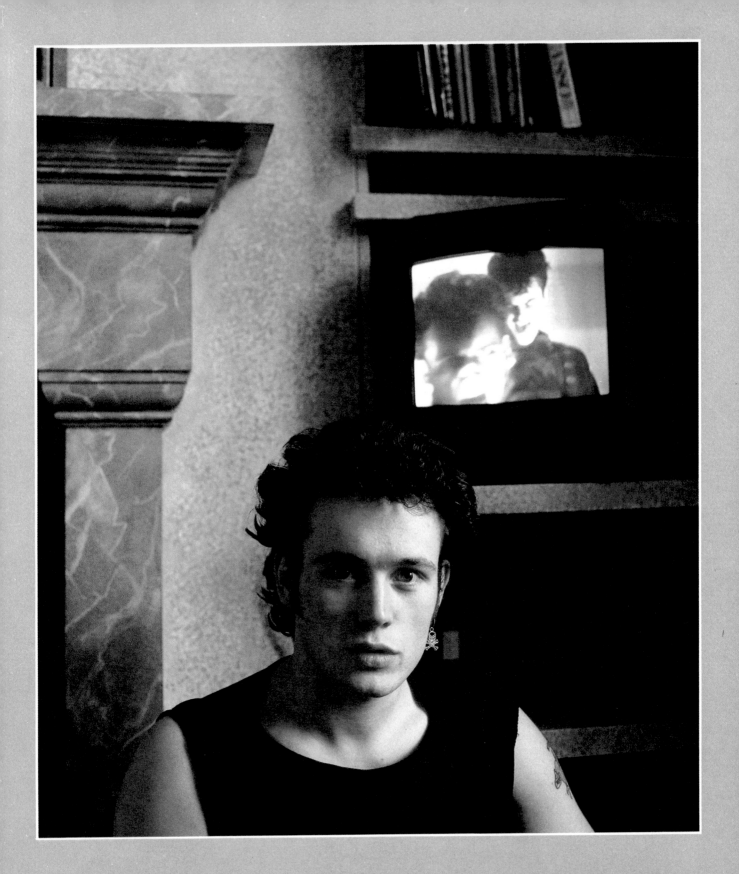

ADAM ANT: 'I photographed him at his home for the London Sunday *Observer* magazine. At that time he still had his famous image of the painted face and pigtails, and the Jimi Hendrix coat. I wanted to get a picture that had some reference to his alter ego, so I had him run a video of himself performing on the TV screen behind him. Seeing him without his make-up at that time came as a bit of a shock, but he'd decided that his new image would be more natural.'
1981

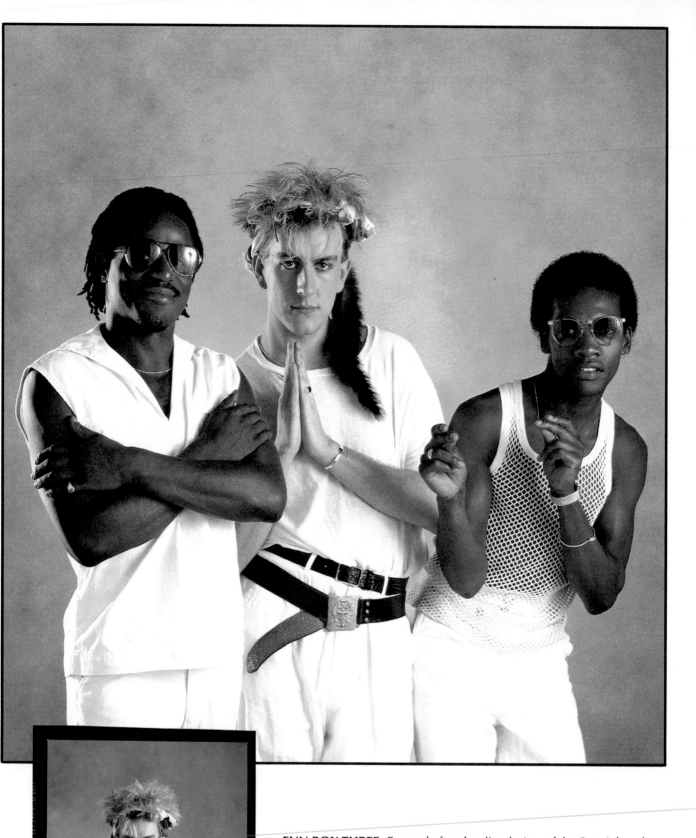

FUN BOY THREE: Formed after the dissolution of the Specials, whose *Ghost Town* had been No. 1 at the time of the Brixton and Toxteth riots. 'When we were doing the exhibition, I really wanted to include the Specials, as I felt the whole 2-Tone thing was very important. I went up to Coventry to do the session, but Jerry Dammers was ill, so it never happened. I was really pleased to get a chance to photograph the Fun Boys, who are very responsive to the camera. Like many of their generation of pop stars, they seem to understand their market much better than the earlier artists did.' *1982*

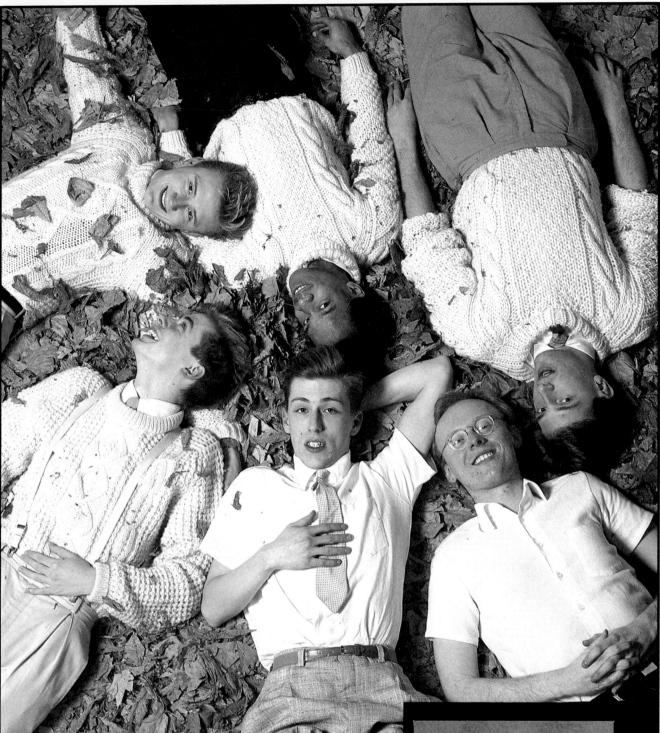

HAIRCUT ONE HUNDRED: Genuine teen idols, as clean cut as they come – their avowed heroes were the Monkees. They recorded one album, *Pelican West*, which yielded four Top 10 singles, before singer Nick Heyward departed for a solo career. 'The album cover – in retrospect it has a very *Brideshead Revisited* feel. I wanted to take a shot from above, and the background had to be tonally simple. I felt their Arran sweaters were very autumnal, hence the use of leaves as a background.' *1982*

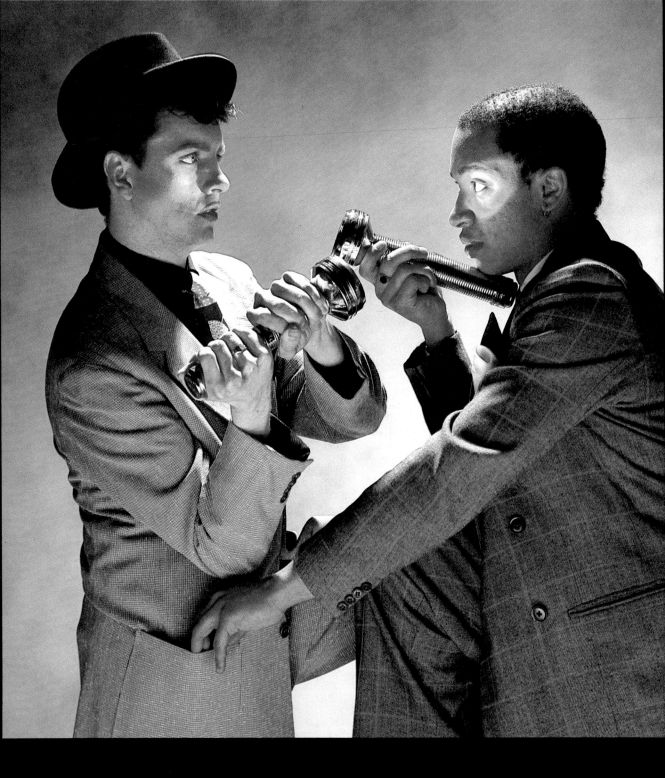

WAH!: After seemingly endless variations in personnel (and the group's name), Pete Wylie finally equalled his Liverpool rivals Teardrop Explodes and Echo and The Bunnymen by scoring a Top 10 hit in 1983 with the sublime *Story Of The Blues*. 'Duos are quite difficult to photograph. This is similar to the Sparks shot, but more in keeping with the vaguely forties style. The torches are very old fashioned American ones – I'd bought them ages before, waiting for the right opportunity to use this lighting idea. It seemed to me that these two lent themselves to it – it's like they're discovering each other with the light.' *1982*

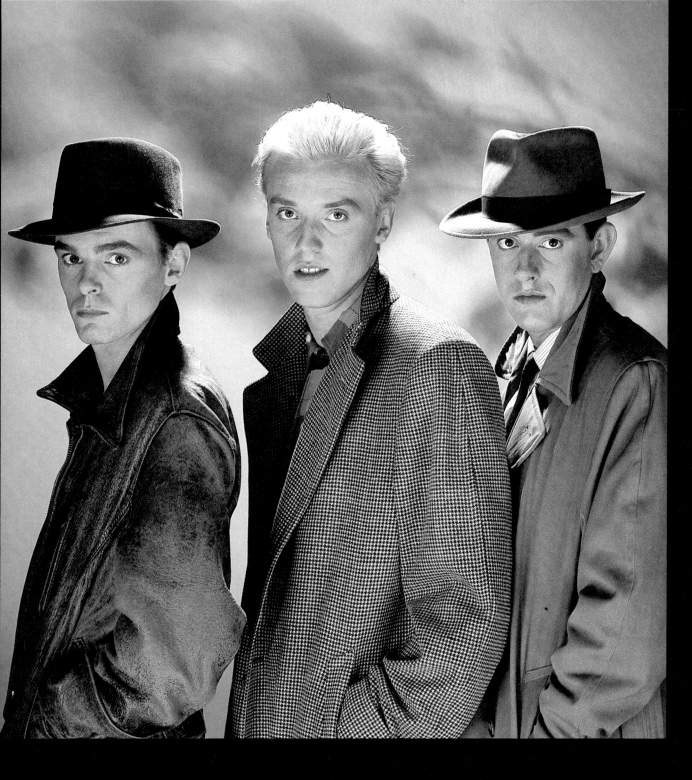

HEAVEN 17: At the end of 1980, Ian Marsh and Martyn Ware left the Human League to go it alone. A year later, the Human League had a number one single and album, but Heaven 17 finally scored a Top 10 hit in 1983 with *Temptation*. 'They were very much into a stylized 1930s/1940s look, so I went for the feeling of a Hollywood film still of that era. I think the thirties and forties were a peak in cinematic lighting – it's always influenced me very strongly.' *1982*

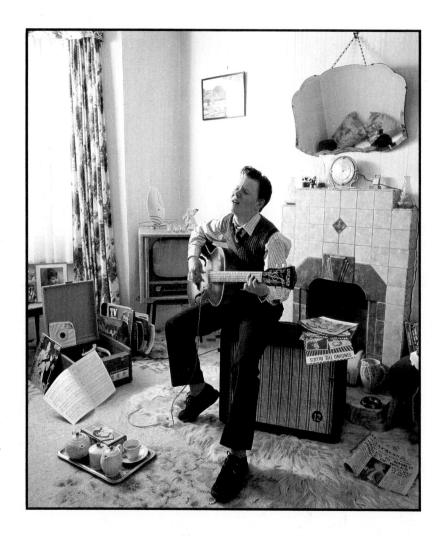

'There'll always be some little arrogant brat who wants to make a noise with a guitar. Rock'n'roll will never die.' *Dave Edmunds*